POPES

AND

FEMINISTS

POPES

AND

FEMINISTS

How the Reformation
Frees Women from Feminism

Elise Crapuchettes

canonpress
Moscow, Idaho

Published by Canon Press
P.O. Box 8729, Moscow, Idaho 83843
800.488.2034 | www.canonpress.com

Elise Crapuchettes, *Popes and Feminists: How the Reformation Frees Women from Feminism*
Copyright ©2017 by Elise Crapuchettes

Cover design by James Engerbretson
Interior design by Valerie Anne Bost
Printed in the United States of America.

All Bible quotations are from the English Standard Version copyright ©2001 by Crossway Bibles, a division of Good News Publishers. Used by permission.

Library of Congress Cataloging-in-Publication Data:
Crapuchettes, Elise, author.
Popes and feminsts : how the Reformation frees women from feminism / Elise Crapuchettes.
Moscow : Canon Press, 2018. | Includes bibliographical references and index.
LCCN 2017055913 | ISBN 194764405X (pbk. : alk. paper)
LCSH: Vocation—Christianity—History of doctrines. | Sex role—Religious aspects—Christianity—History of doctrines. | Women—Religious aspects—Christianity—History of doctrines. | Feminism—Religious aspects—Christianity—History of doctrines. | Reformation. | Reformed Church—Doctrines.
Classification: LCC BV4740 .C734 2018 | DDC 230.082—dc23
LC record available at https://lccn.loc.gov/2017055913

18 19 20 21 22 23 24 9 8 7 6 5 4 3 2

To Andrew:
You were right.

CONTENTS

MY STORY

Since long before I knew the word, vocation has been an important issue for me, as it probably has been for most Christians. It has been a particularly confusing issue for Christian women, myself included, because of the shifts in our culture over the last hundred years. How should a woman use her gifts and skills to honor God in the work she does? How should she accomplish faithful work, pleasing to God?

I grew up down South in a Southern Baptist pastor's family. We were at church every time the doors were open and sometimes when they weren't. I always loved reading and learning, and people often asked me

throughout my childhood and then in my high school and college years what I wanted to be. I regularly read Christian biographies, and that, combined with the missionaries who came to speak at our church, convinced me that all the best Christians were missionaries. So I wanted to be a missionary, and I also wanted to be a mom. Most of the women in the books from the church library had careers, either secular (Susan B. Anthony) or religious (Lottie Moon). As far as I remember, there were few books about the lives of faithful wives and mothers. Still, I wanted to be a stay-at-home mom, most likely because I myself had a wonderful stay-at-home mom.

By the time I'd reached high school, and even more so in college, my professors and advisors and the rest of the world had convinced me that being just a mom would be a waste, and that only reinforced what I'd learned from those books in my childhood—the people who change the world do it through their careers. I always got the impression that with so many opportunities available and with such a love of learning, I should do something more to serve God and others than stay home with children. However, this placed a huge burden on me: there did not seem to be a faithful option that was interesting or exciting to me. All these desires to learn but also to have children could not be combined into obedience, and if I pursued them both, I would live in a perpetual state of guilt.

So I ended up with a college major that was just a precursor to graduate school (called the University Scholars Program, in which I took whatever classes I wanted, from

Greek to organic chemistry). I loved learning, and the longer I stayed in school, the more I could delay jumping into a career I didn't want. I started pre-med but realized I did not want to spend ten years in school and residency before being able to start a family. Since I loved standardized tests so much, I went ahead and took the LSAT and then ended up in a joint law degree and master's of theological studies program at Duke University. The problem was I hated law school from the first day. Turns out I still didn't want a career; I wanted to learn, and one of the only subjects I never found interesting was the law (the fun I had taking the LSAT was no preparation for law school itself). The master's of theological studies was interesting, but not enough to make the subject into a career. I still wanted to get married and have children. I still wanted to do what my professors would have disdained—throw away all my potential in order to stay home and feed and diaper kids. Intelligent and industrious women were supposed to have careers, and the impression I had was that simple and lazy women stayed home, women who would be intellectually challenged by changing a diaper.

Through a whole shakeup of my faith, I joined a Reformed church, and one of the important things I learned was that there is a greater reason for having children than personal happiness—children are a blessing God gives and one of the means He uses to bring the world under Christ's dominion. Raising faithful children is a fundamental means of ministry and missions. Still,

I thought the best Christians were in professional ministry, so since I wasn't inclined to do that, my plan was to marry a pastor or an academic (professors can fill a sort of pastoral role, I reasoned). Instead, God sent me a remarkably brilliant businessman who'd never graduated from high school, let alone college. Three weeks after I turned in my final paper for law school, we got married. And then nine months and one week later, our first of five children was born. For a time, babies and toddlers were my world. After I awoke from ten years of having babies and nursing, I started wondering what I was supposed to do next. Now that I could complete sentences again, I questioned again what the point of my life was after my children no longer need the same amount of attention all day. The women who stayed in their jobs had long since passed by a stay-at-home mom like myself. Taking ten years out of the workplace ensured that much.

Along came Nancy Pearcey. Several years ago, I picked up her book *Total Truth*, in which she presented the cultural mandate, which either I had never heard of or never fully absorbed. Whatever the case, she pointed out that in Genesis 1, God gave His people a mandate to fill the earth and subdue it, and that building cultures—through all sorts of vocations—is one of the means of fulfilling that mandate. She also rejected the evangelical Christian perception that real Christians become missionaries and do kingdom work, and everyone else is subpar. Although I knew the Reformers had fought battles over vocation, Pearcey's modern application of their

teachings was fascinating and helpful. Thus, when I was asked to give a talk for wives at a ladies' event for church, I wanted to flesh out what a wife's vocation should be.

Having loved history, I knew that women hundreds of years ago would have had a different perspective on the American debate about whether women should go to work or stay at home. I figured they would have been fighting different battles, and so they were. I had read a quote about Katie Luther once, so I started with her and then moved on to what her husband Martin said about vocations and how greatly his perspective differed from the Catholic Church of his day. And it struck me that the Catholic Church of the sixteenth century was arguing something similar to what my professors and the biographies in our church library argued, namely, that women have to leave the home to make a difference in the world. Although they never said it outright, I realized these professors and authors and seemingly everyone else had been advancing a feminist cause—that women need careers to matter. Even the conservative Christians I'd known throughout my life had an undercurrent of feminism in their assumptions because they too believed that for a woman to make a real difference, she had to be in a career ministry. They were (inadvertently, I believe) pushing the feminist agenda—more softly and gently than the secular world, but creating the same kind of guilt nonetheless.

As I studied further, the connections between the Catholics of old and modern feminists became obvious.

Both cultures were alike in burdening women who wanted to follow God and serve. The Catholic Church said they had to leave home to be nuns, which was the only vocation or spiritual calling the Church recognized for women. The ultimate goal in the lives of these women was to attain salvation, and the Catholic Church had promised them a better shot at it through their work as nuns than they would have in any other place in society. I felt sorry for them, and at the same time I had an inkling of the burden they must have felt. Having grown up Protestant, I knew that I was justified by faith alone, so I did not view my career choice as salvific. However, I still wanted my life to have purpose and to honor God. What I'd learned growing up in a culture informed by feminism was that women needed to be in full-time ministry if they wanted to be the best Christians and that they needed to be fully devoted to their careers if they wanted to have an impact on the world. Looking at sixteenth-century Catholicism and feminism side by side revealed that feminism is, on the issue of women's vocation, recycling and reliving the errors of the pre-Reformation Roman Catholic hierarchy.

Martin Luther and other Reformers refuted the Catholic Church's teachings on vocation, and that had a significant impact on the women of their day. First, the Reformers recovered the biblical teaching that salvation is only through Christ's work, not any work a person can do. And second, they taught that women are free to serve God wherever He places them. The Reformers

said women who stay home with their families have a noble calling and a real vocation, and therefore they are a crucial part of God's work in the world. Thus, Martin Luther and other Reformers relieved women of the burden the Catholic Church had placed on them. These faithful men were arguing against the prevailing view of their day, and I realized that the prevailing view of their day was analogous to the feminist one I'd been immersed in since childhood. Thus, the work of Reformers—and of the everyday Reformed women—became even more relevant to women today like me who are also struggling to understand their vocation as wives and mothers under a constant barrage of career-first messages.

I began studying the effects of the Reformers' views on their female contemporaries and on their society. Of course I'd heard of the Reformation, but I had never studied the women involved in it or the culture in which it grew. As I delved into the lives of women from the Reformation, it was clear that they were not out to make a difference in the world for the sake of their own fame or because anyone burdened them or guilted them into it. They were just being obedient. But because they focused on obedience wherever God placed them, they did not spend their lives wondering whether they were making the right vocational choices or trying to make sure they did enough to please God. And God used them to change the world.

So that's why I wrote this book about Roman Catholic doctrine and Reformed wives and mothers. Of course

these women's lives were very different from one another, which was a refreshing break from the dichotomy offered in our society—stay home with kids or go to work. Some of them had what we would call careers, some were married with no children, some were unmarried, and some were married with children. All of them were remarkably intelligent women who worked so hard it would be laughable to accuse them of laziness. And, most importantly, all of them honored God with their lives and work.

THEIR STORY (AND YOURS)

"The people who walked in darkness have seen a great light; those who dwelt in a land of deep darkness, on them has light shone" (Isa. 9:2). What is history if not a retelling of this same great story? The prophecy fulfilled on a dark night in Bethlehem has been fulfilled again in all the darkest ages of our race, and we have forgotten it. However, one of our central missions is to remember—Remember the Lord your God, Remember what the Lord your God did, Remember how the Lord your God led you (Deut. 8:18; 7:18; 8:2). This book hopefully will serve as a reminder of how God

faithfully shone the light of His gospel on an undeserving people and how this is His favorite storyline, one He will retell until our world ends. When the culture around us is crumbling, we need to be reminded of His great goodness in the past. "There is nothing new under the sun" (Eccles. 1:9). The same sins of pride, selfishness, and greed permeated other cultures, perhaps with different manifestations, but all sharing the same root. And God was faithful. God raised up His servants to fight the darkness. And in His unsearchable wisdom, one of the central means He used was the lowly family. This book is a study of a crooked culture, in some ways similar to our own, and a generation of men—and particularly women—who stood firm against it and in so doing changed the course of Western history.

Early modern Europe* was a society rife with corruption at every level. The Church was a dominant political force and the only religious force, and she had lost her

* I am using the term *early modern Europe* to distinguish the society influenced in large part by Catholic teaching and practice (out of which the Reformation sprang) from the society influenced by Reformation teaching and practice. Chronologically, early modern Europe covers the period from the end of the Middle Ages to the Industrial Revolution (late 1400s to the late 1700s). Of course, society did not change automatically at the start of the Reformation when Martin Luther nailed up his Theses in 1517. The effects of the Reformation on society were not all immediately obvious, so I will focus on the Reformers' teachings, evidence we have of societal changes effected by the Reformation, and the lives of those involved in the Reformation. This is as close as we can probably get to an understanding of how the Reformers influenced the culture all around them. Encyclopaedia Britannica, "History of Europe," https://www.britannica.com/topic /history-of-Europe/The-emergence-of-modern-Europe-1500–1648.

way. Her princes were like wolves tearing their prey, destroying lives for their own profit. There was a famine of the Word of God, and the inconvenient doctrine of grace had been tucked away out of sight while the works of men were celebrated. According to the Catholic Church, the only truly "holy" members of society were celibate, drawn away from the world into the cloister or presiding over the laypeople[†] as clergy. In reality, they lived like prodigal sons. If an ordinary, sinful man wanted to please an angry God, he could pray to the saints, hoping they would intervene with Christ, the implacable judge, on his behalf. He could do some form of penance to try to reconcile himself to God, or he could buy relief from punishment in the form of indulgences. He could go to Mass or pay for Masses to be said for him and prayers to be offered. In short, he had at his disposal all sorts of works of men and no sort of grace.

And then God intervened in the person of Martin Luther and then through John Calvin, Ulrich Zwingli, and other Reformers. The Reformation separating Protestants from Catholics was not a concerted movement; it was a series of pots boiling over simultaneously. These men were not organized, but they preached truth, and that truth was attractive because grace is potently attractive to people who are sunk deep in sin. They brought the Bible back to the people, translating it and preaching it. They turned a sin-weary people to the sweetness of forgiveness and surprised them all with the news that it

† I.e., a member of the Church but not a member of the clergy.

was free. As the Reformers taught the people how to love God and their neighbors, they explained that all lawful vocations were equally holy and that God used the diligent industry of His people to accomplish His purposes in the world. Even more surprising, the Reformers taught that being a wife and mother is a noble and holy calling through which God blesses His children and raises up a new generation of faithful believers. They believed the family was the foundation of society, and that without a change in the family, their society would not see reformation. God used the men and women who embraced these doctrines to turn European society on its head. This book will highlight the contributions Reformers' wives and other women made during the Reformation. These women were soldiers on the front line of the cultural and religious battles even in their homes. Given the cultural assumptions about feminine capacities at the time, wives and mothers were the Trojan horse of the Reformers' cause. Women of the Reformation embodied the new theology. Without their service, there would not have been a Reformation.

It is important to examine the history of feminism and its trajectory in order to identify the ways we are all shaped by it, so we'll start there. After a brief study of feminism, we'll move on to a short cultural history of sixteenth century Europe. Along the way, we'll see some parallels between the sixteenth-century Catholics and modern feminists and between the societies they've influenced. That will prepare us to read the good news of

the gospel as the Reformers preached it in their pulpits and lives. We will learn about a number of women who participated in the Reformation and were an integral part of its radical cultural change. Their lives provide an encouraging and convicting glimpse into the power of feminine faithfulness in the home. The final chapters will apply some of the lessons learned from the women's lives in this book and answer the questions about vocation that were introduced in the preface. My hope is that looking at these women and comparing their culture with modern American culture will inspire Christian women to lay their lives down for their families and the church, anticipating God's faithfulness to bring modern culture to Him through the sacrifices of His people.

FEMINISM:

A Little Background

Why bother studying feminism? Many of us do not identify with the feminist movement. It seems more like a piece of American history with some strident advocates nowadays who are mostly focused on political ends. Others of us find feminism attractive. We might not embrace the more militant expressions of it, but we don't get why there could be any objection to talk of equality and respect for women. Surely that's not contrary to the Bible, is it?

Whether you are a Christian who is decidedly against feminism or one who is friendlier toward it, it is worth

taking the time to think through exactly what feminism is and how it impacts all of us, whether or not we're aware of it. Those of us who trust Christ and desire to order our lives according to God's Word, particularly as we try to discern what a godly and productive vocation should look like for a woman, would do well to carefully consider how feminism compares to the teaching of Scripture. In future chapters, we will also explore how feminist principles line up with the teaching and practices of the Christian Church both before and during the Reformation, but for now let's look at where we are in twenty-first century America.

American culture today is a hot mess. And by hot mess, I am referring to the state of cultural confusion regarding the roles, responsibilities, and purpose of women in our society. A lot of Christian women are wondering what to do about it, as I was, while living in a state of guilt in their personal lives. On the one hand, they love their families and find great joy in serving them in the home. On the other, they have been taught that their most valuable contributions to society are through the workplace, and they desire the challenges and accomplishments they find there. They feel guilty if they work outside the home and guilty if they stay home and seemingly bury their talents. This confusion is due in part to the effects of feminism on American culture. Feminism has permeated modern society and drives much modern thought both inside and outside the church. It is not possible to understand our culture without understanding a little of its roots.

Feminism is a political and social movement that aims to establish equal rights for women. "Feminism has three components. It is a *movement*, meaning a group working to accomplish specific goals. Those goals are *social and political change*—implying that one must be engaged with the government and law, as well as social practices and beliefs."[1] So feminism is a movement that aims to conform the entire culture—from beliefs to laws—to its standards.

Feminism has penetrated our culture in three waves, each successive wave building upon the ones before it. The first wave in the nineteenth century issued the Declaration of Sentiments at Seneca, New York, proclaiming the great abuses of mankind against womankind. First-wave feminism fought for women's right to vote. Second-wave feminism in the mid-twentieth century fought for women's legal equality and for the entrance of women to the workplace. Modern feminism is sometimes called third-wave feminism and is focused on rights for any victimized segment of society. It intends to dismantle any perceived power structure that might be guilty of oppressing these victims. Today's feminism has embraced and advocated for gay rights and racial and economic equality and has promoted self-determination and human rights.

Christians have created their own feminist movement, and as with all movements, there are many different varieties of Christian feminism. Christian feminists range from women arguing for equality in the workplace

to feminist theologians claiming they are post-Christian. The most basic definition of Christian feminism is feminism as a social justice movement and a means of accepting and affirming women as much as men in social, political, and religious spheres. Unlike secular feminists and other progressives, the Christian feminists base their arguments on their interpretations of Scripture.[2]

Feminism claims to have made important gains for women, and in some ways, that is correct. For instance, today women can legally extricate themselves from abusive relationships, get loans without a male cosigner, and vote, which are all good things. However, because of the underlying beliefs about women's purpose and ultimately about God's authority, there is a flip side to these advances. Women have been encouraged to cease being feminine and to pursue careers like men. Many feminists deride those women who have maintained femininity, even when femininity has been defined biblically, so that the woman is perceived as the glory of the man, and that she comes alongside to help him as he fills the earth and subdues it. Furthermore, modern society's rejection of God's creation of masculine and feminine and devaluation of the feminine roles of wife and mother has led to a push for unrestricted reproductive control. And the success on that front has resulted in the deaths of approximately twenty-eight million baby girls in the past forty-four years in the United States. That's a steep price for equal-opportunity loans.

MODERN FEMINISM

on Vocation, Marriage, and Motherhood

Since its inception, feminism has been on a mission to redefine vocation, marriage, and motherhood, and those redefinitions have created the confusion women often feel about their priorities and roles.

VOCATION: WHAT SHOULD A WOMAN DO WITH HER LIFE AND TALENTS?

For more than a generation, since the publication of Betty Friedan's groundbreaking book *The Feminine*

Mystique, feminism has focused on women's roles in the workplace and the home, and many of her ideas are still current and now spread by people across the religious spectrum from atheist to conservative Christian. Betty Friedan was a very influential leader in the feminist movement and is often considered the mother of second-wave feminism. In her book, Friedan described the plight of the average housewife, and at the time of her writing, almost all American women were housewives. According to Friedan, these women were bored, unfulfilled, unhappy, immature, and failing to live up to their full potential. This is just the sort of characterization I imbibed from my educational experiences. And for many women this was true.

However, Friedan then went on to compare housewifery to concentration camps, suggesting that women who continued as housewives were in danger of losing their humanity, despondently walking in a daze through their lives.[1] Her first solution to this dilemma was education. Women either needed to get an education or continue one they had abandoned for marriage and family. Second, American women needed to engage in some professional activity outside the home, and it had to be paid professional activity in competition with others. That way they could grow up and stop vicariously living through their husbands and children. Women had outgrown the role of housewife. Friedan believed their new growth in the workplace would be the next step in human evolution.[2] In this she echoed Margaret Sanger, the

founder of Planned Parenthood, who believed women's self-development instead of women's self-sacrifice would be key to the evolution of society and the "creation of a new civilization."[3]

Fast-forward to the 2000s. Although women have flocked to the workforce in droves, after fifty years, they still do not represent half of all board-level and c-level positions in the workplace. Half of law school graduates are women, but half of all law partners most certainly are not. Some modern feminists, asking why this is the case, have found, to their great disappointment, that feminism has given women the "choice" to stay home, as though that is as valid an option as the workplace. As one baby boomer said to a younger group of women, "My generation fought so hard to give all of you choices. We believe in choices. But choosing to leave the workforce was not the choice we thought so many of you would make."[4] In *Get to Work . . . and Get a Life Before It's Too Late*, former lawyer and Brandeis University professor Linda Hirshman argues that choosing to stay home is a self-perpetuating choice. A woman cannot choose later to make up for those years lost to productivity in the workplace. And she made that choice initially because society told her it was the right choice to make—she argues that powerful men want women to stay home. In her book, Hirshman tries to refute all the women she talked with who told her they chose to stay home because they preferred it, regardless of what powerful men thought. Whatever those women might think or require

of themselves, Hirshman believes is unjust to require women to bear the responsibilities of the less flourishing domestic sphere.[5] Her description of the home echoes Betty Friedan and fuels the guilt women often feel for staying out of the workplace.

According to Hirshman, staying at home with children is an unacceptable choice because it is not good for society. Hirshman refers to women leaving the workforce "to the selfish precincts of the family."[6] She believes that even if there is a marginal advantage to children in having their mothers at home, the sacrifice to society at large (of her efforts and contribution to the marketplace) is greater than the advantage to her few children.[7] Hirshman and those like her posit that women who enter the workforce not only have more fulfilling lives, using their reasoning capacities "in complex and socially visible enterprises,"[8] but they change society, making women more representative at all levels of employment and power. When women are present at all levels of power in the economy, more laws and decisions will be made to women's advantage. Sheryl Sandberg, the COO of Facebook, argues that society will not be truly equal until more women are in positions of power in the government and in businesses.[9] Hirshman claims a woman who stays at home caring for her children is no different than an animal mother that cares for her young,* and doing housework is doing the work that only the lowest paid members of societies do.[10] She claims, "Although child

* One hopes she is overstating her case to provoke discussion.

rearing, unlike housework, is important and can be dif-
ficult, it does not take well-developed political skills to
rule over creatures smaller than you are, weaker than you
are, and completely dependent upon you for survival or
thriving. Certainly, it's not using your reason to do the
repetitive, physical tasks, whether it's cleaning or driv-
ing the car pool."[11] Sandberg disagrees with Hirshman,
encouraging women to respect different career paths (al-
though her encouragement struck me more as lip ser-
vice), but she wrote her book to spur women on to posi-
tions of power in the workplace. "Whatever this book is,
I am writing it for any woman who wants to increase her
chances of making it to the top of her field or pursue any
goal vigorously."[12]

CHRISTIAN FEMINISM ON VOCATION: NO SUCH THING AS A MAN'S WORK

Although many Christian women do not read modern or
historical feminist writers on vocation, they have often
encountered the Christian variety, and those Christian
feminists were shaped by the secular ones. Christian
feminism would not exist without the groundwork laid
by secular feminists. Christian feminists believe all
people are made to work and are commanded to work,
and they do not believe the Bible requires women to
prioritize the home more than men do. Wives are not
helpmeets, but coworkers with husbands. Although
the Hebrew text uses the word *ezer* for Eve, which
means "helper," the word is otherwise used in the Old

Testament primarily to show the kind of help God provides to mankind. According to Carolyn Custis James, a Christian feminist author, this proves that women's work is not secondary to men's work. The wife is not meant to come alongside and be a helpmeet to her husband. She and her husband are to have similar, if not identical, roles subduing the earth.[13]

Unlike their secular counterparts, many Christian feminists believe work can take place anywhere, paid or unpaid, and there is no greater value to one or the other since the Bible does not recommend one or the other. For example, Katelyn Beaty, former editor of *Christianity Today*, believes that work outside the home has been unfairly derided by Christians. She highlights various career women in her book, showing the ways they have impacted the broader world through their work. Beaty asserts that women working outside the home are doing work that is just as important as the work inside the home. Based on the amount of time she spends discussing women working outside the home, she appears to believe their work is actually *more* important than that done within the home.[14] In order to facilitate women's work in the corporate sphere, she argues that husbands and wives should make equal sacrifices for their careers and their children. According to her interpretation of Scripture, there is no biblical directive for men to work outside the home or for women to stay home with the kids. Underlying her interpretation is the belief she shares with many other Christian feminists, i.e., that

being equal in Christ means men and women can have the same roles and callings.

MARRIAGE ON THE DECLINE

The growth of secular feminism has changed our society's view of marriage and confused even Christian women about the purpose of marriage itself. Feminists believe people will be truly happy when they have the freedom to do whatever pleases them in life and in romance. Far too many Christians have adopted this belief, as well. Christians often emphasize personal happiness rather than biblical obedience. For example, at many evangelical Christian weddings, the focus is on the bride and groom's love story, ignoring the broader purposes of marriage itself or the biblical picture of marriage. Christian and non-Christian marriages have been individualized and thereby undermined.

As I have read influential secular feminists on the subject of marriage, I have been shocked to discover what they intend to do with the institution of marriage. Individualizing marriage was just one stop on the long road to dissolution of marriage itself. These are popular feminists, not just extreme ideologues writing from the back corner of a university library. Many of them now push for gay marriage because they hope to completely dismantle the institution of marriage, which they believe is a social construct designed to give men power over women.[15] One prominent feminist hopes for "a complete rethinking of who women are and who men are and,

therefore, also of what family is and who holds domin-
ion within it . . . and outside it. The expanded presence
of women as independent entities means a redistribution
of all kinds of power"[16] Here are a few quotes from
various secular feminists about marriage:

> The institution of marriage is the chief vehicle for
> the perpetuation of the oppression of women.[17]

> Freedom for women cannot be won without the
> abolition of marriage.[18]

> Marriage as an institution developed from rape as
> a practice.[19]

> "Marriage renders women 'half people.'"[20]

> [Traditional marriage is] "energy-sucking and
> identity-sapping."[21]

> Marriage . . . condemned women "to life-long de-
> pendency, to parasitism, to complete uselessness,
> individual as well as social."[22]

> [Why be] "shuffled down the aisle for a life of te-
> dium and domesticity"?[23]

> Why get married when you're having so much fun?[24]

These are women who hate marriage and think mar-
riage is oppressive. Of course, most Christian women
do not share their views, but the barrage of criticism in-
fluences culture nonetheless. The number of American
women who are married dropped below fifty percent in

2009.[25] For those who continue to marry, they are waiting longer and longer. The median age of first marriage is now twenty-seven, and it's even higher in urban populations.[26] The choice to remain single has become widespread and celebrated, a source of liberation and even a virtue. A new generation of women is avoiding marriage. Instead, they want to find themselves, to experiment with jobs, life, and sex, and to make sure they know what they really want. Whereas marriage used to be the introduction to true adulthood, now women are choosing to live a significant part of their adult lives without marriage, and they believe they are no less "adult" for leaving marriage out of the equation.[27]

One of the foundational requirements for successful marriages is selflessness, but selflessness repulses many modern feminists. Previous generations honored biblical teaching by glorifying women's selflessness in marriage and childrearing—a selflessness that made success in both endeavors possible. Women gave their lives for those closest to them, finding themselves through losing themselves, and honorable women endured the trials and afflictions of life with patience and contentment. By contrast, modern feminists intend to make a virtue out of selfishness. "A true age of female selfishness, in which women recognized and prioritized their own drives to the same degree to which they have always been trained to tend to the needs of all others, might, in fact, be an enlightened corrective to centuries of self-sacrifice."[28] Unbelievers acting like unbelievers is not surprising.

What is surprising is when Christian women are tempted to the same sort of selfishness. Insisting on "me time" is a modern notion acceptable in Christian circles but rooted in this unbiblical sentiment about marriage and family. Being alone, building one's day around one's own desires, being spontaneous without answering to anyone, not having to consider another person—these are common temptations for Christians and unbelievers alike.

MOTHERHOOD: IS IT WORTH IT?

The Bible commands us to be fruitful and multiply and tells us that children are a blessing from the Lord. But we Americans aren't interested in that anymore. In the first three months of 2016, fertility in America dropped to its lowest rate on record, and the total fertility rate fell to 1.87 children per woman.[29] Motherhood used to be an unavoidable part and parcel of married life (and often of unmarried life as well). With the advent of birth control and abortion, modern women are liberated from the chains of biology. Early proponents of birth control, such as Margaret Sanger, who opened the first U.S. birth control clinic in 1916, wanted easy access to birth control for women so women could gain equality with men and "assert . . . the primary importance of the woman and the child in civilization."[30] Betty Friedan also wanted women to be able to "say 'yes' to motherhood as a conscious human purpose and not a burden imposed by the flesh."[31]

Betty Friedan's hopes were fulfilled, and her underlying opinion of children as "a burden imposed by the

flesh" has prevailed as well. Now we live in the world Margaret Sanger dreamed about. Many modern women, Christian and secular, choose not to have children, and almost all women have fewer children than their ancestors did. For them, there are myriad other ways to find meaning in life or to make a difference in the world. Having children is but one option in the mix and is certainly not the most important thing a woman does with her life, although it could be the most harmful thing she does to her future. As one blogger noted, "We are not here to 'breed' for 'breeding' does little more than reinforce women's role as the caregiver, nurturer. By having children we harm our careers, make ourselves vulnerable to attack and abuse, and become reduced to unpaid labour."[32]

By contrast, many women believe there is freedom in choosing not to have babies. Feminists assert that women should not be expected to have children; just as with marriage, they should be free to choose whatever path makes them the happiest.[33] There are three bedrock assumptions here. First, whatever makes a person happiest is what she should pursue. Second, a person should be free, that is, unrestrained by outside forces, to pursue the objects of her desire. And third, a person is capable of identifying for herself, without reference to the Word of God, what will make her truly happy. These unscriptural assumptions have permeated the church, as well, and they dictate the choices women make about marriage, motherhood, and careers. Women are searching

for their own happiness and fulfillment and concluding they've made the wrong choices if they do not find either of them. Unfortunately, instead of turning to the Bible, they usually try the same path repeatedly, hoping to arrive at a different destination.

The point of this book is to show another path that faithful women have trodden. Modern American culture is not the first culture where women have been told that the home was less valuable than a "real" vocation away from a family. While feminism claims to have liberated women, I want to tell the story of a greater liberation. True liberation does not come from acquiring one's rights but from becoming a servant.

CHAPTER 3

THE ROMAN CATHOLIC CHURCH IN THE SIXTEENTH CENTURY

As we prepare to study the Reformers and the women of the Reformation and how they answered these same questions modern American women have about vocation, marriage, and motherhood, we need to gain some context for their culture. Along the way, we'll see parallels between the sixteenth-century Catholic Church and

modern feminism. We can understand the parallels more completely if we have a brief overview of the Church and its teachings. We will see that the Catholic Church connected salvation and vocation, creating a heavy burden.

Five hundred years ago, the corrupted Catholic Church held sway over all of European society in much the same way that secular culture now dominates American society. And just as the modern world looks down on marriage and motherhood, so the Church's view of wives and mothers in the sixteenth century was less than complimentary. The last section of this book tells the stories of women who rejected these views and left the powerful Catholic Church. All the women we'll study were born into the Catholic Church, and some of them were nuns who had devoted their lives to the Church. To better understand their world, it is important to look at some of their contemporaries and at the nature of the Catholic Church and society at the time. We'll also examine key Church teachings that Protestant women abandoned.

What was the state of the Catholic Church in sixteenth-century Europe? In a word, corrupt. In another word, powerful. "The Roman Catholic Church was the center of communal life. It impacted everyday lives of men, women, and children across every social stratum.... The Church was everything: law, order, morality, and eternity, all wrapped into a single powerful entity."[1] A church dominated every small town square; the priest baptized new babies, approved marriages, and buried the

dead, all for a fee.[2] After a death, family members often paid local monasteries or convents to pray for their departed loved ones. Most importantly, the Church told people where they stood with God. Most people lived in fear of the afterlife, and the Church told them that the only way to avoid the agonies of Hell, spend less time suffering in purgatory, and get to the glories of Heaven was by following her rules.[3]

POPES: THEIR POWER AND INFLUENCE

Then as now, the pope was the head of the Catholic Church. However, in sixteenth-century Europe the pope exercised far more power than he does now because of the Church's all-encompassing influence. In Catholic theology (historically and presently), the authority of the pope supersedes the authority of the Word of God. In fact, the Church teaches that the authority of the Word of God derives from the pope, who is the voice of God to the people. Only the pope and the Church are authorized to interpret the Bible, and at the time of the Reformation, any translation of the Bible from Latin into the vernacular was illegal and punishable by execution.[4] In light of this teaching, the corruptions in the Church impacted believers in a more significant and far-reaching way, because they were told the pope was infallible, and his people really had no other alternatives for spiritual leadership. Studying a few of the popes who were contemporaries of the Reformers will help illustrate the problems Reformers denounced within the Church. It

is important to note that other scholars and churchmen spoke out against the excesses of the Catholic Church at the time, but not all of these critics left the Church as the Reformers did. Some stayed inside, continuing to push for reform, and their efforts eventually brought about the Council of Trent (1545–63), which sought to curb abuses and corruption.

ALEXANDER VI

The pertinent popes for this study are Alexander VI (1492–1503), Julius II (1503–13), and Leo X (1513–21). Alexander VI was a man singly devoted to his own exaltation. He has a reputation as the worst pope in history. Historian Philip Schaff notes, "the pre-eminent features of [his] career, as the supreme pontiff of Christendom, were his dissolute habits and his extravagant passion to exalt the worldly fortunes of his children."[5] The Catholic Church officially held that priests and clergy were to remain celibate. Many did not, including Alexander. He had children by numerous mistresses. Before he allegedly bought his way to the papacy, he had fornicated with a Roman lady and then her daughter, with whom he had four children.[6] When he tired of one particular mistress, he married her off to three successive husbands. Another was married at the time of his relationship with her, so "her legal husband was appeased by the gift of castles."[7] A Roman Catholic historian remarked that during Alexander's day, "every priest had his mistress and almost all the Roman monasteries had been turned into

brothels."[8] There were orgies and bawdy entertainments at the Vatican, but if anyone dared to criticize them, he was in danger of excommunication.[9] Nonetheless, the influential Florentine friar Savonarola condemned Alexander's excesses and called for his removal.

Alexander, like other popes, cooperated with the rulers of the day. Upon the death of France's King, Charles VIII, Alexander looked to ally himself with the new king, Louis XII. Louis had a problem—his wife was deformed and barren, and it would be expedient for him to be married to Charles VIII's widow, whose dowry included Brittany. Alexander had a problem—his son didn't want to be a bishop and cardinal deacon any more (in fact, he told his fellow cardinals that "from the first he had been averse to orders and received them in obedience to his father's wish" which one historian "pronounced to be perhaps the only true words the prince ever spoke"[10]). Alexander and Louis found a solution. Alexander gave Louis official permission to divorce his wife, and Louis gave Alexander's son a dukedom and a royal wife.[11]

Alexander appointed his children (many of whom had been legitimized by the Church) and other relatives, including his mistresses' relatives, to Church offices. He gave aristocratic positions to his children, as well. Alexander was criticized for his devotion to the advancement of his children, who were not upstanding individuals. At one point, Alexander's oldest son, Caesar, was imprisoned in Spain. He asked for a confessor and was sent a monk. He killed the monk, donned his hood, and

fled.[12] Caesar was accused of murdering his brother-in-law some years later.[13] Machiavelli was inspired to write *The Prince* using Caesar's political and military tactics as his model.

Later, upon the celebration of the Jubilee in Rome in 1500, Alexander issued a papal bull* offering free indulgences (Church-authenticated remission) for grievous sins to those who attended.[14] He created offices in the Church—more cardinals—all bringing in more money for the pontificate because Church offices were often sold.[15] Upon Alexander's death in 1503, Caesar procured the keys to the papal treasury by threatening to murder the cardinal who held them, and he then stole two chests full of gold and silver.

JULIUS II

Julius II succeeded Alexander in 1503, and he began planning to rebuild St. Peter's Basilica almost immediately. During his tenure, he commissioned Michelangelo to paint the ceiling of the Sistine Chapel and Raphael to decorate several rooms at the Vatican. Julius was a warrior, and his position as pope did not diminish his ferocity. He aimed to be a prince as well as a pope, to aggrandize the papacy's political power. And so he did.[16] As a sixty-seven-year-old man, he led an army of mercenaries to conquer cities and territories for the Church. He fought Venice, then the French, then Florence. Despite his purportedly holy papal office, he led the

* A decree issued by the pope.

army to battle on Easter Day.[17] His goal was a unified Italy, which he intended to accomplish by ridding Italy of foreign princes.[18] Erasmus, a Catholic humanist scholar of the day, was so shocked by Julius's military pursuits that he wrote a play satirizing him. As one of Julius's contemporaries noted, "It is assuredly very difficult to be at the same time a secular prince and a priest, for these two are things that have nothing in common. Whoever looks closely into the evangelical law will see that the popes, although calling themselves Vicars of Christ, have introduced a new religion which has nothing of Christ in it but the name. Christ commanded poverty, and they seek for wealth; He commanded humility and they desire to rule the world."[19] Despite all the wars, Julius II left behind a well-financed Church, in part due to the selling of indulgences, which we will discuss later.[†20] Julius was a successful warrior, and thus it would be difficult to overstate the political power of the papacy after his reign. The Church and state were wed, and thus the Church was a secular power.[21] And it was the major landowner in Europe, a landowner which paid no taxes.[22]

LEO X

The reigning pope when the Reformation officially began was Pope Leo X, who succeeded Julius II. Under

† Technically, indulgences purchased a reduction of time spent in purgatory, but in popular thought, they purchased permission to sin, and sellers of indulgences were not quick to correct the error (D'Aubigne, *History of the Great Reformation 1*, 45).

Leo's reign, Rome enjoyed luxury, literature, theater, art, wealth, and a building boom.[23] He was devoted to entertaining, and spent mountains of money giving gifts, receiving visitors, and making merry in myriad ways. He played chess and cards and kept a monk who could swallow a whole pigeon in one mouthful and eat forty eggs at a sitting.*[24] Leo almost achieved bankruptcy, borrowing money at forty percent interest,[25] so he took to selling church offices. In 1517, he created thirty-one new cardinals, and then he sold the appointments for three hundred thousand ducats ($50 million today). Upon receiving the money he remarked, "How well we know what a profitable superstition this fable of Jesus Christ has been for us."[26] Although he brought in an astounding amount of money per year, one of his contemporaries said of him, "It was no more possible for his Holiness to keep 1,000 ducats than it is for a stone to fly upwards of itself."[27] Upon Leo's death, a number of cardinals who had lent him money went into bankruptcy.[28] A contemporary Catholic historian said, "His manners were so charming, that he would have been a perfect man, if he had had some knowledge in religious matters, and a little more inclination for piety, concerning which he never troubled himself."[29]

In a papal bull in 1516, Leo reaffirmed his authority over all Church councils. He reaffirmed a previous pope's position that subjection to the pope is necessary

* Sometimes others contributed to the revelry. The Portuguese king gave him a panther, two leopards, and an elephant.

for salvation, and disobedience to the pope is punishable by death, although he himself was not subject to canon law.[30] Leo died in 1521, four years after Martin Luther nailed the Ninety-Five Theses on the door at Wittenberg.

The popes were corrupt, and so were many of the priests and other clergymen. As the pope goes, so go the people. Machiavelli quipped, "Italy is the corruption of the world."[31] At one point during Julius's reign, a cardinal tried to tear out his own brother's eyes because the cardinal's mistress thought the brother's eyes were beautiful. On another occasion, the pope's nephew murdered a cardinal in the streets.[32]

SEXUAL LICENSE AND THE CATHOLIC CLERGY

Almost every priest in Rome had a concubine "for the glory of God and the Christian religion."[33] In fact, there were 6,800 prostitutes in Rome alone in 1490 (quite a large number relative to the total population of 100,000), and they were ubiquitous in Italy and Spain. Pederasty was common; sexual license, unrestricted. Sexual corruption among local priests mirrored that of Rome. As a result there was no virtuous pastor to emulate. The Council of Basel in 1435 ruled that priests must renounce their concubines within two months or face the loss of their benefices (Church appointments providing income and property), suspension of clerical status, and loss of titles and offices. However, by the end

of the fifteenth century, it was clear the Church could not enforce these rules. They gave up and just tried to restrain the clergy's sexual activities.[34] In one Catholic region of Switzerland, a 1600 survey found that more than half the priests were married.[35]

Instead of demanding obedience to Church policy, the Church levied a penitential tax on priests for their concubines and a cradle tax for their children, levies collected by the bishops who were paid from the tax monies. This did not curb priestly concubinage. In fact, there were priestly dynasties passed from fathers to sons for generations. For their part, laypeople welcomed priestly concubinage because it gave their wives and daughters some protection from the priests, who were guilty of raping, threatening, and harassing women. The priests often took advantage of their access to families and to the confessional and used it as "an opportunity of instilling deadly poison, that they might gratify their guilty desires."[36] The situation digressed to the point that a popular saying of the day was, "If you wish to keep your house pure, then leave clerics and monks at the door."[37] Despite the prevalence of priestly concubines, the concubines were shamed by society, and their children were reprobates.

Another popular means of breaking the vow of celibacy was brothels, which we will discuss in more detail later. Brothels were plentiful in early modern Europe, and even some of the convents were practically brothels servicing noblemen or monks.[38] Since it was considered

less sinful for a priest to visit a brothel than to be married, priests visited brothels regularly and then paid a fine if they were caught.[39] As for the pope, he needed money for wars and construction, so he welcomed the fines and of course the behavior that provoked them, thus creating an economic interdependence between the Church and brothel.[40]

BUYING CHURCH APPOINTMENTS

Because most of the high offices of the Church could be bought and were reserved for aristocracy, the Church did not emphasize morality and thus created moral scarcity. The priesthood became a dumping ground for useless sons, and worldliness and immorality were common. Bishops even fought their local townspeople, forcing them into submission. "To be able, lance in hand, to compel his neighbours to do him homage, was one of the most conspicuous qualifications of a bishop."[41]

Many clergy also held multiple positions, each bringing in an income. In fact, one German cleric held twenty livings at once.[42] In practice, this meant he rarely visited some of the regions where he held office, which meant Masses and preaching also went missing. The Mass was complete without preaching, so there was a dearth of preaching even when the priests were there to celebrate it. When they did preach, friars or monks often neglected the Word of God and advanced in its place the latest pronouncement of the pope. They were also known to re-preach sermons from church fathers and

then supplement those with fables and foolish tales to entertain their listeners.[43] On one occasion, a preacher dragged a layman dressed up like a monk to the altar; another shocked his audience with stories of indecency; another regaled his listeners with stories of the apostle Peter cheating an innkeeper.[44] During one particular Easter celebration, "one preacher imitated the cuckoo; another hissed like a goose."[45] Perhaps monks and priests entertained because they were ignorant. Surely many of them had little biblical knowledge. One monk remarked, "The New Testament is a book full of serpents and worms."[46] Another celebrated scholar never read the New Testament. On his death bed, he called for it, but when he read a passage, he said, "Either this is not the Gospel, or we are not Christians."[47]

THE CATHOLIC CHURCH AND STINGY GRACE

The Catholic Church had done a poor job of enforcing morality among its clergy, which meant that the average parishioner could not look to the Church to learn how to live an exemplary life. We've looked at the practice of Catholicism in the sixteenth century, so now it is time to look at the substance of the Church's teachings, as well. The doctrines outlined below were familiar everyday doctrines for sixteenth-century Catholics, including the women of the Reformation we'll study later.

The Reformers rejected abuses of power within the Catholic Church, but they also rejected some of these central Church doctrines.

First and foremost, the Catholic Church taught that Jesus was a stern judge, and He was to be feared along with God the Father. Therefore, people were terrified of the punishment they would face if they angered God. Unless they were members of the clergy, people attended Mass but did not participate in the service. They watched and kept quiet while the priest performed the ritual in Latin, which the churchgoer likely did not speak or understand.

The Mass was and is central to the Catholic understanding of salvation, but a little description will be necessary before explaining how. According to Catholic theology, Christ created a "treasury of grace" that sinners must access through the Catholic Church. Through baptism into the Church (which is done in infancy), sinners receive grace which enables them to do works of righteousness pleasing to God. The sinner continues performing these acts of righteousness through his life in hope of thereby attaining final justification. He must continue coming to the Church for more grace to do more works of righteousness. Christ's righteousness is not imputed or credited to sinners, as the Protestant would have it; rather Christ's righteousness works into the believer's life and actions so he can achieve his own justification. Through the righteousness of Christ, the sinner hopes to live a life leading to salvation. However, he or she still sins. All the

sins a person commits after baptism have to be covered with penances and Masses. Catholics teach that when the priest performs the Mass, the bread and wine turn into the actual body and blood of Christ. The priest then offers the body in an efficacious reenactment of Christ's sacrificial death for the people. Jesus is sacrificed again at each observance of Mass. Partaking of Christ's body or simply being present when the bread of the Eucharist was raised up after being consecrated confers grace on the churchgoer and atones for sins.[1]

In addition to attending Mass, sinners atone for sins through penances, such as confession of sin to a Catholic priest, receiving his declaration of forgiveness of sins, and performing whatever act of penance he requires, e.g., fasts, alms, prayers, and other pious acts. Penance cancels or reduces the punishment for sins. Sometimes the guilt may be gone, but the temporal punishment is not satisfied. (Temporal punishment is the payment for sins through penances, prayer, fasting, and almsgiving.) Those who die without being fully punished for their sins go to purgatory to be purified before going to Heaven.

Purification could take a long time, so the Church of the sixteenth century instituted indulgences as a way to alleviate the punishments. In 1343 Pope Clement VI issued a papal bull addressing indulgences. Christ shed His blood for the sake of His Church, but only one drop of blood was necessary for the salvation of the whole world. However, Christ shed more than one drop, there-by leaving an infinite treasury of good works for men at

the disposal of St. Peter and his successors. Mary and other saints also added to this treasure. The good works amounted to what is called the Treasury of Merit. In the Middle Ages, indulgences were the sale of some of these good works, some of this merit, to erase the guilt and penalties of sin in this life and reduce a person's stay purgatory.*[2] They functioned as a sort of insurance policy for sinners, creating an economy around sin and grace.[3]

By the late Middle Ages, popes and bishops granted indulgences for viewing relics, going on pilgrimages, paying for Masses, or paying for Church construction projects. For instance, the castle church at Wittenberg had some 17,443 relics, "including nine thorns from Jesus's crown; thirty-five splinters from the cross; one wisp of straw from the manger; a bit of cloth from Christ's swaddling; one hair from Jesus's beard; one of His crucifixion nails; one piece of bread left over from the Last Supper; a few drops of the Virgin Mary's milk; four hairs from her head; four pieces of fabric from her girdle; one twig from the burning bush of Moses; and one tooth of St. Jerome,"[4] which, when viewed, could reduce a stay in purgatory by two million years.[5] The popes sometimes allowed local rulers to use indulgences for their own construction

* The Catholic Church no longer sells indulgences, but they still hold the doctrine of indulgences. Instead of selling them, the pope may distribute them. For instance, in 2013, Pope Francis offered indulgences (time off purgatory) to those who attended World Youth Day in Brazil. For those who could not afford to attend, they could carefully follow on TV, radio, or Twitter and receive the same indulgence. https://www.theguardian.com/world/2013/jul/16/vatican-indulgences -pope-francis-tweets.

projects. In those cases, half the money from the sale of indulgences went to Rome; the other half stayed locally to build (a fraction of this making up the bankers' cut and sometimes the salesman's cut, which might be used for less than wholesome entertainments).[6] In other cases, such as for the building of St. Peter's Basilica in Rome, the pope took the full amount of the sale.

In 1476, Pope Sixtus IV issued a bull allowing the sale of indulgences for those already dead. For the right price, a loved one could be released from suffering in purgatory.[7] Johann Tetzel was appointed to sell these indulgences in 1501. Tetzel was prior of a Dominican convent, doctor of philosophy, papal inquisitor, and indulgence hawker.[8] He traveled throughout Germany with his papal bull and chest for collecting indulgences. He would place the papal bull on a velvet pillow on the high altar. A red cross decked out with a papal banner stood in front of the altar and the iron chest beneath it. Priests, monks, and magistrates met him with great ceremony and processed with him to the church. Large crowds flocked to hear him preach and then rushed to buy his wares.[9] On one occasion he cried, "You know that all who confess and in penance put alms into the coffer ... will obtain complete remission of all their sins.... Why are you then standing there? Run for the salvation of your souls! Don't you hear the voices of your wailing dead parents and others who say, 'Have mercy upon me, have mercy upon me, because we are in severe punishment and pain. From this you could redeem us with a small alms and yet you do

not want to do so.'""[10] His listeners then raced to the altar
to confess their sins, pay their money, and receive a letter
of indulgence freeing their poor, suffering relatives from
the punishments of purgatory or guaranteeing their own
admission to Heaven.[111] The pope used this money for
military campaigns, for building the Basilica of St. Peter,
and for entertaining his court, among other things.
Indulgences had become such an integral Church prac-
tice that he threatened to excommunicate anyone who
did not preach and believe that he could grant them.‡

In summary, the Catholic Church taught that peo-
ple must participate in acts of good works through-
out their lives as a means of justification and salvation.

* Martin Luther tells this fable about Tetzel: On one occasion a noble-
man approached Tetzel asking for an indulgence for a sin he had yet to
commit. Tetzel, ever happy to make the sale, granted his request. That
night, as he traveled, Tetzel was robbed. The bandit took the chest full
of money from the day's sales. Tetzel was indignant and complained to
the courts. But the clever bandit and the nobleman were one and the
same man, and when it was found that Tetzel himself had signed the
indulgence granting exemption for his own robbery, Tetzel's complaint
was soon dropped (D'Aubigne, *Triumph of Truth*, 76–7).

† Upon the death of his wife, one poor shoemaker was brought to the
courts because he did not pay for a Mass for her soul. The priest demand-
ed he pay for the Mass, so she might enter Heaven. But why, he asked,
since "she entered heaven at the moment of her death." How could he
know? Well, he had the letter of indulgence she had purchased granting
her immediate entry into Heaven upon her death with no stop in pur-
gatory. And he wanted to know whether the priest was in the wrong, or
the pope himself had deceived him. The court had no response for this
argument, so he was acquitted (D'Aubigne, *Triumph of Truth*, 74).

‡ Excommunication barred someone from communion and from the
grace conferred through the Mass. Unable to obtain grace through the
Church, the excommunicated person went straight to Hell upon his death.

They received grace for these good works through the Church in the form of baptism, Mass, and penance. When they failed, they were told to buy indulgences to protect themselves and their relatives from punishment for sins and time in purgatory. In the end, indulgences, viewing relics, going on pilgrimages, doing penance—all of these gave laypeople hope for going to Heaven or at least spending less time in purgatory, but they also gave laypeople permission to sin while depriving them of true repentance and forgiveness. And people without forgiveness are still slaves to their sin.

THE CATHOLIC CHURCH AND WOMEN

The Church's teaching on grace had a significant impact on early modern society, but so did their teachings on women, vocation, and marriage. Since this book is about the impact of the Reformation on women then and now, we need to know what the Catholics were saying about women and the issues important to them. Because of the Church's extensive control, what the Church taught about women, vocation, and marriage dictated what the people thought about them. In many ways

the Church was influenced by the ancient Greeks. Church fathers combined Greek philosophy with Scripture to formulate doctrine. That doctrine influenced their culture and their everyday life. Notably, some Catholic clergy disagreed with the following characterizations about women and called for reform, but they were not successful in changing the Church's teaching.[1]

The early modern concept of women derived originally from the Greeks, who had been rediscovered as humanism took hold on Europe. Although in *The Republic* Plato argues that men and women should both be guardians of his ideal republic, that was his only work where he championed equality between men and women. He made disparaging remarks about women in his other works. For instance, he believed immoral men would be reincarnated as women,[2] and he believed men were superior in just about every realm.[3] His pupil Aristotle thought women were inferior by nature. Aristotle believed society needs both men and women, but the men were by nature more fit to rule and the women by nature more fit to serve. During the Renaissance, Aristotle's ideas "entered with renewed strength in the academic fields of philosophy, medicine, and theology."[4]

Generally speaking, the Catholic Church accepted these ideas about women. The influential church doctor Thomas Aquinas believed women were, as a whole, intellectually inferior to men, although some women might be intellectually superior to some men. He believed that is why Paul instructed wives to submit to their

husbands.[5] As with any age, there are exceptions, and no doubt there were well-treated, well-loved, and well-respected women in the Middle Ages right on through to sixteenth-century Europe. However, by and large, when the Reformation began women were perceived as irrational, unruly, greedy, lazy, and seductive. As two Dominican authors of a book on witchcraft put it, a woman was "a liar by nature ... a foe to friendship, an inescapable punishment, a necessary evil, a natural temptation, a desirable calamity, a domestic danger, a delectable detriment, an evil of nature."[6] Ideas like these were spread through books and pamphlets as well as through prints that hung in homes or taverns and through laws and Church teaching. As one sixteenth-century author stated, "The laws presume women are usually bad, because they are so full of mischief and vices that are difficult to describe."[7] On noting their earlier development than boys, one expert in canon law opined, "Women, like weeds, mature earlier than desired plants."[8]

Scientists of the day also thought women had a stronger sexual appetite than men, which needed curbing. In that vein, one Italian city had a statute stipulating "no woman over the age of twenty ought to be presumed to be a virgin unless her chastity could be proved, at least by circumstantial evidence."[9] In the marriage relationship, the wife was expected to be a domestic servant and student, always submitting to her husband, scurrying around the house to do her chores and make a flavorsome meal before he returned from working hard. Her

husband was permitted to beat her at will.[10] If he committed adultery, it was her fault because women were the root cause of marriage problems and sexual immorality. Women were stupid, defective, and deceptive, so their role was to give, and the husband's to receive and command. "If he beats you out of the house by the back door, then return with docility through the front door."[11] Clearly, women in sixteenth-century Europe had unenviable lives. They enjoyed little respect unless, as we'll see later, they were nuns. Joining the convent protected them from sin and offered them a chance to do something meaningful for society.

THE CATHOLIC CHURCH'S IDEAS ABOUT VOCATION

Do Something Holy

As we know from just about every magazine, advertisement, and movie today, our society believes that self-fulfillment is the ultimate purpose for life. Most of the time, self-fulfillment is tied to a career or to realizing dreams of personal significance. Clearly not biblical. However, women in Christian circles don't always fare

much better. They don't have a biblical understanding of how to please God with their work. Should they engage in "kingdom work," i.e., something that directly fulfills the Great Commission? Is their primary purpose in life to evangelize those outside their homes? Often Christians get the impression that ordinary church members, as opposed to ministers of some kind, are less important to God's plan for the world.

Sixteenth-century nuns seem worlds away from modern career women, but those nuns who willingly joined convents and took vows did it for reasons we can understand—they were following the only path they knew that led to a significant, purposeful life pleasing to God. That is something every faithful Christian throughout history should want to do. The problem is, in our society just as in theirs, we have not defined our terms biblically. In their case, they were confused about what is pleasing to God. In our case, we are confused about what makes something significant, and for Christians, we are often just as confused about what pleases God as the Catholics of old were.

The Catholic Church taught that holiness was possible for those set apart for the Church and not for those people with regular jobs and regular lives. There was only one true vocation—a lifetime commitment to the Church as a monk, nun, or priest. Holiness was achieved through withdrawing from the world, as the monks and nuns did, or consecrating one's life to the Church as the priests did. They gained righteousness

through separation and through adherence to their vows. Monks, nuns, and priests took vows of poverty, chastity, and obedience, and nuns in particular dedicated themselves to Christ as their heavenly bridegroom. A vocation was not for everyone, though. "The holy life was not for the majority, but for a spiritual elite who could withdraw from society and enter the life of a community in the hope that their ambition for a sanctified life might thereby be realized."[1]

In early Christian thought, the ideal life was one of divine contemplation and not physical work.[2] As the Pope Gregory the Great said in the twelfth century, "the active life consists...in giving to each what he needs, in providing for those who are committed to our care. In the holy life, however, while maintaining with his whole heart the love of God and his neighbour, a man is at rest...from exterior works, cleaving by desire to his Maker alone, so that, having no wish for action and treading underfoot all preoccupations, his soul is on fire with longing to see the face of his Creator."[3] Gregory noted that few could live a contemplative life, which was superior to the active life, and in time, the Church believed withdrawal from the world was the only means of doing so.[4] The definition of vocation became a calling outside the world. Anyone who worked an ordinary job in the world was unable to achieve the same level of contemplation and holiness and was therefore a lesser Christian. Work was a "debasing and demeaning activity,"[5] which had no "lasting religious significance,"[6] because it drew a person away

from the pursuit of salvation and focused his mind on earthly gains.

Thirteenth-century theologian Thomas Aquinas said, "Commerce, in and of itself, has a certain shameful character."[7] He eventually came to see commerce as a necessary public good, although not a spiritual undertaking. The spiritual undertaking was for the contemplative soul. "There were not two 'spiritual lives', one for the ascetic, the other for ordinary Christians. There was only one; and that was monastic. From the birth of monasticism, Christians who proposed to take the quest for perfection seriously became monks—either by retiring to the desert or cloister or by practicing domestic asceticism of the monastic kind."[8] Just as today, career women seem to live more exciting, significant lives, and missionaries and ministers seem to live more spiritual lives, so then monks, nuns, and clergy achieved a greater level of holiness through their vocation.

CONVENT LIFE

Vocation has been an issue for Christians for a long time. As we've seen, the Catholic Church defined vocation very narrowly to include only monks, nuns, and clergy. The Church exalted the contemplative life, and virginity was a major part of the life set apart from the world. The link between virginity and vocation was a necessary one for the Catholics. How could a person devote himself or herself to the holy life while still partaking of sensual pleasures and indulging in worldly desires? Virginity in the sixteenth century was supposed to gain salvation for the soul as the nun prepared herself for mystical consummation with her celestial spouse.[1] The

celibate life enabled a woman to devote her time to contemplating the Divine or praying for the salvation of the community. Through her prayers and good deeds, she served her society while working towards her salvation. And given these premises, we can understand why some women wanted to go to the convent—they could live holy lives useful to their societies. Living moral lives with a broader purpose is a goal for modern women as well. Although secular and Christian women define *moral* differently and aim for different life purposes, we all want to do something significant with our lives, but the question for us, as well as for the sixteenth-century nuns is whether separating ourselves from family life is the way to do it.

As mentioned, in the sixteenth century the contemplative life was reserved for those separated from society. Nuns embodied Church teaching on vocation and the ideal spiritual life. Because a number of the Reformers' wives were former nuns, and because modern feminist historians celebrate the all-female convent life, it is helpful to know a little about nuns and convent life. Convents were a typical feature of life in medieval and early modern Europe. Each convent was part of an order, of which there were at least ten. Different orders had different rules and structures and even types of buildings, but all nuns of all orders took three vows of poverty, chastity, and obedience. Not everyone who lived in a convent was a nun. A great many young girls were sent to convents for an education, and some of them did not stay on to become full-fledged nuns.

In sixteenth-century Europe, primary school was not compulsory for boys or girls. Most girls, if they were educated at all, received their education from convents. They lived there either as boarders or novices while they were taught basic reading and writing, morality, domestic skills, and sometimes music.[2] Young women of noble origin were encouraged to learn how to run a household, sew, and do needlework.* However, many girls who received this education likely remained illiterate because the nuns who taught them were almost illiterate themselves.[3]

ESTABLISHING AND SUSTAINING CONVENTS

Convents were interesting and surprising places, not entirely like what one might expect. To gain some context, it helps to know a little about their beginnings and their purpose in society. In many cases, royals and aristocrats established monasteries, churches, and convents to gain divine protection and salvation.[4] Noblemen and other important persons donated land to the convents, and the nuns repaid these gifts through prayer. Other gifts besides land included frescoes, paintings, and musical

* As Sister Prudence Allen notes, women in the Renaissance had more opportunities for higher education (Allen, *The Concept of Woman*, 28). However, as Olympia Morata's translator explained, the lives of learned women in Europe followed a pattern. They were praised widely for their brilliance when they were young girls. As soon as they grew old enough to disturb the order of society, they were married off (Morata, *The Complete Writings*, 23–24). Regardless of her level of learning, a woman who spoke a lot was suspected of unchastity (Morata, *The Complete Writings*, xxviii).

instruments, which meant some convents had signifi-
cant collections of masterpieces.[5] In addition, townspeo-
ple paid the convent for prayers, hoping that the nuns'
intercession would appease Christ, whom they feared.
When their loved ones died, they paid enough money for
Masses on the anniversaries of their deaths. When people
had no money to buy prayers and Masses, they brought
"everything they possessed that was of any value, fowls,
ducks, eggs, wax, straw, butter, and cheese."[6] Apart from
such gifts, most cloisters were not financially solvent, but
through gifts and payments, some convents were able to
turn quite a profit. They rented land to farmers, or the
farmers worked directly for them.[7] Some convents also
got into the business of buying and selling wheat (some-
times at triple markups during years of lean production).[8]
They used these profits in various ways. At times they
purchased relics because these supposedly brought super-
natural power, the protection of the saints, and notori-
ety.[9] Other times they used the profits to lend money to
struggling locals. The end result of their investments was
that many of the nuns were living in better conditions
than the townsfolk, with plenty to eat when locals went
hungry. That had a way of making them unpopular and
calling into question the vow of poverty they had taken.[10]

WHY WOULD A WOMAN GO TO THE CONVENT?

A person might assume that women went to convents to
separate themselves from the world and live a holy life.

Sometimes that was true, but not always. Some women went of their own volition, and others went of someone else's volition. Those who chose to go did it for the salvation of their souls or because they had no other alternative. Through monastic vows, they gained absolution for sin, which meant their past sins were forgiven through the process of taking their vows. Those who were forced went because their families wanted their daughters to intercede on their behalf or because they couldn't afford their daughters or couldn't find suitable spouses for them.

Forced monasticism was common for spiritual, financial, and practical reasons, and it did not always work well. Many nuns pleaded with ecclesiastical courts to let them renounce their vows and leave the convents. In the case of Katie von Bora, the future wife of Martin Luther, her father and stepmother sent her to the convent a two-day trip away from home when she was six years old, most likely for practical and financial reasons.[11] Her parents had her moved to a different convent (with a lower entrance fee) when she was ten, at which time she became a candidate for admission to the order.[12] She was consecrated as a nun at sixteen years old, when she took the vows of poverty, chastity, and obedience. By these vows she renounced her family and all her connections with them, marrying herself to Christ.[13] Katie did not leave the convent until she escaped in her mid-twenties.[14]

Ursula of Munsterberg was a German orphan whose family put her in a convent sometime between the ages

of nine and fifteen (these were the age limits of admission).[15] She never liked her time in the convent—she was physically unfit for fasting or for waking up in the night to sing and pray. She did not find the prescribed readings edifying or useful. And she could not follow the strict regulations of the convent. When she failed, one sister called her "an apostate, a heretic, a violator of her vow, unworthy to live on earth."[16] In Ursula's convent, one third of the nuns became Lutherans because Ursula managed to smuggle Lutheran books through the choir window and disseminate them to the other nuns; plus she requested and obtained a Lutheran chaplain.[17] One of the converted nuns contended she had never wanted to take vows to become a nun. Her mother had forced her so someone could intercede for her in Heaven forever, which was another typical practice of the day.[18] Her mother told her she could expect no support from her family if she would not oblige. This particular girl threatened to stab herself with a bread knife if she could not have evangelical preaching.[19]

Another nun sent to intercede for the souls of her family was Charlotte de Bourbon, a sixteenth-century French nun. Her father hoped she might become an abbess and thereby increase the status of their household.[20] This was not uncommon. Charlotte protested taking vows even at age twelve or thirteen. When she was made an abbess, she protested again,[21] but later she used her position to teach the doctrines of the Reformation, which we will learn about soon. She was charged with

perverting the nuns under her,[22] and, much to her father's dismay, she escaped.

Family finances also landed numerous daughters in the convents. Many families could not afford to marry off their daughters, and the convent provided them an acceptable alternative. In the fifteenth and sixteenth centuries in some Italian cities, the convent dowry (or "cloister dowry," signifying the nun's marriage to Christ),[23] was one-third to one-tenth the cost of a marriage dowry. Marriage dowries were simply too expensive for a lot of families. Their daughters often ended up in convents, which offered "a means to soften the onerous impact of supporting female offspring."[24] In Florence, from 1500–1799, forty-six percent of women from elite families entered convents, and in Milan, an astounding seventy-five percent.[25] Once carted off to the convent, the daughter no longer interfered with anyone else's inheritance, either. After all, she'd renounced all her earthly goods with the vow of poverty. Martin Bucer's wife, Elizabeth, was placed in a convent by her relatives when she was a young orphan. They didn't want to be saddled with raising her, and, on top of that, they wanted her inheritance. Since she was a young girl with no means of fighting them, off she went.[26]

Convents also solved the problem of unmarriageable daughters. As one Venetian woman discovered, to her dismay, disability or homeliness could land a girl in the convent. She was disabled and was the only one of five daughters sent to the convent. She observed, "They

[parents] do not give as brides for Christ the most beautiful and virtuous, but instead the ugly and deformed, and if there are daughters who are lame, hunchbacked, or have any other crippling torment, as if the defect of nature was a defect of theirs, they are condemned to spend the rest of their lives in prison."[27] She loathed her forced monasticism as did many others. As Martin Luther remarked, "It is very shameful that children, especially defenseless women and young girls, are pushed into the nunneries. Shame on the unmerciful parents who treat their own so cruelly."[28]

On the other hand, some women entered the convents freely and eagerly. Convents were a legitimate alternative for widows and for reformed or reforming prostitutes (although this had become less common by the sixteenth century) and even for single women with no better options. Through their vows, they became part of a spiritual family that transcended their birth families because the spiritual ties were eternal and indivisible.[29]

Other women desperately wanted to be nuns because they believed it was a holy calling in which they were betrothed to their heavenly bridegroom, Jesus. In the convent they could spend their lives maintaining their virginity and working toward the mystical consummation of their marriage with their celestial spouse when they got to Heaven.[30] One zealous woman prayed for her parents, husband, and children to die so that she might enter the convent and devote herself to divine perfection. They did die, and she told her confessor that "by God's wish my

mother, a great hindrance to me, died, and soon after, so too did my husband and all my children. Since I had ... prayed to God that they should die, it was a great consolation to me and I thought that, after these divine gifts, my heart should always be in God's and His in mine."[31] Another passionate young girl threw herself in a boiling spa to burn her face and body and thereby sabotage her parents' marriage plans for her and to render herself unacceptable as a bride for anyone else, so she could spend her life serving God.[32] Yet another married woman, desiring to devote herself to God but willing to remain married, begged her husband, "Sir, if it please you, ... grant me that ye will not come into my bed Make my body free to God so that ye never make challenge to me, by asking any debt of matrimony."[33] Upon the advice of her spiritual director, another woman, a widow, sought ways to abandon her children so she might join a convent. This took some effort since her father-in-law was unconvinced and threatened to disinherit her children if she followed through with her plans. Eventually, she happily succeeded.[34] These dedicated women and others like them were celebrated and revered by nuns as truly faithful women devoted to their calling.

WHAT HAPPENED TO THE NUNS WHEN THEY ARRIVED AT THE CONVENTS?

Once they joined the convent, nuns "prayed and performed rituals for the benefit of pious male and female acquaintances, sought grace from saints on behalf of

their patrons and devout supporters, and invoked divine protection for the city, the ruling family, their own relatives, and their spiritual sisters."[35] Nuns recited Psalms and other Scripture as part of their daily "Office of the Dead."[36] The schedule for nuns at Katharina von Bora's convent, which she began to follow when she was ten, was as follows: "The sisters were awakened by a bell at one or two in the morning. They rose from bed in the dark, crossed themselves.... With the ring of the second bell, they proceeded reverently to church This earliest service, Matins, was followed by Lauds. After these two services, the nuns were permitted to return to bed and sleep three hours until 6 A.M. During the rest of the day, Katharina and her sisters attended the services of Prime, Terce, Sext, None, and Vespers. They closed the day just before bed with Compline, which was celebrated at 7 or 8 P.M."[37] Katie's convent may have required more prayers than most, but all convents had prayers in the morning and throughout the day. When not praying, women worked, generally keeping silent, thinking of God.[38] In some convents, like Katie's, nuns were not allowed to speak at all, so they used sign language.[39]

Despite all these services, a number of nuns who fled the convent related the limited exposure they had to Scripture. Katie Luther would have had no access to the Scriptures on her own. She had only what was available in the services.[40] Ursula von Munsterberg fled her convent in Freiberg in 1528 and afterward wrote an apology defending her flight. Among other reasons she argued,

"Jesus told us in John 6:51, 'I am the living bread which came down from heaven; if anyone eats of this bread, he will live forever.' So if our eternal life depends upon the Word of God, why was it rarely offered when our souls hungered and thirsted for it?"[41] Martin Bucer noted that his wife, Elizabeth, learned very little Scripture at her convent since there was so little preaching.[42]

There were other unfortunate aspects to the cloister. Convents could be worlds of intrigue, gossip, backbiting, and competition.[43] There were also documentations of fights between nuns, sexual scandals, and even poisoning attempts.[44] Regardless, some nuns were deeply loyal to the Catholic Church and their cloisters, and when Protestants closed the convents or prohibited them from accepting new members (waiting to close them until all the members had died), these women protested and stayed where they were.

However, other nuns were anxious to escape for spiritual reasons or in the interest of self-preservation. One escaped nun relayed her experiences there. She had written letters to Luther seeking his advice and was discovered. Her superiors found her apology for this offense insufficient. So, she had to wear a straw crown, kneel at the prioress's knees during meals, and was flogged and sent into solitary confinement, among other punishments. Another nun rejected the juxtaposition of her convent's material comfort with penitential abuses of the flesh such as public confessions, bloody whippings, and wearing barbs, horsehair, and brass belts with spikes.[45]

Ursula von Munsterberg recalled how often her sisters, even those who had spent a lifetime denying themselves, would agonize on their death beds over whether their works were sufficient to escape God's judgment.[46]

Nuns found myriad ways to occupy their time. In many convents they staged theatrical performances, primarily for themselves, on holy days. They painted, played instruments, sang, copied manuscripts, embroidered, made tapestries, and wrote poetry and histories. One item of particular devotional interest was the Christ child doll. A girl entering the cloister often received a doll representing the Christ child. Many girls had "visions of baby Jesus and spiritual birth fantasies."[47] The nuns would care for the dolls, sew clothes for them, and "on certain feast days of the year hold and cuddle them, thus symbolically acting as the Virgin Mary. Through the rituals . . . nuns . . . could even experience a kind of symbolic motherhood."[48]

A few nuns also participated in the period's debate about women through pamphlet-writing. They praised women's morals and intellectual capacities. A particular Venetian nun, Arcangela Tarabotti, responded to a contemporary's biblical defense of the innate inferiority of women and their lack of souls with her own biblical interpretations. She also argued that women should be able to choose whether to get married, go to the convent, or stay home. She argued for women's education and for inheritances to be shared equally between all siblings, male and female.[49] If given these options, she reasoned,

women would be able to challenge paternal authority or defend themselves if necessary.[50] Her writings were primarily directed to those outside the convent, although a few of them, *Monastic Hell* and *Paternal Tyranny*, were not published (for somewhat obvious reasons) but circulated among her friends.[51] Her writings and others in a similar vein are "universally acknowledged as the Western intellectual tradition leading to modern feminism."[52]

On the face of it, some of Arcangela's suggestions were also made by the Reformers. Women who escaped the convent and left the Catholic Church would have agreed with Arcangela that no one should be forced into a convent, that women should be educated, and that men and women are equal in the sight of God. However, the fruit of the Reformers' wives stands in stark contrast to the feminism Arcangela expressed in seed form. Initially, the practical ramifications of both groups look similar, but the divergence between their trajectories (what the feminists have done with Arcangela's suggestions) is the difference between life and death.

POSH CONVENTS

Before leaving the subject of convents, it's interesting to note that not all convents were created equal. Among the surprising variety of convents were those that catered primarily to daughters of nobility. These were all-female aristocratic societies made up of women whose families could afford to support the cloister. "The women who entered them, and the families that placed them there,

expected them to enjoy the society of their own kind. They were thus aristocratic and socially exclusive communities."[53] These women took vows of poverty like everyone else, thereby renouncing all worldly possessions, and all the gifts they received while in the convent became property of the convent. However, they had fairly comfortable living arrangements and sometimes even entertained guests.[54] Their cells were multi-roomed; the higher their status in the convent, the larger their individual cells.[55] Their families gave them paintings, tapestries, pillows, rugs, devotional images, and other effects to remind them of home as well as money, clothing, food, and books.[56] The convent was not lonely and austere for them. In some cases, they could house family, friends, or servants in their cells with them. They might even have cells that were multiple stories high with kitchens, fireplaces, and restrooms.[57] Sometimes, the new nun did not suffer any estrangement from her family, since the convent was attached to the family palace, or she joined the same convent as her sister, aunt, niece, or even mother.[58]

So convents could be quite comfortable as well as quite social. Prior to the Council of Trent and the enforcement of laws of enclosure (which prohibited any contact between nuns and the outside world), nuns could converse with family, friends, and patrons in the parlor of the convent. In the parlors, nuns also negotiated land transactions, commissioned artworks, gave spiritual advice, sang, played instruments, and engaged in politics and other community business.[59]

Nuns from noble or wealthy families were called *choir nuns* or *veiled nuns*, and their daily work was administrative or advisory. They engaged in governing the convent, advising the abbess, or other administrative tasks but not in manual labor. These convents accepted servant nuns, those from rural areas and lower classes of society, who paid smaller dowries, to do the physical labor. Servant nuns did the cleaning, washing, cooking, caring for livestock, and infirmary work.[60] They were allowed to attend the meetings of the convents but could not vote, and they were not taught to read, lest it distract them from their work.[61] They often wore habits distinguishing them from choir nuns. In some convents, they were required to eat after the choir nuns were finished, and they lived in separate dormitories, sleeping in the worst cells. Even in death, the choir nuns received the greater honor, sometimes even public funerals with their attendant processions.[62] Thus the class system remained even in the convents.

WHO WAS IN CHARGE?

At first glance, the abbess appeared to be in charge of the convent, but she reported to someone else. This is important because some modern historians have proposed that nuns in the cloister avoided the authority of men in their lives. According to these scholars, nuns were fortunate because they could study, they could hold positions of authority over other nuns, and, most importantly (for the modern scholar), they could be autonomous. Not

always though. Generally, the monks or father superiors ruled over the nunneries.[63] In the case of the Nimbschen convent, where Katie von Bora lived, the administrator and his secretary, the warden, and two monks, all of them men, lived on the grounds. The monks heard confession from the nuns, and the monastery also provided gate-keepers to prevent any unauthorized visits or any exits. Since the monastery was responsible for overseeing the convent, and because their abbot often found it lax, the monastery took over as guardian of the convent. [64] In one case, the abbot was particularly displeased with the nuns' complacency and wrote a report for the order's officials, as well as the city council and the elector. Although the abbess technically had the same rank as the abbot, she was not allowed to file a protest.[65] The few women who were in charge of the convents, abbesses and prioresses, always answered to male clergy, confessed to male priests, and attended Masses presided over by male priests.[66]

So that, in short, is the life of a nun in early modern Europe. She may or may not have wanted to join the convent. She may have been there for religious or worldly reasons. Those reasons may have been her own reasons or her parents', but whatever the case, her life was formally separated from her family. She became part of a new spiritual family when she joined the convent.

CHAPTER 8

MARRIAGE:

A Life for the Less Holy

According to the sixteenth-century Catholic Church the most spiritually advanced people separated themselves from the world. So what about marriage? Marriage became a lesser state—one for those who were weaker and could not commit to the holy life.

The Catholic Church developed its views on marriage centuries before the Reformation, although the practice of marriage changed over time. In the second century, church fathers began exalting celibacy for ordained men, thereby creating a two-tier approach to the Christian life. In the lower tier were the married folks, and in the upper

tier the celibate. Even at this early stage, there was a distinction between morality for the clergy and morality for the laity. Celibacy was the ideal and was praised even by church fathers who were themselves married. However, it wasn't until Pope Siricius' decree in 385 that marriage was banned for all priests and other clergymen. In practice, his decree was rarely enforced for centuries and always faced opposition among Catholic bishops and laymen.[1] In fact, by the seventh century, Pope Pelagius II had given up interfering with clerical marriage as long as the wives and children did not inherit property from the Church. Fast-forward two hundred years, and most priests were not living celibate lives, and abortions and infanticide were common in convents to hide the indiscretions of monks and nuns. Another two hundred years, and Gregory VII (d. 1085) undertook Church reforms and began enforcing clerical celibacy. Wives and concubines of priests were run off or sold into slavery, and children were abandoned.[2] By the sixteenth century, priests and clergy were back to the profligate life. They had not returned to marriages, but they often lived with concubines.

How did the Church conclude that marriage was a lesser state than virginity in the first place? Pushing celibacy was partly an outgrowth of Augustine, Jerome, and other church fathers' teachings that pleasure in the created is a form of idolatry because sexual pleasure enticed creatures to forget their Creator and delight in their fellow creatures. According to Jerome (a late fourth-century priest and influential church father), marriage fills

the earth, but virginity fills paradise.[3] Along with oth-
er church fathers like Ambrose and Gregory of Nyssa,
Jerome believed that virginity was God's original intent
for man and "exalted him to the highest spiritual plateau
available in this life."[4] These men held that in their pre-
fall state Adam and Eve did not engage in sexual rela-
tions, and that marriage and sexuality were introduced
as a result of their sin after God expelled them from the
Garden of Eden.[5] Thus virginity was gold and marriage
silver, although Jerome encouraged married couples that
virginity (in the form of a virgin child) could be the fruit
of wedlock.[6] In this way the child could surpass the par-
ents in holiness. "Let married women take their pride in
coming next after virgins."[7] Augustine was more positive
about marriage than Jerome was, but he still considered
marriage inferior to virginity. He believed that marriage
and sexuality existed prior to the Fall, but that the Fall
had corrupted the sexual drive, making it impossible to
control. He seemed to agree with those who taught that
sexual desire was "a demonic intrusion, a terrible force
that had come to possess men and women, and that lin-
gered deep in the heart, like an evil spirit, even among
baptized Christians."[8] It was the corrupting influence of
human sexuality in its current state that rendered mar-
riage a lesser good than virginity.[9]

Jerome and Augustine agreed that in the parable of
the sower, the virgin yielded fruit one hundredfold, the
widowed sixtyfold, and the married only thirtyfold.[10]
The exaltation of virginity did not change significantly

over the next thousand years. In the sixteenth century, the pope still declared the marriage estate "impure" and said that "one cannot serve God and be married."[11] The famed Ignatius of Loyola, who founded the Jesuits in 1539, instructed Catholics "to praise highly the religious life, virginity, and continence; also matrimony, but not as highly."[12] Nonetheless, the Catholic Church still treated marriage as a sacrament, meaning it conferred grace on the husband and wife, although it was unequal to other sacraments like the Eucharist or the taking of holy orders. Even though it was a sacrament, marriage was not a desirable state; it was an estate reserved for those too weak to manage celibacy.

In practice and not just teaching, marriage was often derided. A thirteenth-century treatise aimed at persuading women to become nuns described the pitfalls of marriage. The treatise listed all the terrible things that might happen in marriage—the husband might be unhappy with the wife, the husband might beat the wife, the husband might become an idiot or a cripple. In the end, "in what slavery wives are, who must endure such things, and in what freedom maidens are, that are free from them all."[13] A woman who married had to endure a husband, the pain of childbirth, and the prospect of many children. But marriage was also burdensome for men. A husband had to take a wife and children under his care. As a popular medieval German proverb had it, "If you find things going too well, take a wife."[14] Another

and even less complimentary proverb, "If you take a wife, you get a devil on your back."[15]

As a result of the Church's teaching, popular views of marriage, economics, and the rising cost of dowries, up to forty percent of women in early modern Europe were unmarried.[16] In Florence, in 1427, less than half the men between twenty-eight and thirty-two were married. Forty-three percent of households were made up of single mothers or unmarried people living alone.[17] This was not the case in all cities, and in rural areas a greater percentage of people married and did so at a younger age, but singleness remained prevalent. Even in rural areas, one-third of people remained unmarried.[18] Just as we see today, when a society devalues marriage, people stop getting married.*

To make marriage even more difficult, the Catholic Church established impediments—onerous restrictions on marriage based on familial relationships, religion, previous romantic relationships, and even physical disabilities. For example, a blind or dumb person could not marry. A person was forbidden to marry the child or sibling of his or her godparent or any relation closer than a fourth cousin.[19] Canon laws on marriage had

* In 2015, twenty-three percent of Americans twenty-five years or older had never married, twenty-six percent of American children lived in single-parent households, and the number of unmarried adults was greater than the number of married adults. Stephanie Hanes, "Single nation: Why so many Americans are unmarried," *The Christian Science Monitor*, June 14, 2015, https://www.csmonitor.com/USA/Society/2015/0614/Singles-nation-Why-so-many-Americans-are-unmarried.

become cumbersome to the point of overwhelming. If they wanted to ensure the validity of a marriage, potential spouses had to apply for approval from the Church.

Martin Luther, who believed the impediments set out in Leviticus were sufficient, criticized the Church's rules as "only snares for taking money and nets for catching souls,"[20] because generally, if one had money and wanted to circumvent an impediment or subsequently get an annulment, the Church would give a dispensation granting the request. If an impediment were discovered after the marriage, an aggrieved spouse or even a third party could request dissolution of the marriage.[21] All for a price, of course. As we might expect, the net effect of impediments was to impede marriages.

Clandestine marriages were also common, albeit peculiar. The Catholic Church taught that marriage was valid when one party "administers the sacrament of marriage to the other," even if no other witnesses were present.*[22] These secret marriages were called *Winkelehen*, or "marriages in a secret corner,"[23] and were often contracted under the influence of alcohol.[24] Since these marriages could be entered in the presence of the potential bride and groom only, with no witnesses or advice from other parties, there were many of cases of foul play. Thus, clandestine marriages kept the marriage courts busy. Many

* They did require consent of both parties for the marriage to be valid. Partly in response to the Reformers, the Catholic Church modified these secret marriages in the Council of Trent. In order for a marriage to be valid, the vows had to be witnessed by at least three parties, one of which had to be a priest (Selderhuis, *Marriage and Divorce*, 14).

women sued because they had thought they were enter-
ing into a state of marriage and thus agreed to engage
in marital relations with the groom, only to find out he
denied the marriage after the fact.[25] Usually courts found
the men innocent in these situations, and for that rea-
son there was an abundance of unmarried mothers and
fatherless children.[26] Sometimes the parents sued be-
cause their children married without parental consent.[27]
Sometimes a third party sued because he or she had al-
ready contracted a clandestine marriage with one of the
parties. Despite all the mayhem, most people agreed with
the Catholic Church, and it was widely accepted that a
marriage could be formed by an exchange of promises
for the future followed by consummation.

Generally, for those marriages contracted openly,
mutual attraction and personal choice were unimportant.
Children had no choice, as their families selected spouses
for them based on family interests and alliances.[28] Often
couples did not meet prior to their marriages, and some-
times the bride and groom did not find out about their
betrothal until after the fact. Noble and wealthy parents
contracted their children's marriages, usually quite a long
time before the wedding itself. Many of these marriages
became friendly and sometimes warm and affectionate,
but certainly not all.[29]

Within marriage, the Catholic Church severely con-
strained the marriage bed. Since Augustine, the Catholic
Church had regarded conjugal duties as sinful and de-
structive to spiritual well-being, a source of regret for the

married man and woman.[30] Normally a Christian was expected to try to resist and overcome sex drives and only engage in sexual activity out of necessity. Married couples, who were presumed to be committing sexual sins daily in their marriage,[31] were permitted to engage in sexual relations for procreation, but they were otherwise restricted. Wednesdays, Fridays, and Saturdays were special days and off-limits for sexual contact. Sundays and feast days (of which there were many) were also off-limits. Sex during pregnancy was prohibited, as was sex during daylight hours.[32] Even the "how" of the marriage bed was regulated. The Church taught that married couples were never to see one another sans clothing and were never to engage in any sort of foreplay.[33]

PROSTITUTION

While we're on the subject of sexuality, we should address prostitution, because it had a significant place in early modern society, and modern scholars have argued that prostitution in Europe during this time had some positive good for women. Also, the subject provides a little more context for the lives of the men and women in this period. It was a widely held belief in sixteenth-century Europe that brothels were advantageous to society. For various reasons, economic and otherwise, men often married later in life. The brothels were a means of protecting young women from sexual immorality, which would have reduced significantly their chances for a good marriage.[34] In the brothels, unmarried men could

gain some experience, and unhappily married men could find relief. According to the wisdom of the day, thanks to prostitution, virtuous women could walk the streets safely since they would be less likely to be attacked by sexually voracious men.*

There were four avenues of prostitution, although not all options were available in each town. Public brothels were owned and maintained by the city or municipality and were very profitable for the towns. Women working in public brothels enjoyed some protections and maybe even some civic privileges. Often cities invested in brothels at the expense of better but less profitable causes. For instance, a number of cities that operated public brothels did not have any schools. Bathhouses, the second avenue of prostitution, were privately owned, and their investors usually included persons of rank whose claims of Christianity or social standing did not suffer due to their ownership. In Seville, Church corporations, religious communities, and hospitals owned brothels and leased them to private citizens. Bordellos were small-scale and frequently run by retired prostitutes. Last, there were entrepreneurs or freelancers, who were often managed by pimps.[35]

In Dijon, nearly half of the prostitutes were forced into the profession by their families, who sold them to the brothels,† and more than a quarter had been raped.[36]

* Notably, brothels were closed during Lent and some religious festivities as well as on Sundays (Lanz, *Marriage and Sexuality*, 176).

† Which was a common practice.

All over Europe, prostitutes were regularly beaten and sometimes stabbed or in other ways assaulted by their clients.[37] One fifteenth-century author puzzled over the property rights of a nun who was also a prostitute. He thought she should be required to hand over her earnings to the convent, although only to be used for charitable causes. He was not posing a theoretical question. At least some Venetian convents were renowned for licentiousness of various kinds, and the Church sometimes taxed the prostitutes to raise money.[38] As noted previously, priests were had to pay a fine if caught visiting brothels, so sometimes the taxes were paid on both ends.

It's fair to say marriage in early modern Europe was a tangled mess, and that should remind us of marriage in modern America. We see people getting married later; so did they. We have rampant pornography; they had a robust prostitution industry. For our high rates of cohabitation, they had pervasive fornication. In both the Roman Church then and the American church now, the practice of marriage is not as distinguishable from the world's practice as it should be. This is because Christians fail to see the connection between marriage and family and advancing the kingdom, fulfilling the cultural mandate, and building a Christian civilization. As we'll see, the Reformers responded to this disparagement of marriage with a vigorous theology and purpose for families. They reinstated a biblical joy in marriage, which their surrounding culture needed as much as ours does.

A REVOLUTIONARY VIEW OF SALVATION

Robert Farrar Capon once wrote, "The Reformation was a time when people went blind-staggering drunk because they had discovered, in the dusty basement of the late medievalism, a whole cellarful of fifteen-hundred-year-old, 200–proof grace—of bottle after bottle of pure distillate of Scripture that would convince anyone that God saves us single-handed."[1]

As we have seen, the Catholic Church was almost all-powerful, governing life from birth to death and

even afterward. And then everything changed. The Reformation was a religious movement that began in the sixteenth century. Its original goal was to reform the Catholic Church and rid it of its many corruptions. But the Catholic Church was uninterested in such reforms, so the protesters left the Church. We call these theologians, priests, and pastors the Protestant Reformers.

Protestants today recognize the official start of the Reformation as October 31, 1517, when Martin Luther nailed his Ninety-Five Theses on the door of All Saints' Church in Wittenberg. Luther was a monk who was troubled by his own sinfulness. He knew his own heart well enough to know he could not be holy. No amount of penance could clean up his heart, and besides, what would a righteous God say to a heap of unrighteous penances? He had been tormented with guilt and unable to do enough good works to free himself, and he feared God's righteousness above all else.

But then he was struck with what God meant by "the just shall live by faith." He related the experience,

> But when, by the Spirit of God, I understood these words, when I learned how the justification of the sinner proceeds from the free mercy of our Lord through faith, then I felt born again like a new man; I entered through the open doors into the very paradise of God And as previously I had detested with all my heart these words, 'The righteousness of God,' I began from that hour to value them and to love them as the sweetest and most consoling words in the Bible.[2]

Luther often preached in Wittenberg, expounding the Scriptures, and the people could not get enough. He brought grace to them. Finally, in order to request a formal debate with the Catholic Church, he nailed the theses on the door.* In them he railed against the doctrine of indulgences, which offered deliverance from the punishments of sin for a price, in contradiction to the gospel, which offered God's grace as a free gift. Here is a small sampling of the Theses:

> 21. The commissaries of indulgences are in error when they say that by the papal indulgence a man is delivered from every punishment and is saved.

> 27. They preach mere human follies who maintain that as soon as the money rattles in the strongbox, the soul flies out of purgatory.†

> 36. Every Christian who truly repents of his sin enjoys an entire remission both of the penalty and of the guilt, without any need of indulgences.

> 37. Every true Christian, whether dead or alive, participates in all the blessings of Christ or of the Church by God's gift, and without a letter of indulgence.

* This was a standard practice asking for an audience. Also, throughout the history of the Church, men within it had called for reform. Often the Church responded by reforming, so Luther was not being disingenuous in thinking he could call for reforms and stay within the Church.

† Another, catchier, translation: "As soon as a coin in the coffer rings, the soul from purgatory springs."

62. The true and precious treasure of the Church
is the holy gospel of the glory and grace of God."[3]

The Catholic Church was furious. It was one thing to preach God's Word to the people, but Luther had taken the controversy public, and, even worse, the people clamored to hear about it. The Church tried to silence Luther and all those who joined the cause, but to no avail. As the Strasbourg Lutheran pastor Matthew Zell said when charged with heresy, "Send out preachers. If you do not, they will come anyway. And though you issue a thousand bulls against them, though you use up the whole Schwarzwald [the Black Forest of Germany] to burn them, though you scatter them over the earth, it will do you no good. If you root them out, from their roots will grow others."[4]

The movement began somewhat simultaneously, but without coordination or organization, in Germany, Switzerland, and France. Martin Luther led the Reformation in Wittenberg, where his friend Philipp Melanchthon gave his teachings systematic theological expression. Martin Bucer headed up the Reformation in Strasbourg, then a German city. Ulrich Zwingli was in Zurich, Switzerland, where he was succeeded by Heinrich Bullinger. John Calvin was French, but moved to Geneva. They had different emphases in theology, academic and applied, but they were basically contemporaries. Foundational for all of them was the authority of the Bible alone instead of the pope, and justification by faith,

the doctrine that salvation was through the cross alone and not through good works. As they read the Bible, they saw that there is no work good enough to appease God's anger except the work of Christ on the cross. However, because of Christ's sacrifice, Christians could be right with God, they could be fully in fellowship with Him, and, wonder of wonders, He could be pleased with them. This was shocking for people who had grown up believing God was perpetually angry with them. For centuries, the Catholic Church had been sending people to nuns, monks, saints, and Mary to intercede for them with Jesus. Suddenly, they were told they could pray directly to the Father and that He would delight in them. What's more, because they were saved through Christ, they could live righteously. God the Father counted their works as righteous because they were done through Christ.

Reformers preached the Bible, translated it into the vernacular, encouraged everyone to read it, wrote commentaries on it, and generally revered and loved it and taught others to do the same. All over Europe, people began turning away from the Catholic Church and toward Scripture. People had become desperate for the Word of God. They clamored for the written Word translated into the vernacular and for the Word preached. Luther published his translation of the New Testament into German in 1522, and the need was so great, ten thousand pages were printed daily. Every copy sold. Eleven years later, his translation had been through fifty-eight editions.[5]

Luther's services in Wittenberg were packed as he systematically preached through the Bible.[6] When he was in Wittenberg, he preached twice on Sunday and several mornings a week, as well, for a total of around three thousand sermons. In the year 1528 alone he preached two hundred sermons.[7] Calvin also preached extensively, as did Bullinger. The Reformers not only reestablished the centrality of the Word of God through preaching, they also encouraged congregants to read their Bibles. Parents read the Bible to their children and reviewed catechism questions with them. In the end, when describing the defeat of the papacy, Luther celebrated the power of the Word of God. "I have opposed the indulgences and all the papists, but never by force. I simply taught, preached, wrote God's Word; otherwise I did nothing. And then while I slept, or drank Wittenberg beer with my Philip and with Amsdorf, the Word so greatly weakened the papacy that never a prince or emperor inflicted such damage upon it. I did nothing; the Word did it all. ... For it is almighty and takes captive the hearts, and if the hearts are captured the evil work will fall of itself."[8]

CHAPTER 10

A NEW VIEW OF
WOMEN

As we have seen, women in early modern Europe had it rough. The Church offered most of them one chance at standing out from the crowd: to leave their homes and join the convents. Theologians did not dispel the common assumptions that women were spiritually inferior to men and the source of societal ills. Women were commonly described as deceptive, irrational, stupid, and lazy. They were a cross to be borne, a devil on a man's back. So it was a striking contrast when the Reformers treated women as spiritual and intellectual equals, carrying on extensive correspondence with many

women, often encouraging them and sometimes taking advice from them.* While early church fathers had said that women's intellectual inferiority rendered them less than fully culpable in the Fall, Calvin and others taught that women were equally culpable and equally competent. Woman was made in the image of God just as man was and had no excuse.[1] This was important, because in this view, women were not inferior and were treated as responsible moral agents, a respect heretofore denied them.

The prevailing theological position for many centuries had been that Adam's sin arose from his desire to please his wife. Augustine, speaking for most theologians before the Reformation, said, "Solomon . . . was unable to resist the love of women So it was in the case of Adam He did not wish to make her unhappy, fearing she would waste away without his support, alienated from his affections, and this dissension would be her death."[2] In other words, Adam's loyalty was misplaced, and when Eve gave him the fruit, she acted as the first temptress. Further, theologians as well as laypeople came to believe that Eve's female descendants were temptresses, as well. Luther, on the other hand, thought Adam and Eve both sinned because of unbelief.[3] Luther also believed that depicting women as sources of temptation

* Of course, Luther continued to repeat some medieval ideas, for instance, claiming that women were made only for child-bearing. However, Calvin would take issue with this, and as the Reformation progressed, more and more theologians recognized that, though different, men and women were equal in worth and dignity.

and wickedness bordered on blasphemy.† Women were created by God, and God's work should not be criticized. "Thus we are: I a man, you a woman, just as God made us, to be honored and respected as Godly work. Man has no right to despise or scoff at woman's body or character, nor has woman any right to denigrate man. Rather each should honor the appearance and body of the other as a divine good work, an achievement that is pleasing even to God Himself."[4]

Women were an essential part of creation. A wife was no longer a devil on a man's back, but his counterpart. Calvin, in his commentary on Genesis 2, wrote, "The vulgar proverb, indeed, is, that she is a necessary evil; but the voice of God is rather to be heard, which declares that woman is given as a companion and an associate to the man, to assist him to live well."[5] Women were created by God and were spiritually equal to men.[6] Not just that, but without women, men were incomplete, and not only for purposes of procreation. A man needed the help and support of a woman. As Calvin wrote, "Moses intended to note some equality. And hence is refitted the error of some, who think that the woman was formed only for the sake of propagation, and who restrict the word 'good,'

† To be clear, no one would suggest Luther was delicate in his conversation. Modern scholars could easily refute the positive statements Luther made about women by pointing to some of the insulting things Luther also said. I think the only people he didn't insult were people he hadn't heard of. Still, Luther and other Reformers turned people to the Bible to understand women and pointed out they were equal in Christ. I am highlighting that huge development here.

which had been lately mentioned, to the production of offspring. They do not think that a wife was personally necessary for Adam, because he was hitherto free from lust; as if she had been given to him only for the companion of his chamber, and not rather that she might be the inseparable associate of his life ... [but] marriage extends to all parts and usages of life ... unless a wife had been given him of the same kind with himself, he would have remained destitute of a suitable and proper help."[7]

In some ways, the Reformers did not change the life of the average woman—most women married, had children, and kept households before, during, and after the Reformation. What the Reformers did was change the perception of the nature and role of women and respect women for their contributions. Reformers emphasized something the medieval theologian Peter Lombard (d. 1160) had taught,[8] namely that woman was created from Adam's rib to stand beside him, rather than his from foot to be trodden upon by him, or from his head to rule over him.[9] Since God made Eve from Adam's rib, "Adam was taught to recognize himself in his wife, as in a mirror.... He lost, therefore, one of his ribs; but, instead of it, a far richer reward was granted him, since he obtained a faithful associate of life; for he now saw himself, who had before been imperfect, rendered complete in his wife." Far from a defective product of conception, woman is the completion of creation. "Moses also designedly used the word built, to teach us that in the person of the woman the human race was at length complete, which had before

been like a building just begun."[10] Without women, not only was the world incomplete, it was chaos. "One has to have women. If one did not have this sex, womankind, housekeeping and everything that pertains to it would fall apart; and after it all worldly governance, cities, and order. In sum, the world cannot dispense with women even if men by themselves could bear children."[11] Luther chastised those men who did not honor their wives, who deserted them, refused to support them, and scorned their sex. In so doing, they despised God's work. "Not only is the house built through [wives] by procreation and other services that are necessary in a household;" he wrote, "but the husbands themselves are built through them, because wives are, as it were, a nest and a dwelling place where husbands can go to spend their time and dwell with joy."[12]

CHAPTER 11

CHRISTIAN MOTHER INSTEAD OF CATHOLIC NUN

Vocation was an important question for the Protestant Reformers, and it's an important question for Christians now. As noted previously, the Catholic Church defined a vocation as a lifetime of service devoted to the Church. That left the laity without much chance of achieving holiness in their work. The Reformers had exactly the opposite view of work from the church fathers. Unlike the early church reverence

for the contemplative life, Calvin taught that all men are created to work.[1] "On the contrary, we know that men were created for the express purpose of being employed in labour of various kinds, and that no sacrifice is more pleasing to God than when every man applies himself diligently to his own calling, and endeavours to live in such a manner as to contribute to the general advantage."[2] Given that work was blessed and pleasing to God, it is no surprise that Calvin and other Reformers sowed the seeds for what came to be known as the Protestant work ethic. But men were not just called to work, they were called to work *in* the world. Luther and Calvin believed Christians were called to "be priests in the world, purifying and sanctifying its everyday life from within,"[3] as opposed to interceding for the world from outside of it, i.e., from the cloister. Christians were called to love their neighbors as themselves through their vocations.

Equally important, Calvin and Luther taught that God called men to serve their neighbors through all sorts of vocations. Because mankind served God and neighbor in every sphere of human existence, all vocations took on religious importance. No more caste system of holiness in the church—preacher, shoemaker, farmer, mother—all were God's instruments for accomplishing his purposes in the world. "No task will be so sordid and base, provided you obey your calling in it, that it will not shine and be reckoned very precious in God's sight."[4] Work, in and of itself, glorifies and praises God, regardless of how lowly it might be. "When a

man works in his labour to earn his living, when a woman does her housework, and when a servant does his duty, one thinks that God does not pay attention to such things, and one says they are secular affairs. Yes, it is true that such work relates to this present and fleeting life; however that does not mean that we must separate it from the service of God.... If a chamber-maid sweeps the floor, if a servant goes to fetch water, and they do these things well, it is not thought to be of much importance. Nevertheless, when they do it offering themselves to God ... such labour is accepted from them as a holy and pure oblation."[5] For Calvin, "to do anything for God, and to do it well, was the fundamental hallmark of authentic Christian faith."[6] Through work, Christians could restore the earth, bring order out of disorder, and thereby glorify God.[7]

This biblical perspective on vocation is not just the opposite of the two-tier approach to the Christian life that the Catholic Church was teaching in the sixteenth century. It is the opposite of what many modern Americans believe, as well—that women must be out in the marketplace in order to impact society. The Reformers' teaching also contrasts with Christianized version of this feminist notion, that the only holy work is done in official full-time Christian ministry. Modern society—secular and Christian—has become like the Catholic Church of sixteenth-century Europe. Careers are of greater consequence than the home; careers supply fulfillment; the right careers yield holiness. Seemingly the only mundane

tasks that matter in a woman's life are the ones she does for someone *outside* her family.

Because Martin Luther and other Reformers knew salvation was fixed in Christ, they no longer believed they needed to work to earn holiness. Instead of wondering whether their works were sufficient, these new Protestants turned their focus to the myriad ways, small and large, that God had ordained throughout society to fill the earth and subdue it. The Reformers set out to build a faithful Christian culture on the bedrock of grace. And in that effort, every small task done in faith was recognized as a building block.

Luther emphasized God's provision for the world through man's work. A man's vocation is the "mask" of God to his neighbor. The faithful worker serving his neighbor is God's agent acting on His behalf and joining His work in the world.[8] To the neighbor, it looks like the blessings he experiences are from the man, but in truth, the blessings are from God. "All our work in the field, in the garden, in the city, in the home, in struggle, in government—to what does it all amount before God except child's play, by means of which God is pleased to give his gifts in the field, at home, and everywhere? These are the masks of our Lord God, behind which he wants to be hidden and to do all things.... God bestows all that is good on us, but you must stretch out your hands and lay hold of the horns of the bull, i.e. you must work and lend yourself as a means and a mask to God."[9] In this way God veils Himself as He comes to us on earth. He gives good

gifts through earthly vocations—food through farmers, education through teachers and parents, peace and justice through princes and judges—but only the man of faith can see past the mask to God Himself.

The Reformers expanded the concept of vocation to every sphere, including marriage, and thus they extended the hope of holiness beyond the cloister. But they did not just exalt other vocations. Martin Luther and other Reformers disparaged the monastic life for theological and practical reasons. Luther taught it was "against God's word, against faith, against evangelical liberty, against reason, and against God's command [of love]."[10] According to Luther, the primary purpose of vocation is not salvation or good works but rather serving one's neighbor. Any station that does not serve one's neighbor is not a legitimate vocation.

Thus the problems with the monasteries were that the monk or nun attempted to obtain salvation by keeping his or her vows, and also did nothing to help his or her neighbor. "It is Satan who commands you to forsake men. On the contrary, the Christian life sends you to people, to those that need your works."[11] Martin Bucer went so far as to say that by entering the cloister as a means of gaining their own salvation, monks and nuns were living for themselves just as much as an Epicurean.[12]

What's more, cloister living stunted spiritual growth. Once settled into a cloister, monks and nuns not only lived for themselves, they did not want for anything. The cloister provided for all their needs, which meant they

were never forced to rely on God's provision. They had no worldly cares, but if they left the cloisters, then they could face the test of trusting God to provide for themselves and their households.[13]

In practice, as the Reformers (and sometimes their wives) emphasized, the cloister and the priesthood were polluted with sin. Protestant Reformers not only demanded approval for priestly marriage, they also said requiring celibacy was unbiblical. Because it was unbiblical, it led to the immorality they saw all around them.

Martin Bucer acknowledged the original purpose of celibacy was for the clergy to leave the world behind and focus on the Divine. However, the law of celibacy became a stumbling block to piety, which is contrary to the purpose of law, namely, the promotion of piety. The fruit of this law was obvious from its rampant immoral fruit.[14] Priests were not known for their morality; quite the contrary. "The prohibition of marriage has filled the world with all sorts of fornication, so that at least a third of the Christian part of the world unfortunately consists of prostitutes and scoundrels."[15]

Luther was even more pointed. "Shameful, nasty fellows are [priests], who befoul their own nests and who, like swine, take pleasure in rooting in filth with their unclean snouts, and in wallowing in their own shame."[16]

Katherine Schutz was the wife of Matthew Zell. She authored a pamphlet defending her marriage to Matthew, and in it she said to the clergy, "You must allow it to be said of you, that one has five or six whores, the other

seven women birthing, plus a pretty doxy in the house and lots more. It is just as Isaiah says, 'there is no health in them from head to toe.'"[17] She continued, "The second reason [why the clergy are so set against marriage] is that if the priests have wives, they cannot exchange them among themselves, as they do with the whores. One goes out, another comes in. For St. Paul says, a bishop is a man who has one wife, for which reason he would have to live honorably, and if a wife did not suit, he could not exchange her for another."[18] As a result of their life of sin, priests turned a blind eye to adultery among their parishioners and themselves,[19] "the unchaste 'chastity' of celibacy, the sin-flowing harlotry of Sodom and Noah's age, they do not punish and have never punished, but instead they protect it."[20]

Every major figure of the Reformation rejected the advancement of celibacy.[21] Although some people were especially gifted by God with celibacy, as Jesus taught in Matthew 19, the Reformers believed the Church should not require celibacy of anyone. Wherever celibacy was required, people's nature would force them to find sexual satisfaction in sinful ways. "[P]riests, monks, and nuns are duty-bound to forsake their vows whenever they find that God's ordinance to produce seed and to multiply is powerful and strong within them. They have no power by any authority, law, command, or vow to hinder this which God has created within them. If they do hinder it, however, you may be sure that they will not remain pure but inevitably besmirch themselves with secret sins

or fornication. For they are simply incapable of resisting the word and ordinance of God within them. Matters will take their course as God has ordained."[22] Without a special command from God, people "without marriage are only half humans. They are only half useful to society as well, and often they are altogether useless, and even harmful."[23]

PROTESTANT MARRIAGE INSTEAD OF CATHOLIC CELIBACY

Studying the Reformers' views on marriage is encouraging as the institution of marriage decays in our culture. The Reformers turn us back to the Bible to understand marriage. Instead of celibacy, the new Protestants wanted to establish a clerical family life, and they established marriage as an ideal. In so doing, they changed the notion of

piety itself. For medievals and those who preceded them, a pious man conquered the world by fleeing from it and denying his desires. By contrast, a pious Protestant fulfilled his domestic and vocational duties. He conquered the world through converting it, reversing the curse in it, just as Jesus did when he attended the wedding feast and changed the water into wine.[1] Instead of seeing women as seductresses, Reformers took wives and contemplated Paul's comparison of marriage with Christ's union with His Church.[2] Calvin said marriage is "a good and holy ordinance of God,"[3] and Bucer a "clear calling from God."[4] Marriage is the holiest and most important commitment among humans. It is "the noblest community of possession, body and soul."[5]*

Where the Catholic Church had belittled marriage, the Reformers praised it. "Now tell me, how can the heart have greater good, joy, and delight than in God, when one is certain that his estate, conduct, and work is pleasing to God?"[6] One Reformer said, "You [papists] say, 'Marriage is a sacrament,' but then you go on to reckon the spiritual fruit of virginity to be a hundred-fold, that of widowhood sixtyfold, and that of marriage thirtyfold. How does it help married people when you make marriage a sacrament, but then treat it as the least spiritually fruitful state a person can be in ...? I believe that God has so established marriage, that a pious married person, even one who has been married three times,

* Later in the book, we will see important Protestant women who never married, who were widows, and who were abandoned by their husbands. Their contributions were significant, but the Reformers argued that marriage is the foundation of Christian society.

is more esteemed by God than a monk or a nun who has been chaste for thirty years. Therefore, I reckon the fruit of marriage to be a hundredfold, and that of monks and nuns [the equivalent of] three ripe pears."[7]

Marriage also has a purpose beyond itself. Reformers believed a reformation of marriage must precede a reformation of church and society. Marriage in the sixteenth century had become so rife with immorality and human ideas and rules that no one knew any more what the purpose of marriage was supposed to be. True reformation in the church and society would come when priests could marry and show their ability to live chastely with their wives (in contrast to the priests who had taken concubines and thereby precipitated moral decline in the laity).[8] Marriage is the foundation for the entire community; it is the essential union. "Indeed: order in society cannot possibly be restored unless there is first a reformation of the families and families cannot possibly be reformed unless first the honorable position of sacred matrimony is regained How can we expect to produce good citizens if the most important and holiest union, namely that between a husband and a wife, is not formed in a holy manner, and in families there is not in effect a form of discipline which corresponds to God's precepts?"[9]

† Bucer put his money where his mouth was and became quite a marriage broker (Selderhuis, *Marriage and Divorce*, 128). He viewed marriage as a way to advance the Reformation. For example, when Wolfgang Capito's wife died, and Capito was attracted to an important Anabaptist woman, Bucer went ahead and got him set up with Wibrandis Rosenblatt. That way the Reformation didn't lose Capito.

Godly marriages and their fruit of faithful children change the world. Thus, the first job of Christian parents is to evangelize and disciple their own children. Their children are their closest neighbors, the poor and needy among them, who need the gospel. Raising godly children spreads the kingdom of Christ. As the Strasbourg humanist Otto Brunfels noted in the 1520s, "If one wants to reform the world and make it Christian, one must begin with children."[10] And so they did, and, as we will see, they changed their society. Their successes are encouraging for us because if God could take the corrupted society of early modern Europe and turn it to Him using faithful teaching of His Word and faithful families, He can do it again in corrupted modern America.

This new understanding of the importance of marriage and family was a huge shift for women especially. Marriage was the highest religious calling for women, "the vocation in which they were to fulfill God's order and will and to redeem the effects of the Fall,"[11] which meant they were equal participants in the mandate God gave to fill and subdue the earth in Genesis 1. It also meant they went from being perceived as seductresses to being honored as righteous companions. "As long as celibacy was regarded as the preferable state, women, by inference, occupied not only a secondary position but could easily be seen as an evil force, the temptation that threatened a man's salvation. It is significant that the first overt act against the Roman church for many of the Reformers was to marry. By marriage they denied the

tradition that the love of a woman would interfere with their love of God. They asserted, instead, that married love reflected divine love and this, in itself, placed women in a new position in society.... [W]omen had become equal partners in the pursuit of the Christian life."[12]

After establishing the importance of marriage, the Reformers taught husbands and wives how to live in marriage because they believed marriage to be "the school and workplace of faith."[13] Marriage "teaches us and compels us to look to God's hand and grace, and simply drives us to faith."[14] In Bucer's view, a wife was a means by which men are helped toward salvation. By learning to love their wives, men are enabled to fight sin and grow more pious.[15] Reformers were full of instruction for men and women. Husbands and wives had God-given duties to one another in marriage, which was a revolutionary idea at the time and has much to teach us today. The ideal servant wife who was beaten out the back door only to let herself back in the front door was no more. The husband should assist the wife, care for her, provide for her, counsel her, and work for her piety.[16] He ought to work faithfully in his calling, not spending money on beer or gambling or other women.[17] He should give his wife as much love as he hopes to receive from Christ,[18] manifesting "Himself to his wife as her head just as Christ is the head of his church, and this naturally means that he will be utterly diligent in providing the things that are best for his wife. There is no greater love to be found anywhere than that with which Christ

loves the church."[19] Husbands should be men "who truly love [their wives] and will help them to live a completely holy and pious life, really wholesome leaders, providers, and saviors in the way Christ was these things for his body, the church."[20] He should do his best to protect her from sin and so save her from the judgment for that sin.[21] In effect, he should serve his wife by drawing her closer to Christ.

The wife obeys Christ when she obeys her husband. "That obedience consists in her not neglecting any of the tasks of a good wife. She will diligently bring up the children; she will wisely manage the household; she will be well-disposed toward all and do all things unflinchingly with firm confidence in God and a cheerful disposition."[22] She shares in all her husband's tasks, and "for this reason she is called woman, or, if we were able to say so in Latin, a 'she-man.'"[23] A wife makes her home "a seminary for the church,"[24] reading to her children and bringing them up in faith. She esteems and honors her husband as the church esteems and honors Christ. "The Lord will use [the faithful wife] as his holy instrument for the upbuilding and honor of her husband, her children, the family, and the whole church."[25] The wife, through her obedience, participates in God's work in the world in a crucial way.

The Reformers realized God intended women to be companions in marriage. Unlike the political marriages of the elite, Luther emphasized love in marriage, "Every one should look upon his or her spouse as the only one…

no king in all his adornment, yea, not even the sun, should in his eyes shine and glow more beautifully."[26] He instructed children to get parental permission before they married, and if parents were to select a spouse for their child, he encouraged them to consult their children first.[27] Bucer agreed: parents should not force their children into marriages they do not want.[28] In response to the ubiquitous clandestine marriages of the day, Luther insisted a marriage was not established until it was public and approved by the parents of both parties. Couples also began meeting with their pastor before announcing their intention to marry.[29] Calvin rescinded marriages contracted by young people without parental blessings, and Zwingli held these marriages invalid in the Zurich marriage courts.[30] As for impediments, Luther called the Catholic Church's impediments, "a net for gold and a noose for the soul."[31] He recognized only the twelve impediments mentioned in Leviticus (a man cannot marry his mother-in-law, stepmother, aunt, etc.), and the laws changed accordingly.[32]

The perspective on sexual relations within marriage changed as well. Following Genesis, the Reformers rejected the Catholic idea that marital relations were immoral or sinful, since God had commanded Adam and Eve to be fruitful and multiply before the Fall. Reformers abandoned the feast days and with them the regulations about sexual relations on feast days. Sexual relations were not a concession for the weak. Rather they increased the couple's love and affection for one another.[33] Reformers

believed sexual relations in marriage preserved and promoted love, friendship, and service.[34] "Because love is ... the fulfillment of the law, a husband and wife can fulfill the law by having conjugal relations."[35] Thus, the sexual relationship became a means to a more glorious end, giving it a purpose beyond itself. Sexual relations were not just a bestial outlet for uncontrollable desires. They were God's way to establish faithful households and deepen love and friendship. They were good when directed toward their proper end.[36]

The Reformers were opposed to the widespread prostitution of the day. They either closed the brothels or moved them outside the city walls. Luther suggested men should pray for wives instead of frequenting brothels, and Bucer was against them because they were dangerous to women. He also suggested men marry at an early age instead of visiting prostitutes. From brothels men learned the kinds of lessons they would take into their marriage, and those lessons were not a benefit to their wives.[37]

So we see that the Reformers exalted marriage as a holy estate. They also assumed both husbands and wives needed instruction. When marriages went wrong, women were not the only ones to blame. Reformers held that husbands and wives were equal before God and shared in a common ministry.[38] It is difficult to imagine the magnitude of this transformation in thought about marriage, about husbands and wives, and about women in general. Modern feminist historians rebuke the Reformers

for not letting the women preach (although there is no indication most of them would have wanted to), but they miss the fundamental shift in thinking for western Christianity. Women were spiritually equal to men, even if they had different roles. Women were no longer a subservient class, an afterthought to creation. To say that a man needed a wife meant that men were incomplete without women, and that meant women were necessary for godliness and for the church and for society, not just for procreation. Cultural change is the result of true and applied theology. When women are moral agents with responsibility equal to that of men, when the home is revered as the seed of civilization, when men are expected to work hard to provide for their families, then we should expect to see a radical change in culture, and as we'll see, that is exactly what transpired.

THE PROTESTANT REFORMERS GLORIFY MOTHERHOOD

It is easy, amidst diapers and runny noses, to lose sight of the greater purpose of motherhood no matter what century you live in. We know that one of the great blessings of marriage is motherhood, but then what? The Reformers insisted that children were made in the image of God and answered to Him for their actions. They focused on disciplining their children, but it was discipline that respected the child's independent personhood—he would answer to God Himself—and it was also discipline with a purpose. Reformers believed faithful children

would better their society and the world. "To the people of Reformation Europe no specter was more fearsome than a society in which the desires of individuals eclipsed their sense of social duty. The prevention of just that possibility became the common duty of every Christian parent, teacher, magistrate."[39]

The German Lutheran pastor Justus Menius instructed, "The diligent rearing of children is the greatest service to the world, both in spiritual and temporal affairs, both for the present life and for posterity. Just as one turns young calves into strong cows and oxen, rears young colts to be brave stallions, and nurtures small tender shoots into great fruit-bearing trees, so we must bring up our children to be knowing and courageous adults, who serve both land and people and help both to prosper."[40] This was a vision for childrearing that looked beyond the immediate future and the immediate family to the future of society at large. Reformers realized childrearing has long-term momentous impact, so they did not take the task lightly. As Luther said, "The greatest good in married life, that which makes all suffering and labor worthwhile, is that God grants offspring and commands that they be brought up to worship and serve him."[41] Their children expanded Christ's reign over the earth.

Motherhood is rife with menial tasks, but Martin Luther and other Reformers encouraged mothers with the teaching that their faithfulness brought pleasure to God and that their duties were meaningful. As Bucer said,

marriage is "the nursery of the human race."[42] Marriage creates a larger community of people to love—the children produced in it. These children are also citizens of society and through Christian love can become good citizens. Husbands and wives were bishops and apostles to their children, teaching them the gospel, reading the Bible to them, and teaching them their catechisms. This was a monumental about-face in religious thought— fathers and mothers began to realize their daily tasks brought glory to God.

> [The Christian faith] opens its eyes, looks upon all these insignificant, distasteful, and despised duties in the Spirit, and is aware that they are all adorned with divine approval as with the costliest gold and jewels. It says, "O God, because I am certain that thou hast created me as a man and hast from my body begotten this child, I also know for a certainty that it meets with thy perfect pleasure. I confess to thee that I am not worthy to rock the little babe or wash its diapers or to be entrusted with the care of the child and its mother. How is it that I, without any merit, have come to this distinction of being certain that I am serving thy creature and thy most precious will? O how gladly will I do so, though the duties should be even more insignificant and despised. Neither frost nor heat, neither drudgery nor labour, will distress or dissuade me, for I am certain that it is thus pleasing in thy sight." A wife too should regard her duties in the same light, as she suckles

the child, rocks and bathes it, and cares for it in other ways; and as she busies herself with other duties and renders help and obedience to her husband. These are truly golden and noble works.[43]

The works a husband and wife do may seem insignificant but are precious in God's sight because all mankind depends upon them.

Many a woman joined her husband in business, took over her husband's business upon his death, or participated in volunteer work outside the home. In fact, the training she received in her husband's trade was sometimes more than a formal apprenticeship would have offered. This left the wife capable of earning a living if her husband passed away.[44] One Elizabeth Baulacre of Geneva took over her husband's small business when he passed away. She turned it into "the largest producer of gold thread and decorations in the city, employing hundreds of workers and leaving the second largest personal fortune in the city when she died."[45] However, a woman's home was her first priority, "a divinely ordained discipline through which women exercised their faith and worked out their salvation; neglect of the household betrayed a woman's reason for existing."[46] As a result, good homemaking became respected and thereby reduced the widespread denigration of women. In short, society changed through the obedience of wives and mothers.[47]

The Reformers looked at their work as the liberation of women—women would have far more say in their own households than they would have had in a convent,

and they could spend their lives joining God in His work in the world. They were the centers of their homes and family life. Reformers taught that the husband was the "father of the house, and the wife was the mother of the house, a position of high authority and equal respect."[48] Marriages of companionship, mutual love and respect were encouraged as were shared childrearing responsibilities.[49] The Reformers successfully changed the perception of marriage, home, and family. What was once ridiculed became revered.[50]

CHAPTER 13

WOMEN OF THE REFORMATION

The shift in doctrines was monumental, but the embodiment of those new doctrines changed culture. The embodiment came, at first, through the Reformers' wives and later through many other women involved in the Reformation cause. All of these women who fleshed out Protestant teachings and spread the Reformation put our modern career women to shame. Their diligence and industry amidst uncertainty, sickness, and death were simply extraordinary, and we have so much to learn from them. The protesting priests and pastors got married, and they did it in droves. As

Erasmus quipped, "Some speak of the Lutheran cause as a tragedy, but to me it appears rather as a comedy, for it always ends in a wedding."[1]

Wives of Reformers paved a new way; they were the first pastors' wives. Their homes were the intellectual, cultural, and social centers of their communities. They hosted other Reformers, students, visiting theologians, and refugees. "They were instrumental in spreading the evangelical faith even without writing any theological treatises themselves."[2] They also set the new ideal for families, raising up their own children and sometimes other people's children in the faith. They took in the sick and encouraged the downtrodden. In short, they set the trend for what modern pastors' families do. As one historian remarked, among the Reformers' wives are "found many of the purest, most refined, and most useful women on earth,"[3] and the reason this is true is because these women sacrificed themselves; they emptied themselves for others in their lives. They did not seek their own advancement; they did not grasp for legal or social "equality" with their husbands. They lived as though the spiritual equality their husbands preached meant they had just as much meaningful work to do as any man, and no time like the present for getting started.

OPPOSITION TO REFORMERS' MARRIAGES

Given the longstanding celebration of celibacy in the Catholic Church, it is not surprising that opponents of

the Reformation claimed sexual desire motivated the Reformers' theology.[4] People said Reformers' wives were concubines. One modern author about these women aptly titled her book *From Priest's Whore to Pastor's Wife*. People said the child of an ex-nun and ex-monk, particularly of Martin Luther and his wife, would be the antichrist or a two-headed monster,[5] which irony was not lost on Erasmus who retorted, "If that prophecy be true, what thousands of Antichrists the world has before now seen."[6] One government official accused Katie von Bora (Luther) of being Martin's "little rat servant,"[7] and of leading other women out of the cloisters and into lives of debauchery. Erasmus of Rotterdam and Luther's own friend Philipp Melanchthon predicted she would thwart the aims and principles of the Reformation; she did the opposite, and Melanchthon himself would eventually choose to marry.[8]

Two years after her marriage, someone printed a pamphlet directed at Katie, "Woe to you, poor fallen woman, not only because you have passed from light to darkness, from the cloistered holy religion into damnable, shameful life, but also that you have gone from the grace to the disfavor of God, in that you have left the cloister in lay clothes and have gone to Wittenberg like a chorus girl. You are said to have lived with Luther in sin. Then you have married him, forsaking Christ your

* Theologically, monks and nuns were married to God and were thus spiritual siblings. A marriage between them was seen as incestuous (DeRusha, *Katharina and Martin Luther*, 165).

bridegroom. You have broken your vow and by your example have reduced many godly young women in the cloisters to a pitiable state of body and soul, despised of all men."[9] She also received letters referring to her as Luther's "so-called wife" and accusing her of being a "dancing girl." They warned her of the fires of Hell if she did not return to her convent.[10]

Katie von Bora was not slander's only victim. People said Bucer hit his wife and had a child with another woman.[11] When people said Matthew Zell beat his wife, Katherine, or seduced another woman, Katherine responded, "I will stand for him with my honor, body, and life, since such liars attack him undeservedly and without true cause and tell lies about him. Toward me and toward the whole world, he behaves in such a way that no one can denounce him to the world, except by lies God desires, therefore, that our marriage stand as it is now until the very end, and I hope that it is and will remain pleasing to God, useful to both of our souls, and beneficial to many others in soul and body."[12]

On top of all the lies, often the Reformers themselves were under threat of martyrdom. Looking back from five hundred years later, we see the Reformation as a fixed event in history. We know how the story ended. But in the 1520s, the success of the Reformation was entirely uncertain. If it had failed, these women would have lost their lives alongside their husbands. For instance, if not for the protection of his elector, Frederick the Wise, Martin Luther would have been burned at the

stake as directed by the Edict of Worms in 1521, and he told his wife she could expect the same treatment.[13] The women responded with courage. When people claimed Matthew and Katherine Zell's marriage was full of dissension, Katherine said, "My husband and I have never had an unpleasant 15 minutes. We could have no greater honor than to die rejected of men and from two crosses to speak to each other words of comfort."[14] These women willingly accepted defamation and even the possibility of martyrdom for the sake of the renewal of the church.

Such criticisms were no surprise to the Reformers. In fact, the lies just served to encourage them. Luther was originally uninterested in marriage for himself, although he advocated the married state for his friends. He decided to marry Katie when one of his opponents said, "If this monk were to take a wife, then all the world and the very devil would laugh, and [Luther] himself would ruin everything that he had created."[15] Luther responded, "If I can arrange it, I will marry Kate [Katie von Bora] in defiance of the devil and all his adversaries."[16] Katherine Zell had intended to remain single all her life, but she and Matthew established the first clerical marriage in Strasbourg so that others might be encouraged to marry. Katherine wrote a pamphlet defending her marriage to Matthew, in which she explained, "This is also a reason why I have helped the priests to establish [clerical] marriage. And the very first one here at Strasbourg occurred with God's help, for I had made up my mind not

to marry. But then I witnessed the great fear, the raging opposition, and the great lewdness. When I nevertheless took a husband, I meant to give heart to and show the way to all Christians, as I hope to have done."[17]

CHAPTER 14

FAITHFUL REFORMERS' WIVES

Reflecting on the women of the Reformation, Roland Bainton wrote, "The weaker vessel when filled with the Holy Spirit is powerful to pull down strongholds,"[1] and, "If the rulers of the land favored the reform, the reformers might even enjoy popular esteem, but if the political regime were altered, the result could be confiscation of goods, exiles, or even executions. The role of a wife under such circumstances was like that of Aaron and Hur who upheld the sagging

arms of Moses, for only while his hands were aloft did Israel prevail over Amalek."[2]

The way the women of the Reformation lived out the gospel is encouraging and inspiring. The family itself and its structure with the woman at the heart of the home was essential to the success of the Reformation.[3] The Reformers' wives got to work, and so did all the other members of their churches. Many women managed households and showed hospitality—one woman housed eighty refugees eating at her house for three weeks, and fed sixty of them (she found food for the other twenty elsewhere).[4] They helped with hospitals and orphanages and schools, visited prisoners, took in refugees, spread the truths of the Reformation,* and advanced the mission of the church. Husbands and wives often worked together to relieve the afflicted.

When Katie von Bora and her friends escaped from the convent, most of them had no family who would take them in. They had no money or even clothes, so various families in Wittenberg housed them, clothed them, fed them, and helped them find husbands.[5] Lucas and Barbara Cranach took Katie in for a time and became faithful friends of the Luthers as well as supporters of the Reformation. [6] Others used calamities as opportunities for spreading the gospel. When the Plague descended on Wittenberg, Dr. Augustine Schurff and his wife moved into Lutherhaus (the home of Martin and Katie)

* One couple were circuit riders, spreading Luther's message throughout Germany and even in Denmark.

to help treat patients. As the Plague dissipated, Katie and a number of her friends took to visiting pregnant and needy women.[7]

Reforming theologians often stayed with one another in their travels, and this hospitality aided the spread of the Reformation. For instance, Zwingli and Johannes Oecolampadius stayed with the Zells for two weeks on their way through Strasbourg.[8] Katherine also hosted Calvin at one point, and at different times thirty other theologians. On another occasion the Zells visited the Luthers and the Melanchthons.[9] And once, Katherine hid Bucer and another minister for three weeks as they tried to flee to England.[10]

Wibrandis Rosenblatt spent her life hosting ministers, refugees, family, and friends.[11] Of her and her fourth husband, Martin Bucer (her first three husbands had predeceased her), one of their visitors commented, "It is like a hostel, receiving refugees for the cause of Christ. In his family during the entire time, I saw not the least occasion of offense but only ground for edification. His table is not lavish nor sparse, but marked by a godly frugality I never left the table without having learned something."[12] These hospitable wives embodied Reformation teaching: serving meals, making beds, and opening their homes. Without their work, the teaching would have remained a skeleton, cold words in inaccessible theological treatises. There's no doubt that their non-stop generosity was hard work, and yet it was glorious at the same time.

KATHERINE VON BORA (LUTHER): MARTIN'S RIB

Perhaps the best way to understand the impact these women made is to study a few of them in a little more depth, to get to know them a little better. They are awe-inspiring women of faith and fantastic company Later we'll take their stories and apply them to our own lives. How did these women in the Reformation and those who came afterward use their vocations to change history?

For starters, there is Katherine (Katie) von Bora, the ex-nun who married Martin Luther. Katie had been placed in a convent as a child, but somehow after a number of years as a nun, she obtained some of Martin Luther's writings. Realizing there was no salvation in the convent, she and eleven other nuns determined to leave. Unfortunately for them, they were under a strict rule of silence. They made an escape plan using sign language and notes. The nuns fled the cloister on Easter Eve 1523 in a merchant's cart. Three of them returned to their families, and the others landed in Wittenberg. Most of them married, and one started what may have been the first non-cloistered school for girls in Germany.[13] Before long, Katie was the only nun left. She boldly refused to marry the men Martin Luther proposed, which did not sit too well with him. As for Martin, as mentioned, he had not planned to marry, because he expected to be martyred. Despite what he preached about celibacy, he was not quite ready to give it up himself. But when he

heard his critics predict doom and destruction if he were to marry, he set out to tie the knot at once.

Katie brought a lot of changes to Martin's life. Prior to their marriage, Luther's bed was "mildewed with perspiration."[14] In fact some reports say the straw had decomposed, since he hadn't really made the bed in a year.[15] Martin and Katie lived in an abandoned monastery (called the Black Cloister) with forty bedrooms on the ground floor. The cloister was in such bad shape when they married that they undertook extensive repairs. Katie participated, even whitewashing all the walls with lime, which was supposed to help aesthetically and also deter bugs.[16] During her first year of marriage, two and a half wagonloads plus two barrels of lime were delivered to the Black Cloister.[17] As soon as they married, even on their wedding night, they began taking in exiled preachers and ex-monks.[18]

This hospitality continued throughout their marriage. Their house was always a hotel for those running from the law—nuns, monks, scholars, and family members, even though aiding and abetting a monk's or nun's escape from the cloister was a crime punishable by death.[19] At some points, all the bedrooms were occupied with refugees, relatives, orphans, tutors, and students.[20] Predictably, Katie had a lot of work to do, but the sheer amount of it boggles the mind. She awoke every day at 4 a.m. and retired at 9 p.m. She grew vegetables, had fruit trees, tended livestock, and caught fish for their table. She bought two farms and two orchards

and managed them.[21] She fed Martin well so that his health improved, and she introduced him to gardening. She made beer so tasty it was served to the elector at the Saxon court.[22] Katie and Martin also raised four orphans and six or seven nieces and nephews in addition to their own six children.[23] When Martin was downcast, Katie kindly invited friends over for dinner to cheer him. Katie was also responsible for the finances of the house. Because Martin refused to take payment for anything—his lectures, room and board at the Lutherhaus, etc.—his generosity often landed him in debt. Katie managed their small income and even started charging the boarders to make ends meet. Thankfully, she had one or two servants, and her Aunt Magdalena lived with them and helped them immensely.[24]

Katie also took in sick townspeople when the Plague arrived, refusing to leave the city as many were doing. In a sermon on the subject, Martin said, "We did not flee I am your preacher and visitor of the sick, and Kate is the nurse, doctor, pharmacist, counselor, etc. God has protected Kate and me and our whole family from two plagues. We have been blessed in this city in good days, why should we leave when suffering strikes?"[25] In early modern Europe, the Plague came and went along with other diseases such as smallpox, measles, and dysentery.[26] People knew that the Plague was spread through human contact,[27] and so the Luthers' choice to remain in Wittenberg was a noble one. Unfortunately, people did not realize that the rats moving like waves through their

streets and the fleas living in their clothes and beds were the real culprits.*[28]

Martin and Katie also hosted the table talks, and there was a waiting list of students and others who were anxious to attend. People from all over the world and all classes of society came together at the Lutherhaus table.[29] During the table talks, Luther (or a substitute if he were absent), would host a discussion about subjects of interest—the Reformation, academic issues, or current news. In this way, news of the Reformation and the rest of the world spread. Katie assigned the seating and participated in the discussions, asking theological questions or jovially bantering with Martin. Sometimes she even hosted banquets for up to 120 people. All reports were that she was a great cook. Katie "preached" through feeding, clothing, housing, loving, nursing, and supporting, and she freed up her husband to do his calling.

Martin's work beyond their home demanded a fit companion and helpmeet, which he found in Katie. We have few letters of Katie's, but we have several from Martin addressed to her. He often refers to her as "Mrs. Dr. Luther" and sometimes as "mistress of the pig market and Lady of Zulsdorf (the name of the farm she purchased).[30] In one, he seeks her advice on who should fill a vacant pastorate, and because he thinks she is prudent, he

* People had so many fleas that it was hard to stop scratching. Doctors recommended tying kipper heads together and putting them under the mattress (Anderson, *Daily Life*, 101). Every mother's chores included delousing her children and removing their fleas (Sarti, *Europe at Home*, 197).

has confidence she will make a good suggestion.[31] In another, he asks her to pass on his explanation of a Gospel passage about thorns to his friend Philipp Melanchthon.[32] She was his secretary and publishing agent, printing and distributing his works.[33] She listened to his progress on the translation of Scripture.[34] Katie was also his counselor and comforter. Once she even persuaded him to come to an agreement about the Eucharist with some other theologians.[35] Martin called her an empress, "a gift of God," "loyal and trustworthy," one who "comforted him with the Word of God," a theologian, his rib, and a "woman worthy to be loved."[36] She taught catechisms to their children, studied her Bible, and participated in the church.[37] Most importantly, as she said when she lay dying, she "wanted to cling to Christ like a burr to a dress."[38]

Katie also knew how to encourage her mercurial husband. Martin Luther sometimes struggled with severe depression. On one occasion, he had been sullen for several days. He had been grumpy, gruff, and discouraged. He refused to speak. None of Katie's counsel placated him, so she stopped giving counsel. Instead, she put on a black dress and a black veil and sat on a stool in the middle of the room. He passed by her and asked, "What is wrong with you? What are you doing?" She replied, "Oh dear, it is just terrible. The Lord in Heaven is dead." He was incensed. "What are you talking about, 'The Lord in Heaven is dead'? God is not dead!" She replied, "Oh really, well the way you've been acting, I thought God was

dead, and I wanted to join you in mourning for Him." He laughed and snapped out of his foul mood.[39] On another occasion he locked himself in his study for several days to write, taking with him only bread, salt, and some water. A lot of people were living at their house, including many children and numerous guests who wanted to talk to Martin. Katie grew worried about him when he did not open the door after her repeated pleas. Finally she hired a locksmith from the village to come and open the door, and there he was, deep in thought with his Bible open on his desk.[40]

Luther said about his beloved wife, "My wife is compliant, accommodating, and affable beyond anything I dared to hope. I would not exchange my poverty for the riches of Croesus."[41] Through Katie, Martin learned to esteem marriage all the more, "The greatest of earthly blessings is a pious and amiable wife, who fears God and loves her family, one with whom a man may live in peace and in whom he may repose perfect confidence."[42] Katie "made things happen. She kept the doors open, put food on the table, welcomed the guests, and cared for whoever was in need Franklin D. Fry appropriately described Katie as the 'balance wheel in the midst of chaos,' the spiritual force and equilibrium in the life of the Reformer and his work."[43]

ELIZABETH SILBEREISEN (BUCER)

Elizabeth Silbereisen was another hospitality expert, married to the Reformer from Strasbourg, Martin Bucer.

She had been placed in a convent as a child, but left because of sickness and lack of spiritual education. Martin had been a monk who left the monastery after contact with Martin Luther. Elizabeth was an impressively hard worker despite her lifelong ill health. At one point, her husband noted she had been unable to sleep for almost eight weeks (even though she was expecting a child) because of one of the children's coughing.[44] In the space of ten years, she had eight babies and three miscarriages. She was often caring for children who were sick, and she regularly had houseguests. Her husband once closed a letter to a friend, "My wife is busy washing. She thanks you for your gift. She offers her excuses for not writing, but we live here with seven boys and four girls. Add to this that she has only half a maid for carrying in the wood and the water and only one nanny. On top of that, she does not much enjoy writing." Elizabeth added in a postscript something every mother can understand: "I don't mind writing at all, if only those hungry stomachs and the small fry would give me a little time. Good night! Pray to God for us. Now I have to go to the kitchen."[45]

The Bucer household also took in refugees. At one point Martin and Elizabeth had eight exiles living with them. Elizabeth bore great fruit through her diligence. One of Bucer's opponents, a Catholic theologian insistent on celibacy said after visiting the Bucer home, "I have witnessed your family in Strasbourg. Your household was run very decently, I must say, so that people can praise you as a good and intelligent family man. Your

wife is modest and diligent and your children are as good and well-mannered as one could wish. If the church laws were no longer in force, I would have no objections to your marriage. I am convinced that at your age you did not enter marriage merely from desire but from necessity, not from lust but from a longing to live a well-ordered and honorable life. Many people have already had the privilege of enjoying your hospitality; acquaintances, friends, and strangers all move in with you. So you really need someone to take care of your household affairs. Who would not see that you, who do so much for everything and are overloaded with all kind of work, could not keep this up without your wife?"[46]

A few interesting points to note here: first, that marriage was not first and foremost a love affair but rather a way to work more effectively and enjoyably; and second, that even Bucer's theological opponents praised the fruit of his wife's labor. Martin himself often praised her for her humility and honesty. He was grateful for her freedom in admonishing him and noted that there was nothing in his wife that displeased him.[47]

Tragically, the Plague struck Strasbourg in 1542. Martin and Elizabeth refused to leave the city. He wouldn't leave his congregation, and she wouldn't leave him. As a result, she and five of their children died, along with two servants and a student from abroad.[48] Hours before her death, she called her friend Wibrandis Rosenblatt to see her. Wibrandis's husband, Wolfgang Capito, had succumbed to the Plague just the day before.

Elizabeth followed her husband's example and did a little matchmaking of her own. She knew her husband needed a wife, and Wibrandis needed a husband, so Elizabeth encouraged them to marry when she passed away. Martin responded only with tears, although he did take her advice afterwards.[49] After Elizabeth's death, Martin wrote of her, "A loving God earlier gave me a wife for almost twenty years who was endowed with such self-discipline, dignity, and godliness, as well as natural kindness in all household duties and work—as many devout Christians know—that by her I was considerably assisted in my ministry. And this not only because she relieved me of all household duties and temporal business but also because by her diligence and dedication she so wisely applied and distributed the material income, which was surely not overabundant, that we were able to render far more service to pilgrims and servants of Christ than I would ever have been able to do had I remained single."[50] In short, her diligence amplified and glorified her husband's labors. She helped spread the Reformation by being a helpmeet to her husband and a hospitable hostess even on a meager income.

WIBRANDIS ROSENBLATT:
BRIDE OF THE REFORMATION

Wibrandis Rosenblatt was a godly woman with a life of trials. She was known as the Bride of the Reformation because she was married to four men, three of them Reformers. She survived them all, bless her heart.

Wibrandis was born in Basel, a hopping city of commerce and culture in the sixteenth century.[51] She married a local humanist when she was twenty. They had one child together before he died just two years into married life. After his death, she heard evangelical preaching from the Reformer, cathedral preacher, and Hebrew scholar Johannes Oecolampadius. Although he was more than twenty years her senior, Wibrandis married Oecolampadius. He hadn't intended to marry, but his friends pressured him, and then he was glad he did. He said of Wibrandis, "My wife is what I always wanted, and I wish for no other. She is not contentious, garrulous, or a gadabout, but looks after the household. She is too simple to be proud and too discreet to be condemned."[52] She was constantly hosting ministers and refugees in their home. Oecolampadius died before they'd celebrated four years together. In the same month, a friend and fellow pastor's wife, Agnes Capito, also died. Martin Bucer, in keeping with his habits, sent the new widower, Wolfgang Capito, on a trip which included a stop in Basel to meet Wibrandis. Bucer was sure they would be a good match, and so they were. Wolfgang was a Reformer in Strasbourg who was not known for his constancy. He was said to cook up fantastical and unhelpful schemes. Enter Wibrandis. She "did curb his foibles, balance his budget, and keep his household sweet, [and thus] her achievement belongs to the annals of unrecorded heroisms."[53] Capito said of his wife, "I have in her a most pure helpmate, intent on hospitality, disposed to almsgiving,

diligent in piety, encouraging to good deportment. I am not equal to her in virtue, and I fear my inferiority may offend some."[54] She had children with each of her husbands, birthing a total of eleven.

When Wolfgang died of the Plague, Wibrandis also lost three of her children.* When Elizabeth Bucer died almost simultaneously, Martin Bucer and Wibrandis determined to marry. The Catholic Church taught that one who held office could not marry again upon his wife's death, basing this on Paul's instruction in 1 Timothy that an overseer must be a husband of one wife, so Martin and Wibrandis were criticized for this marriage. First Bucer had been a monk and married a nun, and now he was marrying a second wife who had been a widow, and two of her husbands had been ex-priests![55] Notwithstanding, they married. Their marriage contract states they married "for the furtherance of the glory of God and the upbuilding of the Christian Church."[56]

Bucer described his second wife thus: "in past years she has really proven that she is not only pure, honorable, faithful, and godly, but also a diligent helper, who fruitfully made herself useful to the church and has a gift for ministry as for many years she demonstrated in her marriage to those two precious men of God, Oecolampadius

* Some scholars have maintained that early modern Europeans were indifferent to the deaths of their children. After all, the mortality rate was quite high. However, their writings convey a deep grief over the loss of life. They aspired to rejoice in the resurrection of their children, but they rejoiced against the backdrop of their sorrow (Ozment, *When Fathers Ruled*, 166–9).

and Capito."[57] She continued the unending hospitality of the Bucer household, taking in Bucer's father and step-mother for a time as well as her own sick mother and "all kinds of guests who stopped over" (as Bucer himself said) even when she was sick herself.[58] After following Bucer to England, where he had been exiled and then died, she moved back home to Basel and lived out the rest of her days as a widow.

KATHERINE SCHUTZ (ZELL): A MOTHER TO THE POOR AND REFUGEES

We know more about Katherine Schutz Zell than most Reformers' wives because she wrote extensively. Katherine was a well-educated and outspoken woman who did not intend to marry, as well as an expert in tap-estry who initially intended to support herself with her skill.[59] However, she struggled with the doctrines of the Catholic Church, namely that her works, attendance at Mass, and confessions never seemed to be good enough to satisfy God.[60] Matthew Zell was a priest in Strasbourg, where Katherine lived, and he preached the gospel. He preached it so well, in fact, that the bishop barred the pulpit to keep him from preaching. No matter; a car-penters' guild built Zell a pulpit that they brought to the church whenever he preached. More than three thou-sand people regularly came to hear him.[61] Katherine was relieved by his preaching as she rested in Christ's work on her behalf. She and most of Strasbourg turned to Protestantism.[62] When Katherine "saw the great fear and

furious opposition to clerical marriage, and also the great harlotry of the clergy… [she] married a priest [Matthew] with the intention of encouraging and making a way for all Christians."[63] Matthew, for his part, married her to honor God. Katherine noted that he did not marry her for beauty or riches or any other virtue, because she had none! She was the first respectable citizen of Strasbourg to marry a priest. According to her description, their marriage was a sweet one, grounded in the gospel. She called herself, "a splinter from the rib of that blessed man Matthew Zell,"[64] "Matthias' wedded companion," and a "faithful help in his office."[65] She said she and her husband were "of one mind and one soul …. What bound us together was not silver and gold. Both of us possessed a higher thing, 'Christ was the mark before our eyes.'"[66]

Katherine and Matthew had two children who died in infancy, which deeply grieved her, but God brought fruit from the hard ground of her suffering. Matthew "commissioned [her] to be a 'mother to the poor and refugees.'"[67] She could not be a physical mother, but she devoted herself to becoming a church mother, and the extent of her work is overwhelming. She visited the sick, including plague victims and a victim of leprosy, as well as the poor and the imprisoned. She demanded and ensured that the hospitals improve their quality of care and food. During this period in Europe, hospitals were places homeless people took refuge and others went to die. They were unsanitary, and sometimes up to six people shared a bed.[68]

As an outgrowth of her Bible study, Katherine wrote prolifically. She wanted to spread the gospel and dispel errors through her writing. Her first published piece was a letter offering comfort to wives of refugees. In response to the Edict of Worms, authorities in one German town evicted 150 men of the parish and their pastor, and executed one man. The rest of them fled to Strasbourg. Katherine housed eighty of them in the parsonage. In her pamphlet to the wives left behind, she pressed them to trust in Christ, to look at their situation as God's gift to them, to encourage their husbands, and to stay strong, resting in God's great mercies without fear.[69] In response to criticism of her marriage, she penned several pamphlets defending her husband for marrying and using Scripture to argue against clerical celibacy. Katherine pulled no punches: "What God thus desires, [the clergy] wish to condemn, punish, and forbid for all of those who come under their power. But the lewd chastity, the diluvian, sodomistic, noachic whoredom, they do not punish, and have never punished it but rather protected it. Yes, clergymen and laymen have formed an alliance to struggle violently against God. Oh, the blindness of the rulers, how do you look to one another, [you] who should be dedicated to everything honorable?"[70]

Later, Katherine composed hymns and published a songbook with songs of faith. She exposited some of the Psalms and the Lord's Prayer and wrote catechetical pieces, prayers, and devotions, which she sent to friends in distress. In all her writings, she argued and

quoted heavily from the Scriptures, and she never shied away from controversy. She was able to write because her husband granted her "space and will to read, hear, pray, study, and be active in all good things."[71] She also corresponded with Luther, Zwingli, and Bullinger, even admonishing Luther on one occasion (which admonishment he took), but always increasing her theological knowledge through them.

The death of her husband grieved Katherine deeply. Still she continued her work for people in Strasbourg until her own death years later. Katherine's "focus was on the work that needed to be done. In that she identified herself with the women and men of the Scriptures...not wishing to be remembered as a woman, but for her acts of love and service to the city."[72]

ANNA REINHARD (ZWINGLI)

Ulrich Zwingli was a priest and Zurich's leading Reformer. He spurred on the Reformation in Switzerland by preaching about eating meat during Lent and then sitting at a table with friends who ate sausages on a fast day (he didn't eat any because he didn't like them). This caused such a stir that it became known as the "Affair of the Sausages." Zwingli secretly married the beautiful widow Anna Reinhard in 1522 and then married her publicly in 1524 after she became pregnant. Anna's first husband had been a nobleman whose father disowned him when he married her because she was a commoner. He died after thirteen years of marriage, leaving her with a son

and two daughters. She had little means, but she raised her children faithfully. Ulrich met her when he became her pastor in Zurich. She was in his parish, and he noticed the extraordinary talents of her son. He became a sort of foster father to him and eventually fell in love with Anna.

The Catholics and the Anabaptists denounced their marriage, and the townspeople protested when pregnant Anna and her children moved into the vicarage. Ulrich eventually had to obtain an order from authorities to allow the move.[73] Later, Zwingli's enemies would smash the windows of the vicarage during the night.[74] Amidst all the hostility, Anna was a faithful helpmeet to her husband, alleviating his cares, comforting him in sorrow, and encouraging him to rest when his work threatened to swallow him. She ministered to the poor and the sick, and, like all the other Reformers' wives, she had an open-door policy for Protestant refugees and guests of all sorts. After visiting their home, one leading government official declared he would never forget her hospitality and described her as an "angel-wife."[75] Anna also delighted to hear the Scriptures and Ulrich's expositions of them. Nothing gave her more joy than understanding her faith more fully. When Ulrich joined the local effort to translate the Scriptures (he began in 1525), Anna would listen to his progress nightly. After he finished, it became Anna's favorite book, and she encouraged each family in the congregation to acquire a copy.

Thanks to Anna's persistence, Ulrich averted many assassination and abduction attempts. When he had to

go somewhere alone at night, she would call a friend to travel with him. If he had a late-night meeting, she would ask someone to accompany him home. Sadly, when the Catholic regions of Switzerland took up arms against the Protestants, Zwingli was called to battle as the chaplain. Anna and the children bid him farewell in front of their home, for what was to be the last time. She said to him, "We shall see each other again if the Lord will. His will be done. And what will you bring back when you come?" Ulrich promised, "Blessing after dark night." After he rode away, she threw herself upon the Lord, "Father, not my will, but Thine be done."[76] On that same day, her husband, son, brother, and brother-in-law died and soon after her son-in-law. It was a devastating loss. Anna and her two daughters then moved into the Bullingers' home, where she lived until she passed away some years later, "softly, like a mild light, and went home to her Lord, worshipping and commending us all to God."[77]

ANNA ADLISCHWYLER (BULLINGER): MOTHER OF ZURICH

Anna Adlischwyler was born to a reputable cook and citizen in Zurich and his wife around 1505. Her father died when she was young, leaving her a reasonable inheritance.[78] At some point she joined the cloister. As a result of the Reformation in Zurich, Zwingli came to the cloister to preach, and he brought Heinrich Bullinger along with him. Heinrich fell in love with Anna. He wrote her a letter asking for her hand and attempting to persuade

her not to waste her life in the convent. He presented arguments for the Reformation and for marriage, laid out his financial and moral situation, and declared his love for her. Although she agreed to marry him, Anna wanted to wait and care for her dying mother who opposed the marriage. She even tried to renege on the engagement, but Heinrich persisted. Six weeks after her mother died, Anna and Heinrich married.[79]

Bullinger took Zwingli's place upon Zwingli's death, and he was the head pastor in Zurich for forty-four years. He wrote extensively (some 150 books) in addition to voluminous correspondence with theologians, heads of state, and others, and, for the first eleven years of his ministry in Zurich, he preached six or seven times per week. Zurich was a city for refugees, and Protestant refugees came from all over Europe. The needs were great. The Bullingers endeavored to be an example of hospitality to their congregation and their city, and many followed their lead, taking in other refugee families. Anna thereby gained an international reputation for her hospitality. One of the refugees who stayed with them wrote to Heinrich, "Your friendliness and your Christian care for us during our stay with you obliges me to give you my inmost thanks. Greet for us very heartily your wife who showed herself so full of kindly service and love to us."[80] A substantial number of English Protestants fled to Zurich to escape the various waves of persecution that swept their homeland. Heinrich established a school in Zurich for these Englishmen to prepare them

for the ministry, and he and Anna hosted them and their
families in his home. John Hooper, Anglican bishop of
Gloucaster and Worcester, and his family stayed with the
Bullingers, and Hooper's wife even delivered a daughter
while she was there. Houseguests giving birth elevates
hospitality to a new level. Many of the men who stayed
with the Bullingers returned to England upon the death
of Queen Mary I, whose persecutions against Protestants
earned her the nickname Bloody Mary, and there they be-
came leading Puritans. All of them wrote and specifically
thanked Anna for her hospitality. Later Queen Elizabeth
I sent the Bullingers an ornamental goblet to thank them
for their service to her fellow Protestant Englishmen.[81]
In addition to refugees, the Bullingers also welcomed
many visitors who stayed with them, including theolo-
gians like Farel, Calvin, Bucer, and Capito, and even no-
bility, including the King of Navarre's ambassador. They
took in students (whose education they paid for), an or-
phan, a few Polish boys with their tutor and family, and
Heinrich's parents. The widowed Anna Zwingli and her
two daughters moved in with them. The Bullingers had
eleven children of their own, so theirs was always a full
house. Anna had help from her mother-in-law and also
from her dutiful but poorly paid servant Britta, whose
devoted service over the years made her "the model ser-
vant girl of the Reformation."[82]

Despite their very modest income, Anna habitually
gave food and clothing to the extremely poor in Zurich.
She and other pastors' wives set up a mercy ministry

to the poor. Because of her work, the people of Zurich referred to Anna as "the mother of the city," and her charitable work gained her an international reputation. The influence of the Bullinger household was widely felt in the new Protestant world. Theodore Beza, another Reformer, called Bullinger "the common shepherd of all Christian churches."[83] In addition to his influence on the English Puritans, Heinrich Bullinger was an able theologian writing commentaries on many books of the Bible, coauthoring the First Helvetic Confession, and meeting Calvin and Farel to reach an agreement on the sacraments that helped unite the Reformed churches in Geneva and Zurich.[84]

Like many other faithful wives, Anna's service in the home made her husband's accomplishments possible. She had been born into a reputable home with an inheritance, had moved to the convent, and had tried to get out of her marriage to Heinrich, but God had a much more magnificent storyline in store for her. He used her in mighty ways that she could not have expected back in those early days in the convent. Her generosity and self-sacrifice touched more people than she could have dreamed possible. Much to Heinrich's grief, Anna died in 1564 after nursing him back to health from the Plague. The Bullingers left a faithful legacy for the next generation. Although three of their sons died young, two became ministers and one served in the army of William of Orange. All five of their daughters married theologians and pastors, as well.[85]

IDELETTE D'BURES: THE BEST COMPANION OF JOHN CALVIN'S LIFE

John Calvin, the great Geneva Reformer, married the widow Idelette d'Bures at the recommendation of his friend and everyone's favorite matchmaker, Martin Bucer. Idelette watched over Calvin in sickness, upheld him and comforted him in physical and spiritual trials, prayed for him in persecution, visited the sick with him, and of course hosted refugees in their home in Geneva. We know very little about their marriage except that they lost three infants in a short time and had no surviving children. Calvin said upon his wife's death, "I have been bereaved of the best companion of my life, of one who, had it been so ordered, would not only have been the willing sharer of my exile and poverty, but even of my death. During her life, she was the faithful helper of my ministry."[86]

KATHERINE KRAPP (MELANCHTHON)

Philipp Melanchthon was a dear friend of Martin Luther and also a Reformer in his own right. He was a brilliant man, subdued and gentle, in contrast to Luther's bold and energetic approach. He systematized much of Luther's teaching and also wrote his own commentaries on the New Testament as well as books on grammar, ethics, and physics. He is still known as Germany's teacher. Like so many other Reformers, Melanchthon long resisted his friends' efforts to help him get married, but at last, they convinced him. He married Katherine

Krapp, a pious and faithful woman who was ever looking out for her husband. His affection for her grew over their years together. Theirs was the first Reformational hearth in Wittenberg, and, as a result, their home was always full of guests. They never turned anyone away.[87] Katherine took such wonderful care of her husband that he remarked, "She always thinks I am dying of hunger unless I am stuffed like a sausage."[88] Their generosity was so great it was a wonder they survived. They were married for nearly forty years and had four children.

CHAPTER 15

OTHER FAITHFUL WOMEN:

The Antidote to Feminism

S tories about the Reformers' wives are inspiring, espe-
cially for pastors' and theologians' wives. However,
for the Reformation to be successful, faithfulness had to
spread beyond the pastor's home. Although the lives of
ordinary early Protestant women are not recorded for
us, we know that the Reformers' teaching honoring mar-
riage and the female sex transformed the lives of wom-
en in every station of life. And we do have the stories

of some extraordinary women—those with exceptional gifts or positions of influence—preserved for us. These early Protestants made significant contributions to the Reformation, supporting their husbands and employing their gifts for the glory of God. Many women besides pastors' wives made significant contributions to the Reformation, supporting their husbands and employing their gifts for the glory of God.

OLYMPIA MORATA

Olympia Morata was a fantastically brilliant Italian scholar. Her father was a teacher and provided her with an excellent education. He began teaching her Latin and Greek when she was twelve, and within a few months she spoke them fluently. By the time she was fourteen, she was considered the most learned woman in Europe. Even now, her Latin translators are amazed at her grasp of the language, the way she wielded it, and the profusion of her allusions to classical literature. At the age of twelve or thirteen, she became the tutor and court companion of Anne d'Este, daughter of Renee d'Este, Duchess of Ferrara. Olympia and Anne studied together, and Olympia gave lectures on Latin classics. Anne's mother Renee had Protestant leanings, much to the dismay of Anne's father, the duke. Renee's court was full of the best scholars of the day, including John Calvin. However, at this time Olympia was uninterested in theologians and the Bible. She was smitten with the classics instead.

After a number of years at the court, Olympia had to leave to care for her sick father. At some point, he had converted to Protestantism, and his conversion instigated Olympia's. By the time he passed away, Olympia's friend Anne had been married off, and Olympia was no longer welcome at court. "She was forbidden to read the Bible, was friends with persecuted Christians, [and] was dismissed by the Duke of Este."[1] She could have stayed at court had she converted to the Catholic faith, but instead she opted to live with her sick mother and four siblings. She rejoiced over this hardship for "if I had remained any longer in that court, it would have been all over for me and my salvation."[2]

Andrew Grunthler was a well-known medical scholar who had attended lectures in Italy. He had heard tales of Olympia's brilliance, and when he had occasion to meet her, he admired her intellect. His admiration grew into love, and she happily returned his affections even though he had no money to offer her. A friend of Andrew's said Olympia married him "so that she could more easily devote herself to sacred literature."[3] They married in 1549 in the little Reformed church of Ferrara, and she even composed a hymn for their wedding. When the persecutions in Italy increased, Andrew and Olympia chose to flee to Germany. They took along Olympia's eight-year-old brother Emilio so she could teach him, but they left behind her widowed mother and her sisters.

Olympia continued to study, learn, and carry on extensive correspondence throughout her life with friends,

family, theologians, and scholars. She delighted in learning and procured Luther's works in Italian and Calvin's commentaries on Lamentations.[4] She translated Psalms into hexameters and sapphics (ancient Greek poetic forms), which her husband then set to music.[5]

Olympia was a prolific correspondent, writing letters about theological matters, letters of advice and encouragement, and letters full of news.[6] She even wrote a letter to her childhood companion Anne d'Este, who had become Duchess of Guise in France. When Anne's husband, the Duke of Guise, persecuted French Protestants, Olympia exhorted Anne to stand up and help the innocent who were being murdered, which was a risky suggestion to make.[7] "You know, my sweet princess, how many innocent persons now are burned and crucified for the gospel of Christ. Surely it is your office to speak up on their behalf. If you are silent, you conspire in their death."[8] Anne remained Roman Catholic, but she was the only member of the French court who publicly opposed the persecution of Protestants.

Olympia offered wise advice to her friends, exhorting them to read the Bible, "Therefore seek Christ. Have no doubt: you will find Him in the books of the Old and New Testament, nor can he be found anywhere else. Pray to Him. Your labor will not be in vain. 'He who calls on the name of the Lord will be saved.' Would so many very rich and great promises be in the sacred books unless God wanted to keep them?"[9] And to another friend, "Make sure a day does not pass without reading with

devotion, praying to God through Christ that He will illuminate things for you in the Holy Scripture."[10] And on sin, she wrote, "We dress our body beautifully, but we go out naked in what pertains to the soul. We want to have laden tables, but we have no desire for the Word of God, which is the only sweet food for souls. Human perversity is incredible."[11] On another occasion, she wrote a dialogue to encourage one of her friends, and in it she explained why she studied so much. "For my part, when I considered the matter over and over again as diligently as possible, I could find no other reason for me to work at these studies than 'it lay at the feet of God.' He gave me the mind and talent to be so on fire with love for learning that no one could keep me from it.... Everything is done according to His plan and purpose, and He does nothing rashly or thoughtlessly. So all these things perhaps will be for His glory and my betterment."[12]

Olympia's husband received an offer from Ferdinand of Austria to be the chair of medicine at Linz. Ferdinand was a devout Catholic, but the position promised wealth and honor. Andrew and Olympia discussed it, and she replied on behalf of her husband, "We greatly appreciate your generous offer and would gladly accept it if there were no obstacle, but you must know that we are enrolled under the banner of Christ and cannot desert on pain of eternal damnation. Please let us know whether Antichrist rages at Linz, as we have heard."[13] Somewhat obviously, they didn't go. They moved instead to Andrew's birthplace, a small village called Schweinfurt, where Andrew

had been assigned to be a physician for the Spanish soldiers stationed there.

In Schweinfurt, Olympia, who had been a great scholar in a world-renowned court, spent her time educating her brother, corresponding, and translating without complaint. She missed her family and friends, but she had her books, and for that she was grateful. Unfortunately, Albert of Brandenburg decided to use insignificant Schweinfurt to defend himself against the Holy Roman Emperor. He laid siege to it, pillaging, plundering, killing, and inciting famine. Almost half the village died from brain fever.[14] At one point, Olympia, her husband, and her brother lived underground in a wine cellar for three weeks, afraid to come out. Eventually Albert surrendered, and then, instead of peace, the Holy Roman Emperor's troops came in and finished off the village. Olympia, Andrew, and Emilio narrowly escaped from being burned alive in a church, but they lost all their possessions, including her writings and their books, when they fled. On their way Andrew was twice taken captive and released, and robbers took their clothes, leaving them to run ten miles to the next village at night, barefoot. She cried out to Lord, "Help me, help me, for the love of Your name."[15] In a letter to a friend recounting these events and comparing her current trials to her previous life at court, Olympia said, "In all these evils, we have relied on one solace—the Word of God by which we sustained ourselves and because of which I have not looked back to the fleshpots of Egypt,

but preferred to seek death here, rather than enjoy all the pleasures of the world somewhere else."[16] They were eventually welcomed in the Palatinate (another region in Germany) by a believing Count and Countess who kindly nursed them back to health and arranged a position for Andrew as a medical scholar in Heidelberg. It was at this time that Olympia's brother Emilio turned to the Lord.[17]

The three of them moved to Heidelberg, but when they arrived they could not even afford their rent and had to take out loans. Publishing houses had taken pity on them and donated books to them to restore their library, but they had very little else. Olympia spent her time reestablishing her household, corresponding, and continuing to educate Emilio in the Bible and the classics, but all of the trials took their toll. Olympia fell ill and did not recover. She died in Heidelberg at the age of twenty-nine most likely from tuberculosis. Her grief-stricken husband treated plague victims with abandon and died about a month later from the Plague, and her brother Emilio soon followed.[18]

CHARLOTTE LAVAL

Charlotte Laval was a courageous woman married to French nobleman and Protestant convert Gaspard de Coligny. The Spanish captured Gaspard and imprisoned him for two years. During that time, he became a Calvinist.[19] Before he publicly announced his conversion, he asked Charlotte whether she were ready for the inevitable persecution that would follow. She replied

that Christ's church is always persecuted, and then she pledged her faith as well.

The anticipated persecution did not tarry. Coligny and his fellow Huguenots (French Protestants who adhered to Calvin's theology) wanted religious tolerance from the king, but the king was uninterested in tolerance. In 1562, one of the other noblemen, the Duke of Guise (Anne d'Este's husband), massacred a group of Huguenots, and Coligny hesitated to join the defense against the Catholic nobles. His brothers came to ask him to lead the Protestant resistance, but Coligny was not convinced they would succeed.[20]

That night, an impassioned and unyielding Charlotte woke him with her weeping,

> I am sorry to wake you with my worries, but when the members of Christ are rent how can one be insensitive? Your feeling is no less strong than mine but you conceal it better. Do you take it amiss that your loyal half lets her tears fall on you with more boldness than respect? Here we are, couched in comfort while our brothers, bone of our bone and flesh of our flesh, are some in prison and some dead in the fields at the mercy of dogs and crows. This bed is to me a tomb because they have no tombs. These sheets are a reproach because they have no shrouds. Shall we snore in sleep and not hear their cries in death? I recall the prudent arguments with which you shut the mouths of your brothers. Will you take the heart out of them, too? I tremble because this prudence

savors of the world and not of God, who has given you the skill of a commander. Can you in conscience refuse? Does not your conscience bite you? Is it not the voice of God? Don't you fear that He will hold you guilty? Is the sword which you carry meant to oppress the afflicted or to pull out the nails of tyrants? You have confessed the rightfulness of taking up arms against them. Can your heart, then, abandon the love of right for fear of failure? God takes away the sense of those who resist Him under pretense of sparing the shedding of blood. He saves the soul that is willing to be lost and damns the soul that would save itself. Monsieur, I have on my heart the blood already shed. Their blood and your wife cry to God in heaven and from this bed I say you will be a murderer of those you do not save from murder.

He replied,

Look at our weakness Put your hand to your breast. Sound your constancy. Are you able to face the debacles, the reproaches of enemies and partisans who measure justice by success, the treachery of our friends, the exiles in store in foreign lands, the rebuffs of the English and the Germans, your shame, your nudity, your hunger, and what is worse those of your children? Can you face your death at the hands of the butcher after witnessing the body of your husband exposed to the jeers of the mob and your children enslaved by your enemies? I give you three weeks.

> If then you are ready to face all this I will go and
> die with you and our friends."

She answered,

> The three weeks are up right now. You will nev-
> er be beaten by the virtues of your enemies. Use
> your own and let not the deaths to come in the
> next three weeks be upon your head. I beg you
> in the name of God, don't let us down. If you do,
> I will testify against you in the judgment day."[21]

As one historian aptly remarked, "Woe to the man
whose wife joins the prosecution at the judgment day!"[22]
And so, together with their children, they joined the
Huguenot soldiers. Charlotte cared for the wounded
soldiers and buried her own son. After the battles, they
moved to the French Huguenot stronghold. Charlotte
died in 1568, and her widower Coligny became the trag-
ic center of a plot to murder thousands of Huguenots on
the night of August 23–24, 1572. Catherine de Medici,
mother of France's king, arranged for her daughter to
marry the leader of the Huguenots, Henry of Navarre
(a region between Spain and France). When all the
Huguenots descended upon Paris to celebrate the mar-
riage, Catherine had Coligny shot and then falsely
claimed the Huguenots would exact revenge. To thwart
their alleged plans, Catherine ordered all the Huguenots
in Paris to be killed at the stroke of midnight. When the
bells tolled, Coligny was thrown from his window, the

first victim. Next was his son-in-law, and then followed thousands more, an event that came to be known as the St. Bartholomew's Day Massacre.[23] We will return to the story of Charlotte and Gaspard's daughter, Louise, (whose husband was the second victim of the massacre) in the next chapter.

MARGARET BLAURER

The Reformers emphasized fruitfulness, primarily through marriage. "Next to God's Word, there is no more precious treasure than holy matrimony. God's highest gift on earth is a pious, cheerful, God-fearing, home-keeping wife, with whom you may live peacefully, to whom you may entrust your goods and body and life."[24] However, many Protestant women were widowed or were abandoned by their unbelieving husbands. Other women did not marry, either from choice or from circumstance, but their lives were given over to bearing fruit. Katie Luther's Aunt Magdalena, for instance, escaped from the convent with her and rather than marrying herself, moved in with Martin and Katie, helping them care for their children and run their home. She also nursed the two of them when they were sick.

Margaret Blaurer was another early Protestant woman who chose not to marry. She was uninterested in marriage because she believed she could live more fruitfully without a husband. The Reformers acknowledged that some, a very few, had the gift of celibacy and were content and fruitful in their single lives, and Margaret was one of

those people. Her brother was Ambrose Blaurer, a former monk and then Reformer in the regions of Konstanz and Wurttemberg. Ambrose said, "Her life as a single woman, which produces so many ripe fruits of faith, is much happier than any marriage could be."[25] Martin Bucer, who was friends with Ambrose and Margaret, often tried to persuade Margaret to marry, but to no avail. She preferred the services she could offer the church through her unmarried state. Recognized widely as a learned woman, she studied Latin, and Martin Bucer encouraged her to study Greek so she could read the New Testament in the original.[26] When trials such as drought, plague, and earthquake struck Konstanz, Margaret served the people even at the risk of her own life. She also taught poor children to read and visited widows and orphans as well as extending hospitality. Margaret "founded the first Protestant women's society to care for the sick."[27] She died at the age of forty-seven.

PROTESTANT WOMEN IN POWER

A good many women during the Reformation faced an enemy in their own homes: their husbands weren't interested in the gospel and sometimes held positions of power in a government colluding with the Catholic Church. As one woman professed, "[my husband] persecutes Christ in me ... [but I will not disobey God] though it cost my neck a thousand times."[1] Some of the more determined Catholic husbands exerted every effort to persuade their wives to return to Rome. They

brought priests, confessors, and the like to debate their wives, sometimes when the wives lay on their deathbeds. And yet, the women remained steadfast. Sometimes the women outdebated their opponents, showing a clear and deep knowledge of Scripture. Sometimes they were simply denounced as "stubborn," refusing to waffle in their convictions. And sometimes, they were so close to death, they simply refused to participate in any debates, being so near to meeting their Redeemer.

On the other hand, God blessed many of these women with positions of power when their husbands died. In France and some parts of Germany, we see the impact of not just wives of Reformed theologians and ministers, but of royalty and nobility. French and German noblewomen helped achieve toleration for the Huguenots or other Protestants, advancement of the Protestant faith, and aid to refugees. These women worked—sometimes alongside their husbands, sometimes in opposition to their husbands—to raise godly families (when their children weren't taken from them) and to spread the Protestant cause.

CHARLOTTE DE BOURBON

Charlotte de Bourbon was placed in a convent by her parents at a young age despite her vigorous protests. She later became an abbess, still under protest, and there she remained for twelve years. At some point along the way she encountered a young Huguenot man, and through that connection she became a Calvinist Huguenot. After

spreading doctrines of the Reformation in the convent, Charlotte escaped, pretending to be visiting an abbey with other nuns, and fled to Calvinist Heidelberg, much to her father's dismay and anger. She was high-ranking enough to attract the attention of the French court, which ordered that she be found and punished.[2] However, in Heidelberg she enjoyed the protection of the elector, Frederick III, and spent her time caring for refugees. None of her father's efforts to recover her succeeded.

After a few years in Heidelberg she met William the Silent (Prince of Orange), the founder and liberator of the Netherlands. "She was a penniless, refugee nun; he was a wanted man with all of Catholic Europe against him. They decided to marry,"[3] which they did three years later. Charlotte made their home a loving and peaceful refuge and took in William's relatives. This meant, first of all, William's five children by his previous two marriages. Together Charlotte and William had six more children. She encouraged her husband when everything appeared hopeless, "Humanly speaking it will be very difficult for you, receiving no support, to resist such a formidable adversary [Catholic Spain], but do not forget that the Almighty has until now delivered you from great perils and with Him everything is possible."[4] His brother noted, "William held up amazingly under frustrations, and it was chiefly because God had given him such a wonderful wife."[5] She ran her household well, and assisted her husband in his endless work. He directed all communications from the Flanders estates be addressed to

her because she was a trustworthy helpmeet.[6] In the end, her father came around and approved of her marriage. Upon Charlotte's death in May of 1582, he took charge of one of her daughters, even raising her as a Protestant, though he himself remained Catholic.

LOUISE DE COLIGNY

Now we return to the daughter of Gaspard de Coligny, a woman of many sorrows and many gifts. After Charlotte de Bourbon died, William married Louise de Coligny. Louise's parents had ensured that she receive a good education. She was charming, sweet, intelligent, and beautiful.

After her mother died, Louise spent some time at the court of Jeanne d'Albret, the Calvinist queen of Navarre, whom we'll meet later. Louise had many suitors. Her father recommended one who was not wealthy but was honorable, a man much loved in France, Charles de Teligny. They were married when Louise was sixteen, just a few short months before Charles and Louise's father were killed during the St. Bartholomew's Day Massacre.[7] No one knows quite how, but Louise escaped and raced to their family home, where she warned her stepmother and siblings. As a precaution, they all fled separately. Louise made it to Switzerland and then later to Heidelberg. She returned to France after the Edict of Beaulieu granted religious tolerance to the Huguenots.[8] The French government offered her land back to her if she would recant and return to Catholicism, but she refused. Her father had once told her, "The loss of earthly

goods and property even unjustly is not something to lament if you have treasures laid up in heaven."[9]

In April of 1583, she married William of Orange, becoming his fourth wife. William proposed to Louise before they had met. She received permission from the King of France to marry him, and off she went to her new country.[10] She was twenty-seven. Although the people of the Netherlands were not particularly excited about their new queen, she and William had a happy marriage.[11] Louise was politically astute, socially intelligent, well-educated, and a wise counselor to her husband. She was also a capable wife and mother. She cared for his children from his previous marriages, and they grew to love her as she did them. She also bore a son to William, Frederick Henry.

The Catholic King Philip II of Spain had offered a bounty on William's head, and he had survived one previous assassination, so Louise was concerned about possible further attempts on his life, and rightly so. One particular servant raised her suspicions, but William was unfazed. On the day of his assassination, Louise asked William about this servant, "Who is that sinister looking man? What does he want?"[12] The man was allegedly asking for a passport, but when William went to sign it, the servant murdered him. The date was July 10, 1584, a mere fifteen months after Louise's marriage to William. Louise was a thirty-two-year-old twice-widowed orphan, whose husbands and father had all been brutally murdered. As one of her biographers noted, "Louise had

the advantage to be born of the greatest man in Europe and to have had two husbands of very eminent virtues, but she likewise had the misfortune to lose all three of them by sudden, violent deaths, her life having been a continuous series of afflictions able to make many sink under them, but a soul like hers had resigned itself entirely to the will of God."[13]

Upon her second husband's death, her stepson Maurice became king. Louise had six stepdaughters, a six-month-old son, and no income. William had used all of his money to fight off Catholic Spain, and upon his death, he left her only debts. Here, her skill in correspondence and persuasion came to the forefront. She wrote to relatives and Dutch officials requesting financial support.[14] Finally the Dutch provinces provided her an annual income beginning in 1592.[15] She sent some of her stepdaughters to live with relatives, but she personally educated the others, giving them as good an education as any European nobleman would have received complete with reading, writing, languages, music, and dancing.[16] Her pastor educated little Frederick Henry.

Louise developed a deep love and care for her children and later her grandchildren, and they reciprocated. She became a bit of a matchmaker and married off her stepdaughters to French Huguenot noblemen. In 1598, Louise moved back to France, but she returned to the Netherlands in 1603 and remained active in politics, negotiating with her sons-in-law and Henry IV of France and also between her stepson and Henry IV.[17]

In 1620, she moved to France again and grew gravely ill. The French did not miss an opportunity to try to bring her back to the Catholic faith. They sent Cardinal Richelieu to visit her. When he arrived, she was flanked by her Reformed pastor and a devout Protestant woman. Richelieu warned her, "Madame, take care of your soul. You have two evil spirits beside you."[18] She was unmoved. She declared herself "firm in the foundations of the Reformed faith, her hope of heaven was solely through Christ."[19] Shortly thereafter, she died. After Louise's stepson Maurice died, her son Frederick Henry became king of the Netherlands. Through him, Louise became the great grandmother of William I, who married Mary, moved to England (becoming William III of England), and carried on the Reformation in England and Scotland.

ELISABETH OF BRANDENBURG

Elisabeth, wife of Joachim I, elector of Brandenburg lived peacefully with her husband for twenty-five years until one Easter when she took both the bread and wine in communion (a practice forbidden by the Catholic Church). It was a sign of her change of heart; she had converted to Protestantism through reading Luther's works. Her husband demanded that she return to the Catholic faith, or he would imprison her for life. She refused. She fled to relatives in a region friendly to the Reformation.

Joachim I was a man of many indiscretions. Elisabeth would have lived contentedly with him, despite his

adulteries, but only if he would continue to share the marriage bed with her, and if she could have her own choice of preacher and take the bread and wine during communion. He rejected her stipulations. Eventually her husband gave her a castle to live in, but she had no food and nearly died of starvation. Her husband sent her no money, and her sons were not permitted to see her.

Even when her husband died, she refused to return home unless her sons allowed her to impose Lutheranism throughout the area where she would live. Having sworn to their father they would do no such thing, they refused. However, eventually they persuaded their mother to return when they abandoned some popish elements of their worship.[20] She finally relented and lived her last ten years in a castle outside Berlin. Despite Elisabeth's difficulties, through her, the Reformation spread to Brandenburg.[21]

ELISABETH OF BRAUNSCHWEIG

Elisabeth of Braunschweig was the daughter of the exiled Elisabeth of Brandenburg. For the first ten years of her marriage, she and her husband were both Catholic, but then she converted to the Protestant faith. Her husband was more tolerant of her than her father had been of her mother. He was satisfied with each of them having their own religion. Elisabeth was determined to evangelize the land. Three cities bought their religious freedom through payments to her husband. Then she headed to the countryside to evangelize there. When her husband died, she

ruled Braunschweig for five years until her son was of age.[22] The region went through periods of Catholicism and Lutheranism, but through Elisabeth's influence, after her death, all of Braunschweig adopted the Augsburg Confession, a Lutheran statement of faith.[23]

MARGUERITE DE NAVARRE

A second influential mother-daughter pair was Marguerite de Navarre and her daughter Jeanne d'Albret. Where the Elisabeths had been influential in eastern and central Germany, Marguerite and Jeanne changed the religious landscape of Navarre, a region between Spain and France, and influenced French religious life as well. Marguerite was queen of Navarre and sister to Francis I, king of France. She was born in to the "poor side of the royal family" in 1492,[24] and in 1498 her uncle became King Louis XII. Louis, who had no male heir, was increasingly nervous about Francis's potential ambitions, so he kept Marguerite and her family under house arrest. Louise, Marguerite and Francis's mother, loved books and passed on her love of learning to her children. She was a tough woman. Her husband had a live-in mistress, and there is no castle large enough for that. Furthermore, the king sent a spy to watch her every move. She endured all of this and focused instead on educating her children. She ensured that Marguerite learned languages and literature unlike most aristocratic girls of that period. When Marguerite's father died, he left a library which Louise and Marguerite both enjoyed.[25]

Louis died when Marguerite was twenty-seven. Her brother became king, and she joined his court. As a result of Louise's devotion to education, King Francis I created one of the most brilliant courts of the century.[26] His court retinue was huge and moved frequently, bringing all twelve thousand horses and three to four thousand men and women along, including Marguerite.[27] She was a sharp-witted, entertaining, and diplomatic presence at the court.[28] When Francis's archenemy, Holy Roman Emperor Charles V, captured Francis and took him back to Spain, Marguerite negotiated his release. The pope wrote to her asking for a favor, and other envoys and diplomats sought her good graces, recognizing her intelligence and her position as one of the king's closest advisors.[29] Marguerite's first marriage was loveless and childless but politically advantageous for France. She was high-spirited and brilliant; he was dull and boring. Her second marriage was far more suitable to her personality. He was King Henry of Navarre, a womanizer, but an interesting and intelligent man. They had two children, but only their daughter, Jeanne, survived.[30]

Marguerite loved God, and she loved her brother. Francis described Marguerite as "the only woman I ever knew who had every virtue and every grace without any admixture of vice."[31] Marguerite was also the most educated woman in France during her lifetime.[32] She studied the Bible, commentaries on the Bible, law, mathematics, geography, Latin, history, philosophy, Hebrew, English, Italian, and Spanish.[33] And she routinely engaged with

scholars and theologians at her court, discussing passages of Scripture and enlarging her mind. She translated at least one of Luther's works into French, and she corresponded with Calvin.[34] Most likely, her move toward Protestantism began with her relationship with the reformist Bishop of Meaux. In the 1520s many of Marguerite's close friends and family died—her sister-in-law Claude, her niece Charlotte, her favorite aunt, and others. This threw her religious views into a tailspin, and she sought counsel from the Bishop of Meaux. They established a correspondence, and through their letters he guided her.[35] Marguerite came to saving faith, although she never became a Protestant. She preferred to try to reform the Catholic Church from inside of it.[36]

When the Huguenots faced persecution in France, Marguerite used her influence to exonerate as many as she could.[37] Her brother knew her Protestant leanings and acquiesced to many of her requests for leniency. At times Marguerite also employed those under suspicion in her court, thereby allowing them to avoid condemnation.[38] On one occasion she persuaded her brother to free Clement Marot, whose French translation of the Psalter would be used by the French church for hundreds of years.[39] Unfortunately, as the battle between the Huguenots and the Catholics raged on, Marguerite's influence over her brother waned. Her Protestant friends were persecuted and burned at the stake, and she became powerless to stop it. She retreated into her writing. Marguerite authored numerous works—poems,

epistles, stories, and plays. Despite her declining power, Marguerite prepared the way for the Huguenot movement that would occur under her daughter, Jeanne d'Albret, when Navarre became a refuge for Protestants fleeing France. Of her daughter's work, Marguerite said, "God, I am assured, will carry forward the work He has permitted me to commence, and my place will be more than filled by my daughter, who has the energy and moral courage, in which, I fear, I have been deficient."[40]

JEANNE D'ALBRET

Jeanne d'Albret was a single-minded queen who established the Reformed church in her kingdom despite criticism, war, political pressure, defeat, and loss of family. Jeanne was born in 1528 to Marguerite de Navarre. King Francis I, Marguerite's brother, removed Jeanne from her parents in 1530 to raise her in the Roman Catholic court of France. This was typical of the time for prominent Protestant (or in this case, Protestant-leaning) families.[41]

Much to Jeanne's dismay, her uncle, King Francis, decided she should marry a German duke for political reasons. She was twelve. She was so opposed to the marriage that she refused to go through with it, and Jeanne was a force to be reckoned with despite her youth and political powerlessness. King Francis tried to persuade her. Then he enlisted her parents' help, but they, too, were unsuccessful. Actually, Marguerite also disapproved of the marriage, but she was unable to change her brother's mind. The ceremony had to have been one of the most

awkwardly tragic weddings in history. Young though she was, Jeanne filed two official protests before the wedding, complaining that it was against her will.[42] Then, with all the court watching, the bejeweled and bedecked Jeanne refused to walk down the aisle. One of the king's officers had to carry her to her future husband.[43]

After the marriage, Jeanne moved to her mother's court while her new husband went to war. There she met Protestants who began to influence her views and lead her away from the Catholic Church. Marguerite conveniently found excuses to prevent Jeanne from seeing her husband and consummating the marriage. In time, Francis I lost political interest in Jeanne's husband. Because she had filed protests, and because she and her mother had ensured the marriage was never consummated, they were able to get it annulled by the pope.[44]

Jeanne's second marriage, to Antoine de Bourbon, was politically advantageous but also full of love. They had five children, two of whom, Henry and Catherine, survived to adulthood. They had a happy marriage (despite his infidelities) for almost two decades until she formally adopted the Reformed faith in 1560, just one year after becoming queen of Navarre. Antoine simultaneously realized the Reformed faith would not further his political ambitions. About her conversion, Jeanne said, "A reform seems so right and so necessary that, for my part, I consider that it would be disloyalty and cowardice to God, my conscience and my people, to remain any longer in a state of suspense and indecision."[45] Jeanne never shared

her mother's hesitations about confessing the Reformed faith. She boldly made Calvinism the official religion of her kingdom, and in response, some people watching from Paris converted.[46]

Catherine de Medici, mother of the teenaged King Francis II (grandson of Francis I), was ruling France as regent and tried to drive a wedge between Jeanne and Antoine. She wanted to annex Navarre to France, and their difference in religion seemed a convenient means to her end. Antoine's commitment to the Protestant cause had been half-hearted at best, so when he was in Paris, Catherine persuaded him to go to Mass, and he thereby committed himself to the Catholic Church. When Jeanne heard, she commented, "He planted a thorn not in my foot, but in my heart."[47]

Soon, Jeanne went to Paris to visit Antoine and brought their son Henry along. All was not well. Her enemies threatened to throw her into the River Seine.[48] Antoine threatened to divorce her and permanently imprison her if she would not go to Mass.[49] Then Catherine joined the fray, urging Jeanne to submit to her husband and trying to force her to go to Mass. Catherine refused to let Jeanne hold Protestant services in her own home, but Jeanne was undeterred. She went to the homes of other noblemen to worship.[50] Jeanne and Antoine had many intense and vociferous disagreements about their religious differences, so that just about everyone was privy to their problems. Even Geneva knew about it. Calvin wrote to encourage Jeanne, "I know, Madame,

you are their prime target. Do not fail to stand firm."[51] Catherine escalated. She threatened Jeanne with the loss of her son, but Jeanne was unmoved despite all she stood to lose. "Jeanne answered that were she in possession of her son and her kingdom she would plunge them both to the bottom of the sea rather than go to mass."[52]

Finally, Antoine and Catherine forced Jeanne to leave France, but they refused to allow Henry to go back to Navarre with her. They took Henry so they could rear him in the (immoral) Catholic court of France. Jeanne made him promise never to attend Mass, and then she returned home amidst threats on her life as she moved through enemy territory. Conflict between husband and wife and between Catholics and Huguenots continued for years, but as he died, Antoine said that were he to have lived long enough, he would have subscribed to the Augsburg Confession.[53]

After Antoine's death, Jeanne courageously "abducted" her own child from the French court. She got permission to take him to a town about a hundred miles southwest of Paris, but not all the way to her kingdom. To ensure their safety, she sent a courier ahead to Navarre, asking for an armed escort to come meet her. Six hours later, she and Henry began riding on horseback through the night to her kingdom.[54] They arrived unharmed, and she was finally free to instruct her child as she saw fit. She established her own rules for Henry's education, focusing on the Reformed faith. For the rest of her life, she pled with him to stay faithful to the Bible.[55]

The enemies of the Reformation despised Jeanne. She survived plots on her life, attempted abductions, threats of war, and the threat of confiscation of her kingdom. Sometimes she heard about the danger from friends and once from the wife of the king of Spain. She used diplomacy when necessary and tenacity when that failed.

At one point, Jeanne became the military commander for the Huguenot forces as they fought the French Catholics, inspiring them to continue fighting after their previous commander had died. As she recommended her young son to lead the army back into battle, she said, "Soldiers, I offer to you everything in my power to bestow—my dominions, my treasures, my life, and that which is dearer to me than all, my children. I make here a solemn oath before you all—and you know me too well to doubt my word—I swear to defend to my last sigh the holy cause which now unites us, which is that of honor and truth."[56] From there the army had great victories until the Catholic forces made peace with them as they approached Paris.

Jeanne was a staunch Calvinist, in fact "the highest ranking Frenchwoman ever to become a Calvinist."[57] She was a wise, intelligent, and generous ruler, not to mention fearless, and she devoted herself to aiding the growth of the Reformed faith in Navarre.* Her efforts enjoyed much success. Jeanne had the Bible translated into the Basque language of her people at her own

* Huguenots were French Calvinists, those who followed the teaching of French Reformer John Calvin. Calvinists of any origin (French or otherwise) hold to Reformed Protestant doctrines.

expense, and she also had the Genevan Catechism[†] and new liturgy translated. In her spare time, she studied theology, and of course she had Calvinist ministers in her court. She was committed to education, sponsoring a seminary and paying the Reformed professors herself. She also established a public school system for boys and girls as others Reformers did.[58] Religious refugees found shelter with her as they had with her mother, and Jeanne promoted religious liberty in her realms. Although she expected her subjects to subscribe to the Reformed faith, she did not prosecute those who refused to do so, which was quite tolerant given the murderous tone of most religious conflicts of the day.[59] She did seize Catholic property, but then she sold it and gave the money to the poor or used it for education. Jeanne was also a uniquely capable ruler. The economic and judicial reforms she implemented remained in force for two hundred years.[60]

When Jeanne's husband died, the Catholic king of Spain, Philip II, initially wanted her to marry one of his sons. She was uninterested for both religious and political reasons. Nonetheless, she had to participate in the proposal negotiations. Philip II demanded that she give up her Protestantism and change the policies she'd implemented in Navarre. She boldly replied, "Although I am just a little Princess, God has given me the government of this country so I may rule it according to

† A confession written by John Calvin to explain the doctrines of the faith. The Editors of Encyclopaedia Britannica, "Geneva Catechism," Encyclopedia Britannica Online, https://www.britannica.com/topic/Geneva-Catechism.

his Gospel and teach it his Laws. I rely on God, who is more powerful than the King of Spain." For context, Navarre was tiny. Spain was large, exceedingly powerful, and ravenous for more territory. Philip II did not appreciate her resolve. He responded, "This is quite too much of a woman to have as a daughter in law. I would much prefer to destroy her and treat her as such an evil woman deserves."[61] And thus the negotiations ended.

The Catholic Church was displeased (to put it mildly) with her rule and even excommunicated her. An old acquaintance, Cardinal Georges d'Armagnac, wrote her a letter, and their exchange is worth a read. In it, you can see the pressures and not-so-veiled threats Jeanne faced, the way her enemies distorted the facts, and how they tried to manipulate her emotions. The best bit is, of course, her response. She doesn't take any of the cardinal's bait and instead rebuffs his pretense of friendship. In fact, her response is scalding, but I think she was honest when she told him she prayed for him. She managed to combine incisive, pointed, and biblical discourse with heartfelt intercession for his soul.

Cardinal d'Armagnac wrote,

> I hope you will not take it amiss if an old and affectionate friend and faithful subject of your parents and yourself addresses himself to your conscience. I have been truly shaken by the report that in your presence and by your command the church at Lescar has been pillaged, the altars broken, the baptismal font mired, the jewels and ornaments stolen and the accustomed services forbidden. You are

being misled by evil counsellors who seek to plant a
new religion in Bearn and Basse Navarre. You will
never succeed because your subjects will not stand
for it. You will forfeit their allegiance if you try to
force consciences. Your neighbors will intervene.
Spain will not tolerate a different religion beyond
her borders, nor France within. You have not an
ocean to protect you like Queen Elizabeth.

I know you will tell me you would rather lose
all your territories than slacken your zeal for the
honor of God but you have no right to deprive
your children of their heritage. The fruit of the
gospel is not an infinitude of murders, robberies,
sacrileges, rebellions, apostasies and all the bar-
barous cruelties perpetrated by those who call
themselves evangelicals. I always excuse the poor
people beguiled by the wolf in sheep's clothing,
but when the wolf comes in his own hide, how
can you be seduced? How can you incite subjects
to take up arms against kings and princes? The
apostles, martyrs and saints preferred death to re-
bellion even though their rulers were infidels and
idolators. I do not want to enter into a doctrinal
discussion with you but your leaders are full of er-
rors because they do not read the Church Fathers.

You will say we must follow Scripture. Certainly,
but Scripture is amenable to diverse interpretations
and the Prince of Darkness makes even the plain
obscure Join the great lords, momentarily se-
duced, but now striving to exterminate these sedi-
tious heretics. Join them and save Navarre for your
son. I write as an old friend and also as a legate of

the Pope. I implore you with tears to return to the true fold. Restore the churches at Lescar and Pau. Forgive my prolixity. I speak from the heart

Jeanne responded,

My cousin, I am not unmindful of your services to my parents. As for Pau and Lescar I am following the example of Josiah who destroyed the high places. I am not planting a new religion but restoring an old one. My subjects are not in rebellion against me. I have forced no one with death, imprisonment or condemnation. As for Spain, we differ indeed, but that does not prevent us from being neighbors. And when it comes to France the Edict allows both religions.

Your feeble arguments do not dent my tough skull. I am serving God and He knows how to sustain His cause. On the human level I am ringed about by small principalities providing more security than does the channel for England. I do not believe that I am despoiling my son of his heritage. How much good did it do my husband to defect to Rome? You know the fine crowns that were offered to him and what became of them all when he went against his conscience, as his final confession proves.

I am ashamed of your throwing up to us the excesses on our side. Take the beam out of your own eye. You know who are the seditious through their violation of the Edict of January. I do not condone outrages committed in the name

of religion and I would punish the offenders. Our ministers preach nothing but obedience, patience and humility. I, too, will refrain from doctrinal discussion, not because I think we are wrong but because you will not be brought to Mount Zion. As for the works of the Fathers, I recommend them to my ministers. You have abandoned the holy milk of my mother for the honors of Rome and have blinded your understanding.

I know that Scripture is sometimes obscure, but when it comes to the Prince of Darkness you are an example If you have not committed the sin against the Holy Ghost you have not missed it far. You say our preachers are disturbers. That is just what Ahab said to Elijah. Read 1 Kings chapter 18. You appeal to your authority as the pope's legate. The authority of the pope's legate is not recognized in Bearn. Keep your tears for yourself. Out of charity I might contribute a few. I pray as I have never prayed from the bottom of my heart that you may be brought back to the true fold and the true shepherd and not to a hireling. I pity your human prudence which, with the apostle, I regard as folly before God. I do not know how to sign myself. After you have repented I will sign as your *cousine et amye*.[62]

Jeanne remained a faithful leader of her people until her death in 1572, shortly before the St. Bartholomew's Day Massacre. Although the Huguenots and Catholics had made peace and were planning the marriage of Jeanne's son Henry with Catherine de Medici's daughter,

there was treachery underneath. Jeanne had suspected something horrendous was afoot and resisted all efforts to negotiate the marriage terms, but she could not convince any of her advisers of the danger. The Catholics rejoiced at her death and then proceeded to kill thousands of her fellow Huguenots.[63] When Jeanne's son became King Henry IV of France, he determined that he could not govern France as a Huguenot. "Paris is worth a mass," he said, and converted to Catholicism. He then issued the Edict of Nantes, which was a policy of official toleration between Catholicism and Protestantism. Catholics and Protestants were each given freedom of worship and control over different regions of the country. France's Protestants became its most successful inhabitants, bringing prosperity to the nation through trade and manufacturing.[64]

Whatever official toleration he granted, Henry showed little personal toleration for his sister's Reformed faith when he forced Catherine to marry a Catholic duke. Although she acquiesced to her brother's wishes (did she have a choice?), she was unwavering in her religious devotion just as her mother had been. After the marriage ceremony, her husband went to a Catholic Mass and she to a Reformed service. The pope refused to acknowledge their marriage because she was "a heretic," which assured her husband of his own eternal damnation but did not bother her conscience one whit. She faced tremendous pressure to convert to Catholicism, but she remained steadfast just like her mother.[65] Her brother threatened

her, and her response was, "If you desert me, God will not desert me. I would rather be the most miserable creature on earth than to desert God for the sake of men."[66]

RENEE D'ESTE

Duchess Renee d'Este was the daughter of King Louis XII of France. Both of her parents died before she was five years old. So she grew up and received her education under the care of her cousin, Marguerite of Navarre. Under Marguerite's influence, she heard Protestant teachings and probably converted from Catholicism. At seventeen, she was married to Ercole II d'Este, duke of Ferrara, a northern region of present-day Italy. Their marriage was meant to strengthen the alliance between France and this region, but it was a disastrous match. He was, of course, Catholic, and did not support her religious beliefs. His mother was Lucrezia Borgia, a notorious member of a notorious family and daughter of Pope Alexander VI (see Chapter 3).[*67]

Renee surrounded herself with Reformed influences as best she could in her new home. She tried to recreate the home she'd left behind when she came to this foreign and hostile country. In fact, she was ridiculed for continuing her French customs and dress and for her ineptitude with the Italian language. Renee's children had

* Scholars disagree about Lucrezia. She is accused of sexual immorality, among other things, but others say after her third marriage, at the age of twenty-three, she settled down to be a model wife for the rest of her life.

Reformed tutors; she employed Reformed people in the court. John Calvin even lectured in the palace at times. Renee aided French refugees as they passed through her territory.[68] "The poor and sick were sure of relief—orphans of care and protection: so that, in the whole city of Ferrara, there was scarce a person who could not shew some instance of that unlimited goodness."[69] The duke's initial leniency toward Renee's Reformed activities did not last. He had Calvin arrested, although Renee orchestrated an attack on his captors as they were taking Calvin to his trial, and he escaped over the Alps. The duke also had Reformers imprisoned, but Renee visited the prisoners. Eventually, as the persecution intensified, all the Reformers fled, and she was left with correspondence as her only means of sharing religious sympathies. She exchanged letters with Calvin regularly.[70]

Sadly, her plight grew worse. Her husband gave her a Jesuit chaplain, but when she bested him in their debates, she was forced into solitary confinement. She could not even have books, and, tragically, her husband put her younger children in a convent. She was allowed to talk only to Jesuits. For a time, Renee lapsed back into Roman Catholicism, but then she began talking of the Reformed doctrines again. After Ercole died, Renee was given the option of affirming Catholicism or leaving Italy. She chose the latter and returned to her ancestral castle in France.

Back at home, Renee did not relax and ride off into the sunset. Finally free from harm, despite ongoing criticism from her children, she stayed engaged in the

Protestant Reform, sheltering Huguenot refugees.[71] She pled their cause with Catherine de Medici and Queen Elizabeth I. Renee also fed refugees, on one occasion serving three hundred people at a single meal.[72] This angered local Catholics, and her son-in-law, the Duke of Guise, sent an officer to threaten her. He told her she could either give him the castle, or he would "batter it to pieces and put her Reformed ministers to death." She valiantly rejoined, "Consider well what you do, for no man in the kingdom has a right to command me but the king, and if you advance I will put myself foremost in the breach, and see whether you will have the audacity to kill a king's daughter, whose death heaven and earth would avenge on you and your seed, even to the children of the cradle." He left, and shortly thereafter was assassinated, so she was spared.[73] What a life Renee had. She was born a princess and therefore a political pawn. She was orphaned at a young age. Yet God brought her to true faith. Then He gave her a marriage full of trials from solitary confinement to having her children forcibly removed from her. Even though it was wrong, we can sympathize with her lapse back into Roman Catholicism. However, she was faithful in the end and used all her wealth and power as a princess to stand firm in her faith once she returned home to France.

HOW MODERN FEMINISTS VIEW THE REFORMATION

The preceding chapters portrayed only a sampling of the righteous women God used to accomplish His work in the Reformation. Each of them used her gifts, her education, her background, whatever tools she had cultivated, and whatever position God had given her, to build a Christian culture. Modern scholars, however, attempt to rewrite the history of Reformation women as if they were primarily concerned with advancement as

women rather than with the claims of the gospel. Rather than acknowledging the courage of these women in overcoming their trials and pursuing their individual faith, scholars claim that Protestant women not only lost the autonomy and self-expression of the convents, they also lost any other lifestyle of autonomy. For instance, as one historian remarked, "To view the Reformation's legacy as largely beneficial for women ... would be 'a profound misreading of the Reformation itself.'"[1]

To support this dubious claim, modern scholars go so far as to cite purported negative effects of the Reformation on prostitution, convent life, and widowhood. "Legally speaking, only convent life, widowhood, or prostitution offered—ambiguous—freedom from male control; it was not a coincidence, that the reformers discouraged these options ... and offered marriage ... as the only feasible honorable and spiritually worthy option. Even if the intent of such laws was ... to benefit women in need of legal protection, the actual effect of the relevant laws was to ensure that women stayed dependent on men."[2]

The Reformers tried to eliminate or reduce prostitution, but according to some feminist authors, this had a negative impact on the prostitutes. Although it brought its own grief and bondage, modern scholars believe prostitution offered freedom from marriage and some measure of bodily autonomy.[3]

Even the once oppressive lives in convents are now interpreted as "an important alternative to the general path of marriage and motherhood [C]losing of the

convents stripped women of the opportunities their all-female environments allowed them of higher education and religious expression, as well as of many cherished rituals and ceremonial roles. Coinciding with the dismissal of beloved female figures in religious practice and piety, such as the Virgin Mary and the female saints, the deletion of the offices of nuns and powerful abbesses meant the disappearance of recognizable examples for women's religious leadership and spiritual roles and deeply felt changes in spiritual life Reformed prayer could no longer be addressed to a woman."[4] Not only did women lose the benefits of convents for themselves as individuals, they also "lost a forum for a collective voice and religious group action."[5]

What's worse, according to this line of thinking, women who left the convent and married were suddenly confined by domestic roles. The drawbacks of the married life included deference to a husband, pregnancies, and childrearing.[6] "The majority of nuns had no desire to sacrifice their position for the in their eyes questionable pleasures of marriage with all its dangers, including childbirth mortality and abusive husbands—and yet that was for all practical purposes the only alternative offered by Protestant reformers."[7] These new Protestant wives appeared to have gained a whole new world in their marriages, but "they became seemingly (to us anyway) imprisoned in this exclusively preached domestic model for women. With the coinciding loss of the convents, women lost the environment that had most essentially

supported women's individual spiritual development and mystical activity and nurtured many a visionary writer."[8]

Modern scholars believe these women were "just" wives. They lost their chances for spiritual vocations and formation and the sisterhood of the convent.[9] They heard spiritual equality preached and the priesthood of the believers espoused, but they still had to submit to their husbands and were not permitted to enter the pulpit themselves. Although they could read and talk about Scripture on their own, they were still subject to their husbands. Their lives were still at the mercy of a male-dominated hierarchy, in "theologically argued subjection and domestication via motherhood."[10]

Even a pastor's wife, which was a new concept arising in the Reformation, only found her purpose and role in light of her husband's work. In fact, even though most of these women were content with their lot, scholars still argue "the marital ideal and practice did not alleviate but continued the oppression of women, with a lasting negative impact on women's lives, identities, and the futures they envisioned for themselves."[11] Here the scholars expose their underlying assumption: In order for women to have true freedom, they must be identical to men. They must have the exact same roles and the exact same career opportunities. Their place in the world must be indistinguishable from that of men. In their estimation, freedom for women means freedom from femininity and any rules or roles that distinguish women from men.[12] In short, many modern scholars have been teaching the

average American that the Reformation was not a blessing to women.[13]

WHY THOSE MODERN HISTORIANS ARE WRONG ABOUT THE NUNS

Even if all the claims feminist historians make about the increased autonomy and power for nuns were true, and even if those who left the convents felt restricted by their new lives, no Protestant woman should ever argue that the convents were a better place for women than their new homes. Since the primary purpose of convent life was to achieve one's salvation, a goal unattainable by works, any woman found in such circumstances should have run as fast as she could out of the convent and into grace (as many nuns did). There is no physical confinement so restricting as the doctrine that a woman has to earn her own salvation and prove her own righteousness. Abandoning the dungeons of Roman Catholicism meant no more works, no more guilt, no more penances, and no more indulgences. Grace was the greatest liberty a woman would ever have.

No doubt the nuns had to adjust to the new habit of praying only to the Father through the Son instead of to saints and to Mary. Modern feminists suggest this was a great loss to them. For although Mary could do nothing for them, and neither could the saints, at least they had the privilege of praying to a woman. If praying to a woman is more important than fellowship with God, then by all means, this was a disaster for those nuns who left the

convents. If, on the other hand, efficacious prayers mattered to them, then praying to the Father through the Son would have been a relief—they could go directly to the Father with their requests. They had hope of answers; they had assurance of righteousness through the Son. Surely those were true consolations for the "loss" of female saints and exaltation of Mary. The erroneous presupposition for modern feminist scholars is that these women saw themselves as women first and then as Christians, but we have no reason to believe they would have been more concerned with opportunities as women than with true theology or faithfulness.

Modern scholars love to ignore yet another fact about convent admission. Most young girls were sent away to school at a convent, much like a modern boarding school, but then, by the age of ten, they were sometimes committed for life to the cloister. They went to bed at eight and got up for prayers at one or two in the morning, went back to sleep and then back up at six a.m. At some convents, they were not allowed to talk to one another during the day and had to invent a special sign language, and then at night they slept in rooms alone, as well.[14] If we are using today's standards to measure their lives, we would call this treatment child abuse.

Certainly there were women who preferred the convents, whether because of their religious beliefs, or because of the habits they'd developed, or because they simply enjoyed convent life. There were also women who, because of their beliefs, left the life they'd known

for years and without financial certainty, entered the nonreligious life. They became wives and mothers, and, from what we can see in the historical record, they relished these new roles, enjoying the authority they wielded in their homes. Although they did not have authority over their husbands, they had a lot of authority over their households. Many also capably managed the day-to-day operations of what were effectively small companies. They embraced their labors with vigor and then raised up daughters to do the same thing. There is no evidence that most of them longed for careers apart from their homes or lived in fear of husbands who domineered them. On the contrary, when possible, they furnished half the wealth of the household upon entering marriage,* they knew their household labor was indispensable, and they often learned their husbands' trades and took them up if he passed away. Evidence suggests they were confident in their positions in their marriage.[15] As Christians, they knew that "He who finds a wife finds a good thing" (Prov. 18:22) and "Children are a heritage from the Lord" (Ps. 127:3), so the women of the Reformation did not describe marriage and childrearing as drawbacks. Rather, they took their role as bishops and apostles in the home seriously, working night and day building the kingdom of God.

To suggest that nuns left the convent only to be blindsided by a hierarchical theology that did not allow them

* A wife often brought one of the couple's most valuable possessions to the marriage, a bed (Sarti, *Europe at Home*, 45).

to preach or rule over their households is anachronistic at best. They understood the doctrine of priesthood of believers to mean they could study and understand Scripture apart from the pope, and they found this truly liberating. We have no record of their dissatisfaction with their new lives or any sadness over careers lost. Our records indicate they engaged in more enterprises than most modern women. Katie Luther ran a boardinghouse and a few farms, made beer, and even became an herbalist.[16] The escaped nuns we know about were well-educated women who made dangerous choices for the sake of righteousness. It is patronizing to claim they were unaware of what they were doing or that they made choices that, had they had our superior knowledge, they would never have made. More likely, if they had had the option of either the same legal and career opportunities modern women have *or* the security and purpose they had in their roles as Christians, wives, mothers, and women, they probably would have stayed put.

When modern scholars reject the advances for women that the Reformation brought, they are also rejecting the Bible. These scholars are offended that the Reformers taught that women should submit to their husbands and stay out of the pulpits. That is their fundamental contention and their fundamental confusion. They cannot understand how women could be submissive in the home and restricted from the pulpit and still be secure, strong, diligent, industrious, world-changing women. Because scholars cannot understand this, they reject it, and they

have encouraged the rest of our society—Christian and secular—to reject it as well. But we're Christians, and we can't reject the Bible, so we'll have to reject the modern scholars instead.

SOCIETAL CHANGES IN THE SIXTEENTH CENTURY

*The Reformation
Made a Lot of Things Better*

We know that we reap what we sow, both individually and as a society, so we would expect that as the Reformers preached the Bible and as Christians established obedient homes, the culture would be transformed, which is exactly what faithful Christians today

are longing for. Like the Catholic Church of old, the modern world says the only way to reform culture is through vocations, narrowly defined. But look at what the Christians of the sixteenth century did when they obeyed God in the stations He gave to them: as a whole, and over hundreds of years, they reshaped the West.

The Reformation rocked European society, and western civilization has never been the same. The corrupted Catholic Church lost its stranglehold on Europe, and, through the Reformation, religious freedom triumphed.[1] True grace and faithful theology began to produce fruit in all areas of life. To begin with, people were born—people who would not have been born without clerical marriage. In 1750, approximately 230 years after the Reformation began, one Justus Moser, a German legal expert and social analyst, calculated that between ten and fifteen million people were born because the Reformers abolished clerical celibacy, "An unusual proportion of eminent scholars and useful men in church and state" were descendants of former monks and nuns and priests.[2] It was not just that the population increased, though; the Reformers emphasized the value of work, so this increasing populace was productive. The shift in the understanding of vocation had tremendous impacts on the way people worked and thus on the trajectory of society as a whole. Over the years and centuries, as the doctrines of the Reformation spread, Western civilization adopted "a new work ethic that would fuel the industrial revolution and create a political climate that made free democracies possible."[3]

Prior to the Reformation, society expected monks and nuns to care for the poor. The social outcasts were the Church's problem. However, during the Reformation social ills became the problem of individual congregations and not distant Church authorities. Reformers taught that caring for the sick and the poor flowed from right worship.[4] Wherever the Reformation spread, the monasteries and convents were abolished, and the communities took on charity work. Church wealth was used for the poor, and the monasteries and convents became homes for the poor or hospitals.[5] Public brothels were eliminated, and prostitution and birth out of wedlock were discouraged.

ENCOURAGING EDUCATION

Because of the translation of Scripture into the vernacular, and because of its emphasis on universal reading of Scripture and knowledge of the catechisms, the Reformation encouraged literacy and education for all.[*] Literacy rates rose as men and women eagerly read their Bibles (still a top motivator for those who pursue literacy in adulthood). In the pre-Reformation system, education was expected of nuns and priests and monks (although not always achieved), but many people thought if their children were not going into the cloister, then their children did not need an education.

Luther sought to dissuade these people of their error in a sermon he wrote for all the ministers in Nuremberg

[*] This was something Erasmus, who remained in the Catholic Church, also argued for (Anderson, *Daily Life*, 186).

to preach and which he had already preached himself: "For if the Scriptures and learning disappear, what will remain in the German lands but a disorderly and wild crowd of Tartars or Turks, indeed, a pigsty and mob of wild beasts?"[6] To prepare for a future in which they would rule, govern, educate, or preach, children needed to learn. And one of the central things they were to learn in school was how to be good Christians. They studied catechisms and read Scriptures. "Even women and children can now learn from German books and sermons more about God and Christ—I am telling the truth!—than all the universities, foundations, monasteries, the whole papacy, and all the world used to know."[7] Universal education provided new opportunities to men and women, raised their social conditions, and established the foundations for modern science and education.[8]

Prior to and even during the Reformation, the prevailing belief in Germany (if not elsewhere) was that educating women was unnecessary and could be dangerous. Intellectual pursuits might be a disadvantage to them, and learning to read might put them in contact with worldly writings.[9] Those sent to the convent for an education did not always learn to read, because their teachers did not always know how to read.[10] By contrast, the German Reformers pushed for universal education, and this idea eventually spread to encompass all women in the Western world. No one should be denied an education, it was argued, because who could say what person, man or woman, God would choose

as an instrument for His glory? A German pedagogue claimed, "There was no reason to exclude girls from education They too were formed in the image of God, were endowed with equal, sometimes even superior, sharpness of mind and capacity for knowledge."[11] He went on to quote I Timothy 2:12 to show that women should not be forbidden to read. After all, Paul said they were to learn at home. Martin Bucer thought women should certainly strive for higher education. He even counseled Margaret Blaurer to learn Greek so she could better understand the New Testament.[12] Numerous other Reformers agreed. As one of them argued, "I do not think that the Christian religion is opposed to the studies and scholarship of girls, as some have misrepresented it. We ought to be thankful to God for the gifts he has given to either sex; it pleased him that the first proclamations of the most glorious resurrection of his Son, Jesus Christ, were held by female preachers in the houses of the apostles."[13]

Germany was the first to institute universal education in the seventeenth century as a result of Reformation teaching. Following Martin Luther's instruction, they emphasized female, and not just male, education.[14] Luther had proposed compulsory education for boys and girls, and in his home territory of Wittenberg, every town was required to have a girls' school.[15] Boys and girls had separate schools that only met for an hour or two each day, but they learned religion, history, classical and modern languages, literature, music, and mathematics.[16]

Girls who were intellectually gifted might go on to become teachers and receive some liberal arts training.[17] Philipp Melanchthon also promoted education for girls to prepare them for life. "From such girls who have laid hold of God's word there will come useful, skillful, happy, friendly, obedient, God-fearing, not superstitious and self-willed housewives, who can control their servants and train their children in obedience and to respect them and to reverence God."[18] Although he did not discuss it fully, John Calvin also expected girls to have a primary education.[19] He established a functional educational system in Geneva, and once the Reformation had taken hold, all children were required to attend school.[20]

The push for education saw great success. In one region of Germany, the number of schools went from fifty in 1534 to 401 in 1600.[21] In another region, at the start of the Reformation, there were four girls' schools and fifty-five boys' schools. Sixty years later there were forty-five girls' schools and one hundred boys' schools.[22] Yet another territory decreed, "The Scriptures do not belong to men alone, but to women also, who expect heaven and eternal life just as do men."[23] By 1649, all German children under fourteen were required to attend school.[24] By the end of the eighteenth century, the literacy rate for German males was over ninety-five percent, the highest in Europe. Presumably, the rate for girls was also high since they were educated as well.[25] Of course these changes did not happen in a day, but over the centuries, as the Reformers' teachings bore much fruit.

CELEBRATING MARRIAGE

"The Reformers burst the chains of papal tyranny," writes Philip Schaff, "and furnished the practical proof that it is possible to harmonize the highest and holiest calling with the duties of husband and father."[26]

The concept and practice of marriage shifted dramatically through the Reformation. For one thing, the Reformation put an end to condoning the unbridled lusts of the priests and monks. It also reinstated the respectability of wedlock, and it elevated the position of women in society.[27] "The Protestant doctrines of Christian vocation and the priesthood of all believers, along with [this] new view of marriage, did in fact tend to change the image and role of women in the direction of greater personal freedom and responsibility, both immediately and over the centuries."[28]

In one sense, the role of a wife did not change. She still kept the house and raised the children, but the Reformers strengthened her role and honored it. The Reformation emphasized and exalted the home and family. Marriage became the school for character. In another sense, the wife took on far more important work, becoming the bishop to her children and the helper to her husband's work. In contrast to the permissive parenting common at the time, Reformers emphasized the importance of raising godly children who were fruitful and productive members of society, sacrificing themselves for the sake of others, subjecting emotion to reason, and always being faithful to their God.

The wife continued to submit to her husband, but not as a slave to a master, and wife-beating was discouraged. In fact, men who beat their wives in Geneva faced the courts, which led to Geneva's nickname, the Woman's Paradise.[29] A wife was recognized as her husband's spiritual equal, and they were companions in marriage. Luther's teaching on marriage emphasized love and mutuality in the marriage relationship, which was both novel and monumental, resulting in a drop in contested marriages. Because it was important to marry someone of a similar religious persuasion, marriages shifted from being family-arranged to being individually chosen, which increased the companionability of marriage as well. "[The Protestants'] new marriage laws...became the most emphatic statement of the ideal of sharing, companionable marriage in the sixteenth century. The domestic legislation of the Reformation encouraged both spouses to be more sensitive to the other's personal needs and vocational responsibilities, thereby enhancing the status of both men and women."[30]

As Luther himself said, "When I was a boy, the wicked and impure practice of celibacy had made marriage so disreputable that I believed I could not even think about the life of married people without sinning. Everybody was fully persuaded that anyone who intended to lead a holy life acceptable to God could not get married but had to live as a celibate and take the vow of celibacy. Thus many who had been husbands became either monks or priests after their wives had

died. Therefore it was a work necessary and useful for the church when men saw to it that through the Word of God marriage again came to be respected and that it received the praises it deserved. As a result, by the grace of God now everyone declares that it is something good and holy to live with one's wife in harmony and peace even if one should have a wife who is barren or is troubled by other ills."[31]

CHURCH SERVICES, MANNERS, AND FOOD

On a very practical note, prior to the Reformation, men and women observed the Mass but did not participate in it. A choir of monks or nuns might sing a chant, and the priest would perform the sacraments, but the people in the congregation acted as an audience, listening to what was happening behind the rood screen. Reformers introduced congregational singing by translating Psalms and hymns into the vernacular and setting them to music. For the first time, men and women participated in the liturgy as they sang together in church.[32] One visitor described the service thus, "The sermon is accompanied by hymns that have been translated from the Hebrew Psalter into the vernacular. The female voices mix in a wonderfully beautiful way with those of the men. It is a joy to listen to this. After the meal, four hours later, there is another service in the same church building. Once again, the hymns before and after the sermon are not absent. It is as if, through these hymns, they ask for the grace that enables them to receive the seed of the

gospel, and having received it, to express their gratitude for it."[33]

The Reformation changed acceptable manners as well. In Saxony, the bride and groom traditionally bathed together after the wedding and then served refreshments to their guests before dressing again. With the spread of the Reformation, that practice ceased, as did the widespread practice of relieving oneself publicly.[34] Fashion also changed, as Protestants wore simpler clothing than the flashy styles of the Renaissance.[35]

The Reformation changed diets and therefore economies. Catholics were prohibited from eating meat or animal fats, including butter, eggs, and cheese, 140–160 days a year, but they were permitted to eat fish.[36] The Church believed animal products were more nourishing to the body and produced extra energy to fuel lust.[37] Those people who could not endure the forty–day Lenten fast without butter paid hefty sums to the Church to obtain dispensations allowing the consumption of butter.[38] Sometimes entire regions paid to be able to eat butter on fast days (beginning with the French and spreading to other countries).[39] By contrast, Protestants ate meat and animal fats all year long. This changed culinary tastes, moving from sauces made of wines and vinegars that Spanish and Italian Catholic cultures enjoyed to creamy sauces made by peoples of more northern regions.[40] Abandoning fast days also reduced the number of fishermen and increased the number of farmers.[41]

TRUE PROGRESS

Reformers made the kinds of progress in their society hundreds of years ago that Americans are trying to realize now. They argued that the sexes were fundamentally equal because both equally bore the image of God. Arguably the concept of women's equality with men could have only gained traction in a society that once knew and applied the Bible. The foundation for valuing both sexes is that God made man and woman in His image, and the Reformers built a godly society on this foundation.

Surprisingly to modern minds, the Reformers were big proponents of choice. They wanted women to be able to choose to stay home with families rather than be forced to enter convents. And children were encouraged to choose their spouses rather than entering arranged marriages

By contrast, Americans idolize moral progress apart from the preaching and reading of the Bible, which digresses instead of progresses. Without an understanding or acknowledgment of God, many modern American beliefs are just expressions of the same age-old sins of greed, selfishness, and immorality that we saw in sixteenth-century Catholicism. Where women were once only valuable for their vocations in the Church, American culture preaches a woman's worth is based on her occupation outside the home. American culture might be, in some ways, just repackaged popery.

There is only one true fairy tale in this world, and feminism is not it. Only one worldview ever offered true progress for women and for society, and that is

the biblical Christianity preached by the Reformers. The only equality women will find is through Christ. Through the death of the Son and the redemption of the cosmos, Christianity says this world will be made right again. By grace alone, the faithful will continue living the gospel until the earth is full of the knowledge of the Lord as the waters cover the sea.

CHAPTER 19

THE
REFORMATION
AND YOU

S o what is there to learn from the men and women
of the Reformation? For starters, the Reformers
preached the Word of God and encouraged people to
read it themselves. Nothing has a more powerful im-
pact on societies than the faithful teaching and practice
of God's Word. They also taught that there is nothing
sinners can do to save themselves except to rest in the
mercy of God. We are justified only through Christ.
These are potent doctrines that, if they were believed

and practiced, would upend American society just as they upended European society five hundred years ago.

Without fail, the women who contributed to the Reformation knew God's Word, and they knew and loved the doctrines the Reformers taught. It seems strange to love a doctrine, but why wouldn't they have loved knowing they were without condemnation in Christ and that they could turn to the Bible to know God's thoughts rather than to the pope? Leaving a convent was a punishable offense, and if they escaped punishment, former nuns faced significant uncertainty in their new lives. Upon returning to secular life, these nuns often met resistance and rejection from their families. They had no job prospects, and most of them had no marriage prospects. They sacrificed the security of the convents and became charity cases, relying instead on the generosity of strangers, and all because they believed that grace was theirs. In the same way, women like Jeanne d'Albret, Elisabeth of Brandenburg, and Renee d'Este risked their lives and their children for right doctrine. That is what it means to love the doctrines of Scripture.

The women described in this book were committed to Christ. They knew Christ because they knew Scripture. Most of them were wives and mothers, as well, but they were Christians first. Thus, when they faced the loss of husbands, children, position, and material wealth, they clung "to Christ like a burr to a dress."[1] Because of this, they were fruitful even in the midst of great sorrow. Katherine Schutz lost her two infants and became

a spiritual mother in the Church rather than a physical mother. Wibrandis Rosenblatt lost her husband and several children in an outbreak of the Plague, and within a year she was married again to glorify God and serve her new family. Louise de Coligny lost her father and two husbands to Catholic murderers, and she became a beloved stepmother and grandmother and able politician holding fast to her faith to the end. Jeanne d'Albret's son was taken from her by her unbelieving husband. These women could not have produced fruit from their own weakness. Their strength came from Christ, but it is impossible to look at them and miss the strength. They were not "just" wives and mothers or women who were trapped by their domestic roles. They were strong, faithful, diligent women grounded in the Word.

The Bible dictated the nature of their marriages. The Reformers not only taught that marriage is a glorious gift of God to be accepted in obedience, they also married with that in mind. Just as their lives were not their own, neither were their marriages. Martin Luther did not marry Katie because he was burning with passion for her. He married her because he believed it was the right thing to do. "For I feel neither passionate love nor burning for my spouse, but I cherish her."[2] Heinrich Bullinger wrote a love letter to his future wife, proposing to her with the assurance that "the greatest surest treasure that you will find in me is the fear of God, piety, fidelity, and love, which with joy I will show you and labor in earnestness and industry which will not be wanting

in temporal things."[3] He did not offer her romance; he offered her faithfulness, and she took it. Katherine and Matthew Zell married to be an example to the flock in Strasbourg. She noted he did not marry her for any beauty, virtue, or riches of her own. The marriage contract for Martin Bucer and Wibrandis Rosenblatt stated they married "for the furtherance of the glory of God and the upbuilding of the Christian Church."[4] They were both grieving the loss of their spouses less than a year earlier. In short, many of the women in this book had delightful marriages, but they and their husbands entered them out of obedience, anticipating lives of faithfulness and not looking for happily ever after.

Martin Luther's scriptural teaching on vocation changed these women's lives. Unlike the Catholic Church, Luther and other Reformers taught that any lawful work was a vocation blessed by God to love one's neighbor. Scripture does not require a person to commit himself or herself to the church to honor God through his or her work. A faithful wife and mother serves God in her family, and God blesses that effort and uses it to change cultures. In the providence of God, some women are widowed, abandoned, or unmarried, and when they are obedient to Him, God uses them to spread His gospel. Whatever their situations, the women represented here were confident in their God-given purpose—to glorify God, filling the earth and subduing it.

Unlike moderns, the Reformers and the women of the Reformation were not confused about the roles of men

and women. They did not subscribe to the modern belief that a man and woman must be able to occupy the same roles and callings in order to be equal. The Bible never requires it, so neither did they. Instead, Reformers respected women for the unique capacities God gave them to be nurturers and life-givers. The Reformers' wives embodied this theology, preaching the gospel in their own feminine but often unrecorded ways, without which the entire movement would have failed. They turned society's view of women on its head through faithful, biblical obedience.

A whole book could be written on the influence of hospitality on the Reformation. Hosting so many strangers, refugees from Catholic persecution, visiting theologians, and family left no "me time," but it had the positive effect of changing the world. "Me time" rarely does that. The women in this book were engaged with their husbands all day every day to build a Christian culture, and for the women, that meant cooking, cleaning, counseling, administering, disciplining children, and hosting, hosting, hosting. They were busy filling the earth and subduing it.

The women of the Reformation were diligent. They supported their husbands and the church by studying, writing, hosting, raising children, caring for the sick, visiting the imprisoned, establishing schools, and more. Reading lists of their accomplishments make us wonder when they slept. Had it not been for the assurance they had of Christ's grace to them through the cross, they would not have been able to work as they did.

Almost all of the women in this book were born into the Catholic Church and left it when they encountered the Reformers' preaching. They grew up going to Masses and doing penance and good deeds, hoping these would justify them before an angry God. When they understood that the Bible teaches God is kind and good and justifies His people through the righteousness of Christ on the cross and nothing else, they could rest. And from that rest came a truly productive diligence that stood in contrast to the ineffectual busyness of trying to earn their way to God. They were not saved to laziness; they were saved to good works. These were women whose salvation gave them purpose and direction. As a result, they were industrious and fruitful.

When faced with opposition, the women of the Reformation were refreshingly bold. They did not back down from their convictions even when their lives were in danger. Many people criticized these ladies for leaving convents, for marrying priests or monks, for adhering to the Protestant faith, and for whatever else they could imagine. The women of the Reformation responded with courage, from Katherine Zell and her impassioned letters to the bishop to Jeanne d'Albret and her stalwart refusal to bend to Catherine de Medici's will. The very fact of their position as women of the Reformation required courage for most of the women in this book. They did not know how their story would end, whether the Catholic Church would successfully quash the Protestant movement, or how costly their obedience might be.

Despite their similarities, God gave each of the women in this book different circumstances and different ways to use her gifts to glorify Him. The former nuns took the skills they'd learned in the convents and made them fruitful. Women like Katie von Bora, Elizabeth Silbereisen, and Anna Adlischwyler took their educations, administrative abilities, domestic skills, and capacities for feeding large numbers of people, and they used those to minister to their husbands and to all the hundreds of people who would come through their homes. Jeanne d'Albret used her court education to run a country; Olympia Morata and Katherine Schutz wrote extensively, drawing from their years of study. These women had devoted time and energy to wisdom, knowledge, and practical skills that they were able to use most effectively when God brought opportunities.

Last, but not least, the women in this book were selfless in the way they perceived their place in society. Certainly they were sinners, but when they faced culturewide defamation, they did not respond with agendas, lobbies, or protests demanding restitution. The women of the Reformation did not see themselves as a class with specialized interests or demand rights for themselves as modern Americans tend to do. They were not offended that the Bible required them to submit to their husbands. On the contrary, the Reformers' wives made their husbands more successful through their work. As Rosaria Butterfield noted, "Saints of old were often clear on a point on which contemporary Christians are muddled:

you can't defend your right to yourself... and at the same time defend God's righteousness.... In Christ's strength, you must choose: you or God. If you choose yourself, you will always feel alone, even in a crowd or internet community of like-minded thinkers. This is because Christ knows you better than you do."[5] These women chose God and not self. They had tasted the sweetness of grace, and their mission was simply faithfulness and obedience to God. They used their ordinary and mundane duties and sometimes their powerful civic duties as *weapons* to fight the culture of death around them and as *tools* to build a faithful culture to replace it. In response to defamation, they didn't succumb to fruitless fretting, but got to work, using whatever means they had at their disposal to accomplish the tasks in front of them. Their obedience was not just a blessing to their generation; it was a gift to us. We are still feeling the ripple effects of their faithfulness.

WHAT DOES ALL THIS MEAN FOR WOMEN'S VOCATIONS?

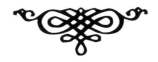

Many women are unaware of the impact feminism has made on the question of vocation, as I was. Feminism has influenced our culture, and that trickles down to young women in the form of career pressure, and the American church at large has not handled this particularly well. The church seems to have unintentionally adopted the feminist principle that the only truly important work earns a salary outside the home.

Feminist culture can and has trickled down even to many Christian stay-at-home moms, who can be just as tempted by promises of self-fulfillment and living out their dreams. If they are staying at home with the kids as a means to that end, it's still an idolatry of the self. As long as the ultimate goal is finding ourselves or feeling fulfilled, it doesn't matter how we pursue it: we will always be disobeying God.

The other idol of our culture a study of feminism and the Reformation exposes is the idol of making a difference. Christians and unbelievers alike aspire to this, although they don't have the same definitions of that goal. At first glance, how could this be an idol? The Bible encourages us to make a difference: "Go therefore and make disciples of all nations, baptizing them in the name of the Father and of the Son and of the Holy Spirit, teaching them to observe all that I have commanded you. And behold, I am with you always, to the end of the age" (Matt. 28:19–20). This passage makes sense to good Christians: We are supposed to lead people to Christ. The hard part is how and whom. As P.J. O'Rourke so aptly said, "Everybody wants to save the earth; nobody wants to help Mom do the dishes."[1] It's fun to imagine leading some heretofore unknown people group to Christ, but it's a lot more work to train up children in the way they should go all day every day. Humbling ourselves is hard work.

Just about everyone in our age wants to live a life worthy of future biographies (or, more likely, a video of our amazing exploits gone viral), but the truth is, most of us

just need to do the next thing, the one right in front of us. God sees our faithfulness, and that has to be enough for us. The best part is that God then takes our faithfulness in the small things, and uses it, as He did with the Christians at the time of the Reformation, to make everything new. The women in this book were only representative. Eighteen women did not change western civilization. There were thousands of people who turned to Christ, and God used all of them whether or not we know their names five hundred years later.

Practically speaking, what about that love of learning? Ignore it? Give it up to raise kids? As Olympia Morata said, "He gave me the mind and talent to be so on fire with love for learning that no one could keep me from it.... Everything is done according to His plan and purpose, and He does nothing rashly or thoughtlessly. So all these things perhaps will be for His glory and my betterment."[2] God gives desires, and He fulfills them in His own ways. The most important thing is to start with the right priorities in the right order—love God by knowing and obeying His Word. Make my husband more effective in his vocation by using my skills, time, and efforts on his behalf. Cheerfully sacrifice myself for my husband and children day in and day out. Love God's people. Love the stranger. After the priorities are set, everything else comes into focus. As it turns out, children are not at home forever. In fact, that time between their birth and when they first head off to school is the most time their mothers will ever have with them. Truly the days are long and

the years short. And then, for many women, there is suddenly time to read a book, take a class, teach a class, plan a garden, cook a more elaborate meal, set a beautiful table, write a book, buy some property, or pursue any number of other avenues to building a godly culture.

Of course, some women are simply unable to stay home with their children, just like some of the women we've studied. Other women are unmarried or unable to have children. In both cases, the right priorities in the right order still matter. God gives different stories to each of His children, and He is not limited in what He can accomplish by the circumstances He ordains. He is the same Father who comforted Katherine Schutz and who provided her with a life of service. Whatever the situation God brings, He is sufficient, and our faithfulness honors Him.

And last, the most important lesson the Reformers taught—we are saved by grace. We could never accomplish enough with our lives to justify ourselves before-God. Finishing a to-do list, no matter how extensive, will not satisfy Him. No career, no mission work or ministry, no childrearing technique is righteous on its own. We have nothing but the blood of Jesus to cover us, but thankfully that's enough. Because of Christ, God is infinitely pleased with His children, and because that is true, we can't help but overflow in gratitude and good works. Of course we could never outgive God, but at least we can spend our lives giving it a try.

ENDNOTES

CHAPTER 1 | *Feminism: A Little Background*

1 Jennifer Baumgardner and Amy Richards, *Manifesta: young women, feminism, and the future* (New York: Farrar, Straus and Giroux, 2010), 56. Available at http//www.feminist.com/resources/artspeech /genwom/whatisfem.htm.

2 See Nicola Slee, *Faith and Feminism* (London: Darton, Longman & Todd, 2003) for a more in-depth discussion.

CHAPTER 2 | *Modern Feminism on Vocation, Marriage, and Motherhood*

1 Betty Friedan, *The Feminine Mystique* (New York: W.W. Norton & Company, 2013), 366.

2 Betty Friedan, *The Feminine Mystique*, 453–54.

3 Margaret Sanger, *Pivot of Civilization (Classic Reprint)* (San Diego: Forgotten Books, 2016), 79.

4 Judith Ronin, quoted in Sheryl Sandberg and Nell Scovell, *Lean In: Women, Work, and the Will to Lead* (New York: Alfred A. Knopf, 2017), 14.

5 Linda R. Hirshman, *Get to Work: And Get a Life, before It's Too Late* (New York: Penguin, 2006), 24–25.

6 Hirshman, *Get to Work*, 15.

7 Hirshman, *Get to Work*, 36.

8 Hirshman, *Get to Work*, 78.

9 Sandberg and Scovell, *Lean In*, 159.

10 Friedan, *The Feminine Mystique*, 32. Quoted in Hirshman, *Get to Work*, 30.

11 Hirshman, *Get to Work*, 34.

12 Sandberg and Scovell, *Lean In*, 9–10.

13 Carolyn Custis James, "The Ezer Kenegdo: Ezer Unleashed," *FaithGateway*, March 20, 2015, http://www.faithgateway.com /ezer-unleashed/#.WLB6CjvyvI.

14 Katelyn Beaty, *A Woman's Place: A Christian Vision for Your Calling in the Office, the Home, and the World* (New York: Howard Books, 2017), 91.

15 Rebecca Traister, *All the Single Ladies: Unmarried Women and the Rise of an Independent Nation* (New York: Simon & Schuster, 2016), 30.

16 Traister, *All the Single Ladies*, 30.

17 Marlene Dixon, quoted in Traister, *All the Single Ladies*, 23.

18 Sheila Cronan, quoted in Traister, *All the Single Ladies*, 23.

19 Andrea Dworkin, quoted in Traister, *All the Single Ladies*, 23.

20 Gloria Steinem, quoted in Traister, *All the Single Ladies*, 26.

21 Traister, *All the Single Ladies*, 36.

22 Emma Goldman, quoted in Traister, *All the Single Ladies*, 60.

23 Jen Doll, "Dear Single Women of NYC: It's Not Them, It's You.," *The Village Voice*, February 9, 2011, http://www.villagevoice.com /news/dear-single-women-of-nyc-its-not-them-its-you-6430067.

24 Jen Doll, "Dear Single Women of NYC."

25 Traister, *All the Single Ladies*, 5.

26 Traister, *All the Single Ladies*, 5.

27 Traister, *All the Single Ladies*, 5.

28 Traister, *All the Single Ladies*, 134.

29 Madison Park, "US Fertility Rate Falls to Lowest on Record," *CNN*, August 11, 2016, http://www.cnn.com/2016/08/11/health/us-lowest-fer-tility-rate/; Central Intelligence Agency, "Country Comparison: Total

Fertility Rate," accessed September 15, 2017, https://www.cia.gov/library /publications/the-world-factbook/rankorder/2127rank.html.

30 Sanger, *Pivot Of Civilization*, 75.

31 Friedan, *The Feminine Mystique*, 167.

32 @planetcath, "*The Breeders*," Motherhood is a Feminist Issue, September 27, 2014, https://miafi.wordpress.com/2014/09/27/the-breeders/.

33 Sandberg and Scovell, *Lean In*, 10.

CHAPTER 3 | *The Roman Catholic Church in the Sixteenth Century*

1 Michelle DeRusha, *Katharina and Martin Luther: The Radical Marriage of a Runaway Nun and a Renegade Monk* (Grand Rapids: Baker Books, 2017), 70.

2 James M. Anderson, *Daily Life During the Reformation* (Santa Barbara, CA: Greenwood, 2011), 32.

3 Anderson, *Daily Life*, 32.

4 Anderson, *Daily Life*, 29.

5 Philip Schaff, *History of the Christian Church, Volume 6: The Middle Ages* (Peabody: Hendrickson Publishers, 1996), 445.

6 Merle D'Aubigne, *History of the Great Reformation of the Sixteenth Century in Germany, Switzerland, &c, Volume 1*, 3rd ed. (London: D. Walther, 1840), 48.

7 Schaff, *History of the Christian Church 6*, 447.

8 Schaff, *History of the Christian Church 6*, 461.

9 Anderson, *Daily Life During the Reformation*, 33.

10 Schaff, *History of the Christian Church 6*, 453.

11 Schaff, *History of the Christian Church 6*, 453.

12 Merle D'Aubigne, *The Triumph of Truth: A Life of Martin Luther*, trans. Henry White (Greenville, SC: Bob Jones University Press, 1996), 37.

13 Schaff, *History of the Christian Church 6*, 455.

14 Schaff, *History of the Christian Church 6*, 455.

15 Schaff, *History of the Christian Church 6*, 456.

16 Ferdinand Gregorovius, *The History of the City of Rome in the Middle Ages, Vol. VIII, Part I*, trans. Annie Hamilton (London: George Bell and Sons, 1902), 118–19.

17 Schaff, *History of the Christian Church 6*, 470.

18 D'Aubigne, *History of the Great Reformation 1*, 93.

19 Quoted in Gregorovius, *The History of the City of Rome, Vol. VIII, Part I*, 116–17.

20 Schaff, *History of the Christian Church 6*, 478.

21 Gregorovius, *The History of the City of Rome, Vol. VIII, Part I*, 120.

22 Anderson, *Daily Life*, 31.

23 Schaff, *History of the Christian Church 6*, 489.

24 Schaff, *History of the Christian Church 6*, 489.

25 James Reston, *Luther's Fortress: Martin Luther and His Reformation Under Siege* (New York: Hachette Book Group, 2015), 7.

26 Reston, *Luther's Fortress*, 7.

27 Quoted in Schaff, *History of the Christian Church 6*, 492.

28 Schaff, *History of the Christian Church 6*, 493.

29 D'Aubigne, *History of the Great Reformation 1*, 282.

30 Schaff, *History of the Christian Church 6*, 487–88.

31 Quoted in Schaff, *History of the Christian Church 6*, 617.

32 Gregorovius, *The History of the City of Rome, Vol. VIII, Part I*, 76.

33 Schaff, *History of the Christian Church 6*, 614, citing a Roman diarist.

34 James A. Brundage, *Law, Sex, and Christian Society in Medieval Europe* (Chicago: University of Chicago Press, 1987), 537.

35 H. G. Koenigsberger, G. Q. Bowler, and George L. Mosse, *Europe in the Sixteenth Century* (New York: Longman Scientific & Technical, 1989), 224.

36 Merle D'Aubigne, *History of the Great Reformation of the Sixteenth Century in Germany, Switzerland, &c, Volume 3*, 3rd ed. (London: D Walther, 1843), 285.

37 Quoted in Herman J. Selderhuis, *Marriage and Divorce in the Thought of Martin Bucer*, trans. John Vriend and Lyle D. Bierma (Kirksville, MO: Truman State University Press, 1999), 25.

38 Schaff, *History of the Christian Church 6*, 667.

39 Selderhuis, *Marriage and Divorce*, 27–28.

40 Selderhuis, *Marriage and Divorce*, 25.

41 D'Aubigne, *History of the Great Reformation 1*, 47.

42 Schaff, *History of the Christian Church 6*, 665–66.

43 Charles Terpstra, "The Reformation: A Return to the Primacy of Preaching," Protestant Reformed Churches in America, November 13, 2001, http://www.prca-evangelism.org/pamphlets/the-truth /the-reformation-a-return-to-the-primacy-of-preaching.

44 D'Aubigne, *History of the Great Reformation 1*, 43–44.

45 D'Aubigne, *History of the Great Reformation 1*, 43.

46 D'Aubigne, *History of the Great Reformation 1*, 52.

47 D'Aubigne, *History of the Great Reformation 1*, 52.

CHAPTER 4 | *The Catholic Church and Stingy Grace*

1 Terpstra, "The Reformation."

2 Schaff, *History of the Christian Church 6*, 757.

3 Dave Roos, "How Butter Fueled the Protestant Reformation," How Stuff Works, August 28, 2017, http://history.howstuffworks.com /historical-events/butter-fueled-protestant-reformation.htm.

4 DeRusha, *Katharina and Martin Luther*, 88.

5 Koenigsberger et al., *Europe in the Sixteenth Century*, 143.

6 D'Aubigne, *The Triumph of Truth*, 72.

7 Schaff, *History of the Christian Church 6*, 758, 761.

8 Philip Schaff, *History of the Christian Church Volume 7: The German Reformation* (Peabody: Hendrickson Publishers, 1996), 151.

9 Schaff, *History of the Christian Church 7*, 153.

10 Carter Lindberg, *The European Reformations Sourcebook* (Malden, MA: Blackwell Publishing, 2000), 31, quoting Tetzel. This story was originally told by Martin Luther.

11 Schaff, *History of the Christian Church 7*, 154.

CHAPTER 5 | *The Catholic Church and Women*

1 Steven E. Ozment, *Ancestors: The Loving Family in Old Europe* (Cambridge, MA: Harvard University Press, 2001), 36.

2 Plato, *Timaeus*, 42b.

3 "The Nature of Women in Plato and Aristotle: Plato and Aristotle's view of the nature and capabilities of women," *Classics Network*, accessed September 25, 2017, https://www.classicsnetwork.com /essays/the-nature-of-women-in-plato-and/786.

4 Sister Prudence Allen, R.S.M., *The Concept of Woman, Volume III: The Search for Communion of Persons, 1500–2015* (Grand Rapids, MI: William B. Eerdmans, 2016), 19.

5 Marie I. George, "What Aquinas Really Said About Women," *First Things* 98 (December 1999): 11–13, https://www.firstthings.com /article/1999/12/what-aquinas-really-said-about-women.

6 DeRusha, *Katharina and Martin Luther*, 171, quoting Sprenger and Kramer.

7 Brundage, *Law, Sex, and Christian Society*, 549, citing Giovanni Nevizzani.

8 Cited in Steven E. Ozment, *When Fathers Ruled: Family Life in Reformation Europe* (Cambridge, MA: Harvard University Press, 1983), 11.

9 Brundage, *Law, Sex, and Christian Society*, 492.

10 Anderson, *Daily Life*, 121.

11 Selderhuis, *Marriage and Divorce*, 229–30.

CHAPTER 6 | *The Catholic Church's Ideas about Vocation: Do Something Holy*

1 Raymond Brown, "Medieval Spirituality," *The Baptist Quarterly* 27 (1978): 194, https://biblicalstudies.org.uk/pdf/bq/27-5_194.pdf.

2 Gary Chamberlain, "Protestant and Catholic Meanings of Vocation: Is Business a True Vocation?" University of St. Thomas, accessed September 15, 2017, https://www.stthomas.edu/media/catholicstudies /center/documents/businessasacallingpdf/06Chamberlain.pdf.

3 Brown, "Medieval Spirituality," 196.

4 Brown, "Medieval Spirituality," 196.

5 Alister McGrath, "Calvin and the Christian Calling," *First Things* 94 (June 1999): 31–35, https://www.firstthings.com/article/1999/06 /calvin-and-the-christian-calling.

6 Chamberlain, "Protestant and Catholic Meanings of Vocation: Is Business a True Vocation?" citing Hardy.

7 Aquinas, quoted in James R. Farr, *The Work of France: Labor and Culture in Early Modern Times, 1350–1800* (Lanham, MD: Rowman and Littlefield, 2008), 123.

8 Brown, "Medieval Spirituality," 208, citing Pourrat.

CHAPTER 7 | *Convent Life*

1 Silvia Evangelisti, *Nuns: A History of Convent Life* (Oxford: Oxford University Press, 2007), 43.

2 Evangelisti, *Nuns*, 4.

3 Phyllis Stock, *Better Than Rubies: A History of Women's Education* (New York: Capricorn Books, 1978), 82.

4 Evangelisti, *Nuns*, 19.

5 Evangelisti, *Nuns*, 8.

6 D'Aubigne, *History of the Great Reformation 1*, 42.

7 Miriam U. Chrisman, "Women and the Reformation in Strasbourg 1490–1530," *Archive for Reformation History* 63 (December 1972): 163, https://doi.org/10.14315/arg-1972-jg09.

8 Chrisman, "Women and the Reformation," 164.

9 Evangelisti, *Nuns*, 64.

10 Chrisman, "Women and the Reformation," 164.

11 Rudolf K. Markwald and Marilynn Morris, *Katharina Von Bora: A Reformation Life* (Saint Louis: Concordia, 2002), 23.

12 Markwald and Morris, *Katharina Von Bora*, 25, 31.

13 Markwald and Morris, *Katharina Von Bora*, 70.

14 Markwald and Morris, *Katharina Von Bora*, 32.

15 Roland H. Bainton, *Women of the Reformation in Germany and Italy* (Minneapolis: Fortress Press, 2007), 45.

16 Bainton, *Women of the Reformation in Germany and Italy*, 46.

17 Bainton, *Women of the Reformation in Germany and Italy*, 47–48.

18 Kirsi Stjerna, *Women and the Reformation* (Malden, MA: Blackwell Publishing, 2009), 24.

19 Bainton, *Women of the Reformation in Germany and Italy*, 48.

20 Roland H. Bainton, *Women of the Reformation in France and England* (Minneapolis: Fortress Press, 2007), 89.

21 Bainton, *Women of the Reformation in France and England*, 89.

22 James I. Good, *Women of the Reformed Church* (San Bernadino, CA: Leopold Classic Library, 2016), 105.

23 DeRusha, *Katharina and Martin Luther*, 41.

24 Evangelisti, *Nuns*, 20.

25 Evangelisti, *Nuns*, 5.

26 Selderhuis, *Marriage and Divorce*, 116.

27 Arcangela Tarabotti, quoted in Evangelisti, *Nuns*, 21.

28 As cited in Markwald and Morris, *Katharina Von Bora*, 24.

29 Evangelisti, *Nuns*, 9.

30 Evangelisti, *Nuns*, 43.

31 Quoted in Evangelisti, *Nuns*, 16.

32 Evangelisti, *Nuns*, 17.

33 Quoted in Evangelisti, *Nuns*, 17.

34 Evangelisti, *Nuns*, 17.

35 Evangelisti, *Nuns*, 19.

36 DeRusha, *Katharina and Martin Luther*, 111.

37 Markwald and Morris, *Katharina Von Bora*, 32.

38 Evangelisti, *Nuns*, 28.

39 Markwald and Morris, *Katharina Von Bora*, 30.

40 Markwald and Morris, *Katharina Von Bora*, 41.

41 Markwald and Morris, *Katharina Von Bora*, 161–62.

42 Selderhuis, *Marriage and Divorce*, 117.

43 Craig Harline, *The Burdens of Sister Margaret: Inside a Seventeenth-Century Convent* (New Haven, CT: Yale University Press, 2000); Judith C. Brown, *Immodest Acts: The Life of a Lesbian Nun in Renaissance Italy* (Oxford: Oxford University Press, 1986), quoted in Amy Leonard, "Female Religious Orders," in R. Po-chia Hsia, ed., *A Companion to the Reformation World* (Malden, MA: Blackwell, 2004), 250.

44 Evangelisti, *Nuns*, 60.

45 Evangelisti, *Nuns*, 38.

46 Ozment, *When Fathers Ruled*, 21.

47 Ozment, *Ancestors*, 50.

48 Evangelisti, *Nuns*, 156.

49 Evangelisti, *Nuns*, 92–93.

50 Evangelisti, *Nuns*, 92–93.

51 Evangelisti, *Nuns*, 91.

52 Evangelisti, *Nuns*, 90.

53 C.H. Lawrence, quoted in DeRusha, *Katharina and Martin Luther*, 39.

54 Evangelisti, *Nuns*, 28; and DeRusha, *Katharina and Martin Luther*, 39.

55 Evangelisti, *Nuns*, 32.

56 Evangelisti, *Nuns*, 53 and 28.

57 Evangelisti, *Nuns*, 53.

58 Evangelisti, *Nuns*, 9.

59 Evangelisti, *Nuns*, 51.

60 Evangelisti, *Nuns*, 30.

61 Evangelisti, *Nuns*, 31.

62 Evangelisti, *Nuns*, 32.

63 Ozment, *When Fathers Ruled*, 21; Evangelisti, *Nuns*, 9.

64 Markwald and Morris, *Katharina Von Bora*, 30.

65 Markwald and Morris, *Katharina Von Bora*, 37.

66 Ozment, *Ancestors*, 39.

CHAPTER 8 | *Marriage: A Life for the Less Holy*

1 Brundage, *Law, Sex, and Christian Society*, 538.

2 Future Church, "A Brief History of Celibacy in the Catholic Church," https://www.futurechurch.org/brief-history-of-celibacy-in -catholic-church.

3 Merry Weisner-Hanks, "Martin Luther on Marriage and Family," *Religion: Oxford Research Encyclopedias* (July 2016), http://religion .oxfordre.com/view/10.1093/acrefore/9780199340378.001.0001 /acrefore-9780199340378–e-365.

4 Joshua Appel, "A Theology of Regret: Augustine on the Good of Marriage," paper, Reformed Theological Seminary, 5.

5 Appel, "A Theology of Regret," 5.

6 Jerome, "Letter XLVIII to Pammachius," in W.H. Fremantle, trans., *Jerome: The Principal Works of St Jerome*, vol. 6 of *Nicene and Post-Nicene Fathers of the Christian Church*, ed. Philip Schaff (Peabody, MA: Hendrickson Publishers, 1893), https://www.ccel.org /ccel/schaff/npnf206.v.XLVIII.html.

7 Jerome, quoted in DeRusha, *Katharina and Martin Luther*, 144.

8 Appel, "A Theology of Regret," 8.

9 Appel, "A Theology of Regret," 10–11.

10 Selderhuis, *Marriage and Divorce*, 28.

11 Martin Luther, *The Marriage Ring: Three Sermons on Marriage*, trans. J. Sheatsley (San Diego, CA: The Book Tree, 2003), 38.

12 Cited in Ozment, *When Fathers Ruled*, 10.

13 Emilie Amt, *Women's Lives in Medieval Europe* (New York: Rout-ledge, 2010), 80–82.

14 Ozment, *When Fathers Ruled*, 3.

15 Ozment, *When Fathers Ruled*, 3.

16 Ozment, *When Fathers Ruled*, 1.

17 Brundage, *Law, Sex, and Christian Society*, 494.

18 Ozment, *When Fathers Ruled*, 42.

19 Ozment, *When Fathers Ruled*, 44.

20 Cited in Ozment, *When Fathers Ruled*, 45.

21 Ozment, *When Fathers Ruled*, 45.

22 Selderhuis, *Marriage and Divorce*, 13.

23 Selderhuis, *Marriage and Divorce*, 193.

24 Brundage, *Law, Sex, and Christian Society*, 497.

25 Selderhuis, *Marriage and Divorce*, 27.

26 Selderhuis, *Marriage and Divorce*, 27.

27 Selderhuis, *Marriage and Divorce*, 194.

28 Raffaella Sarti, *Europe at Home: Family and Material Culture 1500–1800*, trans. Allan Cameron (New Haven, CT: Yale University Press, 2002), 51.

29 Brundage, *Law, Sex, and Christian Society*, 497.

30 Appel, "A Theology of Regret," 11.

31 Brundage, *Law, Sex, and Christian Society*, 503.

32 Selderhuis, *Marriage and Divorce*, 28.

33 Brundage, *Law, Sex, and Christian Society*, 508.

34 Ozment, *Ancestors*, 33.

35 Brundage, *Law, Sex, and Christian Society*, 521–22, 526.

36 Brundage, *Law, Sex, and Christian Society*, 522.

37 Brundage, *Law, Sex, and Christian Society*, 529.

38 Brundage, *Law, Sex, and Christian Society*, 523.

CHAPTER 9 | *A Revolutionary View of Salvation*

1 Robert Farrar Capon, *Between Noon and Three: Romance, Law, and the Outrage of Grace* (Grand Rapids, MI: William B. Eerdmans, 1997), 109.

2 D'Aubigne, *The Triumph of Truth*, 38.

3 D'Aubigne, *The Triumph of Truth*, 82–83.

4 Cited in Bainton, *Women of the Reformation in Germany and Italy*, 59.

5 D'Aubigne, *The Triumph of Truth*, 360–361.

6 D'Aubigne, *The Triumph of Truth*, 378; Terpstra, "The Reformation."

7 John Piper, "Martin Luther: Lessons From His Life and Labor," *Desiring God*, January 30, 1996, http://www.desiringgod.org/messages /martin-luther-lessons-from-his-life-and-labor.

8 Henry Eyster Jacobs, ed., *Works of Martin Luther* (Philadelphia: Muhlenberg, 1943), 2:399–400.

CHAPTER 10 | *A New View of Women*

1 Thompson, John Lee, *John Calvin and the Daughters of Sarah: Women in Regular and Exceptional Roles in the Exegesis of Calvin, His Predecessors, and His Contemporaries* (Geneva: Librarie Droz, 1992), 127.

2 Augustine, quoted in Thompson, *John Calvin*, 129.

3 Thompson, *John Calvin*, 129.

4 Brundage, *Law, Sex, and Christian Society*, 560, quoting Luther.

5 John Calvin, *Commentary on Genesis*, Bible Hub, http://biblehub.com /commentaries/calvin/genesis/2.htm.

6 Wiesner-Hanks, "Martin Luther on Marriage and Family," 31.

7 Calvin, *Commentary on Genesis*, Bible Hub, http://biblehub.com/ commentaries/calvin/genesis/2.htm.

8 Thompson, *John Calvin*, 122.

9 Wiesner-Hanks, "Martin Luther on Marriage and Family," 31.

10 See Calvin's commentary on Genesis.

11 Luther, quoted in DeRusha, *Katharina and Martin Luther*, 200.

12 See his comments on Gen. 2:22 in Martin Luther, *Lectures on Genesis: Chapters 1–5*, ed. Jaroslav Pelikan (Saint Louis: Concordia Publishing House, 1955), 134.

CHAPTER 11 | *Christian Mother Instead of Catholic Nun*

1 Ian Hart, "The Teaching of Luther and Calvin About Ordinary Work: 2. John Calvin (1509–64)," *Evangelical Quarterly* 62, no. 2 (1995): 121, https://biblicalstudies.org.uk/pdf/eq/1995-2_121.pdf.

2 Calvin, quoted in Hart, "The Teaching of Luther and Calvin," 127.

3 Alister McGrath, "Calvin and the Christian Calling," *First Things* 94 (June/July 1999): 31–35, https://www.firstthings.com/article /1999/06/calvin-and-the-christian-calling.

4 Calvin, *Institutes of the Christian Religion* (Philadelphia: Westminster Press, 1960), 725.

5 Calvin, quoted in Hart, "The Teaching of Luther and Calvin," 128.

6 McGrath, "Calvin and the Christian Calling."

7 Hart, "The Teaching of Luther and Calvin," 135.

8 Gustaf Wingren, *Luther on Vocation*, trans. Carl C. Rasmussen (Eugene, OR: Wipf and Stock, 2004), 19.

9 Luther, cited in Wingren, *Luther on Vocation*, 137–38.

10 Wingren, *Luther on Vocation*, 200.

11 Luther in a sermon, cited in Wingren, *Luther on Vocation*, 54–55.

12 Selderhuis, *Marriage and Divorce*, 333–34.

13 Wingren, *Luther on Vocation*, 32.

14 Selderhuis, *Marriage and Divorce*, 331.

15 Bucer, quoted in Selderhuis, *Marriage and Divorce*, 332.

16 Luther, *The Marriage Ring*, 42.

17 Katharina Schutz Zell, "Defending Clerical Marriage," trans. Thomas A. Brady Jr., in Brady and Ellen Yutzy Glebe, eds., *German History in Documents and Images: Vol. 1 From the Reformation to the Thirty Years War 1500–1648*, http://germanhistorydocs.ghi-dc.org /pdf/eng/Doc.60–ENG-ZellMarriage_eng.pdf.

18 Zell, "Defending Clerical Marriage."

19 Zell, quoted in Elise McKee, trans. and ed. *Katharina Schutz Zell: Church Mother, The Writings of a Protestant Reformer in Sixteenth-Century Germany* (Chicago: University of Chicago Press, 2006), 75.

20 Zell, quoted in McKee, *Katherine Schutz Zell*, 74.

21 Brundage, *Law, Sex, and Christian Society*, 538.

22 Martin Luther, "Estate of Marriage," trans. Walter I. Brandt, 1215. org, https://www.1215.org/lawnotes/misc/marriage/martin-luther -estate-of-marriage.pdf.

23 Cited in Selderhuis, *Marriage and Divorce*, 173.

CHAPTER 12 | *Protestant Marriage Instead of Catholic Celibacy*

1 Schaff, *History of the Christian Church* 7, 477.

2 Schaff, *History of the Christian Church* 7, 477.

3 Calvin's *Institutes*, 4.12.24–25.

4 Selderhuis, *Marriage and Divorce*, 181.

5 Selderhuis, *Marriage and Divorce*, 172, summarizing Bucer.

6 Luther, "The Estate of Marriage."

7 Heinrich von Kettenbach, cited in Ozment, *When Fathers Ruled*, 31.

8 Selderhuis, *Marriage and Divorce*, 128.

9 Cited in Selderhuis, *Marriage and Divorce*, 250–252.

10 Cited in Ozment, *When Fathers Ruled*, 136.

11 Stjerna, *Women and the Reformation*, 35.

12 Chrisman, "Women and the Reformation," 166.

13 Cited in Selderhuis, *Marriage and Divorce*, 231.

14 Luther in his commentary on the Sermon on the Mount, cited in Wingren, *Luther on Vocation*, 33.

15 Selderhuis, *Marriage and Divorce*, 236.

16 Selderhuis, *Marriage and Divorce*, 236, paraphrasing Bucer's thought.

17 Luther, *The Marriage Ring*, 69.

18 Selderhuis, *Marriage and Divorce*, 238.

19 Cited in Selderhuis, *Marriage and Divorce*, 234.

20 Cited in Selderhuis, *Marriage and Divorce*, 198.

21 Selderhuis, *Marriage and Divorce*, 233.

22 Bucer, quoted in Selderhuis, *Marriage and Divorce*, 235.

23 Luther, *Lectures on Genesis*, 137.

24 Merry E. Weisner, "Nuns, Wives, and Mothers: Women and the Reformation in Germany," in Sherrin Marshall, ed., *Women in Reformation and Counter-Reformation Europe* (Bloomington, IN: University Press, 1989), 18.

25 Selderhuis, *Marriage and Divorce*, 236.

26 Luther, *The Marriage Ring*, 17.

27 Luther, *The Marriage Ring*, 66.

28 Selderhuis, *Marriage and Divorce*, 198.

29 DeRusha, *Katharina and Martin Luther*, 140.

30 Brundage, *Law, Sex, and Christian Society*, 553.

31 Luther, "The Estate of Marriage."

32 Ozment, *When Fathers Ruled*, 45–46.

33 Selderhuis, *Marriage and Divorce*, 45, 168; and Brundage, *Law, Sex, and Christian Society*, 556.

34 Selderhuis, *Marriage and Divorce*, 176, citing Bucer.

35 Selderhuis, *Marriage and Divorce*, 177.

36 Selderhuis, *Marriage and Divorce*, 178.

37 Selderhuis, *Marriage and Divorce*, 176.

38 Selderhuis, *Marriage and Divorce*, 231.

39 Ozment, *When Fathers Ruled*, 177.

40 Quoted in Ozment, *When Fathers Ruled*, 132.

41 Luther, quoted in DeRusha, *Katharina and Martin Luther*, 234.

42 Selderhuis, *Marriage and Divorce*, 174, citing Bucer.

43 Luther, "The Estate of Marriage."

44 Ozment, *Ancestors*, 40.

45 Merry Wiesner-Hanks, *Women and Gender in Early Modern Europe* (Cambridge: Cambridge University Press, 2008), 129.

46 Ozment, *When Fathers Ruled*, 68.

47 Ozment, *When Fathers Ruled*, 69.

48 Ozment, *When Fathers Ruled*, 54.

49 Ozment, *When Fathers Ruled*, 55, 56.

50 Ozment, *When Fathers Ruled*, 49.

CHAPTER 13 | *Women of the Reformation*

1 Cited in Schaff, *History of the Christian Church* 7, 479.

2 Stjerna, *Women and the Reformation*, 37.

3 Schaff, *History of the Christian Church* 7, 478.

4 Schaff, *History of the Christian Church* 7, 475.

5 Markwald and Morris, *Katharina Von Bora*, 93.

6 Cited in D'Aubigne, *History of the Great Reformation* 3, 282.

7 Cited in Ozment, *When Fathers Ruled*, 23.

8 Stjerna, *Women and the Reformation*, 52.

9 Cited in Bainton, *Women of the Reformation in Germany and Italy*, 27.

10 Markwald and Morris, *Katharina Von Bora*, 78–79.

11 Selderhuis, *Marriage and Divorce*, 118.

12 Zell, "Defending Clerical Marriage."

13 Bainton, *Women of the Reformation in Germany and Italy*, 19, 27.

14 Cited in Bainton, *Women of the Reformation in Germany and Italy*, 55.

15 Quoted in Markwald and Morris, *Katharina Von Bora*, 63.

16 Quoted in Markwald and Morris, *Katharina Von Bora*, 63.

17 Zell, "Defending Clerical Marriage."

CHAPTER 14 | *Faithful Reformers' Wives*

1 Bainton, *Women of the Reformation in France and England*, 211.

2 Bainton, *Women of the Reformation in Germany and Italy*, 81.

3 Stjerna, *Women and the Reformation*, 215.

4 Bainton, *Women of the Reformation in Germany and Italy*, 61.

5 Markwald and Morris, *Katharina Von Bora*, 53.

6 Markwald and Morris, *Katharina Von Bora*, 151–52.

7 Markwald and Morris, *Katharina Von Bora*, 158.

8 Bainton, *Women of the Reformation in Germany and Italy*, 64.

9 Bainton, *Women of the Reformation in Germany and Italy*, 65.

10 Bainton, *Women of the Reformation in Germany and Italy*, 68.

11 Bainton, *Women of the Reformation in Germany and Italy*, 84.

12 Cited in Bainton, *Women of the Reformation in Germany and Italy*, 88.

13 Markwald and Morris, *Katharina Von Bora*, 56.

14 Schaff, *History of the Christian Church* 7, 456.

15 Bainton, *Women of the Reformation in Germany and Italy*, 29.

16 Markwald and Morris, *Katharina Von Bora*, 81.

17 DeRusha, *Katharina and Martin Luther*, 177.

18 Markwald and Morris, *Katharina Von Bora*, 76; Derusha, *Katharina and Martin Luther*, 178.

19 Markwald and Morris, *Katharina Von Bora: A Reformation Life*, 82.

20 Bainton, *Women of the Reformation in Germany and Italy*, 30.

21 Stjerna, *Women and the Reformation*, 62.

22 Ozment, *Ancestors*, 32; Stjerna, *Women and the Reformation*, 60.

23 Stjerna, *Women and the Reformation*, 58.

24 DeRusha, *Katharina and Martin Luther*, 178.

25 Luther, quoted in Markwald and Morris, *Katharina Von Bora*, 166.

26 Anderson, *Daily Life*, 63.

27 Anderson, *Daily Life*, 178.

28 Anderson, *Daily Life*, 113–14.

29 Markwald and Morris, *Katharina Von Bora*, 128–29.

30 Matthew Barrett, "Martin Luther on Marriage as a School of Character," *The Gospel Coalition*, August 3, 2011, https://www.thegospelcoalition.org/article/martin-luther-on-marriage-as-a-school-of-character.

31 Markwald and Morris, *Katharina Von Bora*, 110.

32 Markwald and Morris, *Katharina Von Bora*, 118.

33 Markwald and Morris, *Katharina Von Bora*, 124.

34 VanDoodewaard, *Reformation Women*, 3.

35 Markwald and Morris, *Katharina Von Bora*, 163.

36 Quoted in Markwald and Morris, *Katharina Von Bora*, 142.

37 Markwald and Morris, *Katharina Von Bora*, 164.

38 Quoted in Markwald and Morris, *Katharina Von Bora*, 192.

39 Markwald and Morris, *Katharina Von Bora*, 139.

40 Markwald and Morris, *Katharina Von Bora*, 84; DeRusha, *Katharina and Martin Luther*, 208.

41 Quoted in Bainton, *Women of the Reformation in Germany and Italy*, 26.

42 Quoted in D'Aubigne, *History of the Great Reformation 3*, 282.

43 Markwald and Morris, *Katharina Von Bora*, 142.

44 Selderhuis, *Marriage and Divorce*, 120.

45 Quoted in Selderhuis, *Marriage and Divorce*, 120.

46 Quoted in Selderhuis, *Marriage and Divorce*, 120–21.

47 Selderhuis, *Marriage and Divorce*, 118, 125.

48 Bainton, *Women of the Reformation in Germany and Italy*, 87; and Selderhuis, *Marriage and Divorce*, 121.

49 Selderhuis, *Marriage and Divorce*, 122.

50 Selderhuis, *Marriage and Divorce*, 122.

51 Edwin Woodruff Tait, "Bride of the Reformation," *Christianity History & Biography* 84 (2004): 43–45, http://www.christianitytoday.com/history/issues/issue-84/bride-of-reformation.html.

52 Quoted in Bainton, *Women of the Reformation in Germany and Italy*, 82.

53 Bainton, *Women of the Reformation in Germany and Italy*, 87.

54 Quoted in Bainton, *Women of the Reformation in Germany and Italy*, 81.

55 Selderhuis, *Marriage and Divorce*, 124.

56 Selderhuis, *Marriage and Divorce*, 123–24.

57 Bucer, quoted in Selderhuis, *Marriage and Divorce*, 125.

58 Selderhuis, *Marriage and Divorce*, 126.

59 Stjerna, *Women and the Reformation*, 111.

60 VanDoodewaard, *Reformation Women*, 15.

61 Anderson, *Daily Life*, 51.

62 VanDoodewaard, *Reformation Women*, 16.

63 Zell, quoted in McKee, *Katharina Schutz Zell*, 77.

64 Cited in Bainton, *Women of the Reformation in Germany and Italy*, 55.

65 McKee, *Katharina Schutz Zell*, 221.

66 Quoted in Good, *Women of the Reformed Church*, 46–47.

67 Stjerna, *Women and the Reformation*, 114.

68 Anderson, *Daily Life*, 177.

69 McKee, *Women and the Reformation*, 50–56.

70 Zell, "Defending Clerical Marriage."

71 Zell, quoted in McKee, *Women and the Reformation*, 188.

72 Stjerna, *Women and the Reformation*, 125.

73 Regula Bochsler, "Anna Reinhart, Zwingli's Wife: 'Nothing is more precious than love'," SwissInfo, May 22, 2017, https://www .swissinfo.ch/eng/anna-reinhart--zwingli-s-wife_-nothing-is-more -precious-than-love-/43198036.

74 Bochsler, "Anna Reinhart."

75 Good, *Women of the Reformed Church*, 13.

76 Good, *Women of the Reformed Church*, 15.

77 Good, *Women of the Reformed Church*, 16–17. This whole section is taken from Good, *Women of the Reformed Church*, 5–19.

78 Rebecca A. Giselbrecht, "Myths and Reality about Heinrich Bullinger's Wife Anna," *Zwingliana* 38 (2011): 53–66, http://zwingliana.ch /index.php/zwa/article/viewFile/2323/2342.

79 Giselbrecht, "Myths and Reality."

80 William VanDoodewaard, "Reformation Church History—Women of the Reformation, pt 1," Lecture at Puritan Theological Seminary, November 13, 2015, https://www.youtube.com/watch?v=mwQpQyG4VNQ.

81 VanDoodewaard, *Reformation Women*, 12.

82 VanDoodewaard, "Reformation Church History—Women of the Reformation, pt 1."

83 Schaff, *History of the Christian Church 8*, 207.

84 Steven Lawson, "Covenant Theologian: Heinrich Bullinger," in Greg Bailey, ed., *Pillars of Grace (A Long Line of Godly Men, Volume 2)* (Lake Mary, FL: Reformation Trust Publishing, 2011), 427–48.

85 VanDoodewaard, *Reformation Women*, 10.

86 Bouwsma, *A Sixteenth Century-Portrait* (Oxford: Oxford University Press, 1998), 23.

87 D'Aubigne, *History of the Great Reformation 2*, 130–32.

88 Markwald and Morris, *Katharina Von Bora*, 156.

CHAPTER 15 | *Other Faithful Women: The Antidote to Feminism*

1 "Reformation Church History—Women of the Reformation, pt 2," Lecture at Puritan Theological Seminary, November 18, 2015, https://www.youtube.com/watch?v=l7e59ZYd71o.

2 Olympia Morata, *The Complete Writings of an Italian Heretic*, edited and translated by Holt N. Parker (Chicago: University of Chicago Press, 2003), 26.

3 VanDoodewaard, *Reformation Women*, 101.

4 Stjerna, *Women and the Reformation*, 205.

5 Morata, *The Complete Writings*, 27.

6 Stjerna, *Women and the Reformation*, 207.

7 Stjerna, *Women and the Reformation*, 206.

8 Bainton, *Women of the Reformation in Germany and Italy*, 262; cited in VanDoodewaard, *Reformation Women*, 106.

9 Morata, *The Complete Writings*, 42.

10 Morata, *The Complete Writings*, 43.

11 Morata, *The Complete Writings*, 121.

12 Morata, *The Complete Writings*, 102.

13 Quoted in Bainton, *Women of the Reformation in Germany and Italy*, 260.

14 Morata, *The Complete Writings*, 137.

15 VanDoodewaard, *Reformation Women*, 104–5.

16 Morata, *The Complete Writings*, 137.

17 VanDoodewaard, "Reformation Church History—Women of the Reformation, pt 2."

18 VanDoodewaard, "Reformation Church History—Women of the Reformation, pt 2."

19 Moniek Bloks, "The Fifteen Princesses of Orange: Louise de Coligny," Royal Central, November 14, 2015, http://royalcentral.co.uk /blogs/the-fifteen-princesses-of-orange-louise-de-coligny-55996.

20 Bainton, *Women of the Reformation in France and England*, 114–15.

21 Quoted in Bainton, *Women of the Reformation in France and England*, 115. He notes that this record comes from a third party who was not present at the discussion, although it is possible that person talked to one of the conversants.

22 Bainton, *Women of the Reformation in France and England*, 115.

23 Bainton, *Women of the Reformation in France and England*, 116–17.

24 Luther, cited in Schaff, *History of the Christian Church* 7, 461.

25 Quoted in Selderhuis, *Marriage and Divorce*, 130.

26 Selderhuis, *Marriage and Divorce*, 242.

27 VanDoodewaard, *Reformation Women*, 27.

CHAPTER 16 | *Protesatant Women in Power*

1 Peter Matheson, *Argula von Grumbach: A Woman Before Her Time* (Eugene, OR: Cascade Books, 2013), 62.

2 VanDoodewaard, *Reformation Women*, 64.

3 VanDoodewaard, *Reformation Women*, 66.

4 Quoted in Bainton, *Women of the Reformation in France and England*, 101.

5 Quoted in Bainton, *Women of the Reformation in France and England*, 101.

6 Bainton, *Women of the Reformation in France and England*, 101.

7 VanDoodewaard, "Reformation Church History—Women of the Reformation, pt 1."

8 Diana Maury Robin, Anne R. Larsen, and Carole Levin, eds., *Encyclopedia of Women in the Renaissance: Italy, France, and England* (Santa Barbara, CA: ABC-CLIO, 2007), 86–87.

9 Quoted in VanDoodewaard, "Reformation Church History—Women of the Reformation, pt 1."

10 Bloks, "The Fifteen Princesses."

11 Bloks, "The Fifteen Princesses."

12 VanDoodewaard, "Reformation Church History—Women of the Reformation, pt 2."

13 VanDoodewaard, "Reformation Church History—Women of the Reformation, pt 2," quoting a biographer.

14 Robin et al., *Encyclopedia of Women*, 86–87.

15 Bloks, "The Fifteen Princesses."

16 Robin et al., *Encyclopedia of Women*, 86–87.

17 Robin et al., *Encyclopedia of Women*, 86–87.

18 VanDoodewaard, "Reformation Church History—Women of the Reformation, pt 2."

19 VanDoodewaard, "Reformation Church History—Women of the Reformation, pt 2."

20 Bainton, *Women of the Reformation in Germany and Italy*, 111–21.

21 Markwald and Morris, *Katharina Von Bora*, 149–50.

22 Bainton, *Women of the Reformation in Germany and Italy*, 125–31.

23 Bainton, *Women of the Reformation in Germany and Italy*, 142.

24 Rouben Cholakian, *Marguerite de Navarre: A Literary Queen* (Bloomington: Xlibris, 2016), 5.

25 Cholakian, *Marguerite de Navarre*, 6–7.

26 Cholakian, *Marguerite de Navarre*, 7.

27 Anderson, *Daily Life*, 215.

28 Cholakian, *Marguerite de Navarre*, 7–8.

29 Valerie Foucachon, *The Mirror of All Christian Queens: A Translation of Marguerite de Navarre's Correspondence* (Moscow, ID: Roman Roads Media, 2016), 26–27.

30 Cholakian, *Marguerite de Navarre*, 11–12.

31 Cited in Good, *Women of the Reformed Church*, 60.

32 Stock, *Better Than Rubies*, 45.

33 Stock, *Better Than Rubies*, 46.

34 Stjerna, *Women and the Reformation*, 152.

35 Cholakian, *Marguerite de Navarre*, 14–16.

36 VanDoodewaard, *Reformation Women*, 30.

37 Bainton, *Women of the Reformation in France and England*, 20, 22.

38 Bainton, *Women of the Reformation in France and England*, 24.

39 VanDoodewaard, *Reformation Women*, 31.

40 VanDoodewaard, *Reformation Women*, 39.

41 VanDoodewaard, *Reformation Women*, 34.

42 VanDoodewaard, *Reformation Women*, 42.

43 Cholakian, *Marguerite de Navarre*, 20.

44 Cholakian, *Marguerite de Navarre*, 20.

45 Quoted in Bainton, *Women of the Reformation in France and England*, 46.

46 VanDoodewaard, *Reformation Women*, 44.

47 Quoted in Bainton, *Women of the Reformation in France and England*, 50.

48 VanDoodewaard, *Reformation Women*, 45.

49 Bainton, *Women of the Reformation in France and England*, 54.

50 VanDoodewaard, "Reformation Church History—Women of the Reformation, pt 1."

51 VanDoodewaard, "Reformation Church History—Women of the Reformation, pt 1."

52 Bainton, *Women of the Reformation in France and England*, 54.

53 Bainton, *Women of the Reformation in France and England*, 57.

54 Good, *Women of the Reformed Church*, 77.

55 Martha Walker Freer, *The Life of Jeanne D'Albret, Queen of Navarre, Vol. II* (London: Hurst and Blackett Publishers, 1855), 84.

56 VanDoodewaard, *Reformation Women*, 50.

57 Roelker, quoted in Stjerna, *Women and the Reformation*, 150.

58 VanDoodewaard, "Reformation Church History—Women of the Reformation, pt 1."

59 Bainton, *Women of the Reformation in France and England*, 58, 68.

60 Bainton, *Women of the Reformation in France and England*, 58.

61 Stjerna, *Women and the Reformation*, 168.

62 Quoted in Bainton, *Women of the Reformation in France and England*, 59–61.

63 Stjerna, *Women and the Reformation*, 166.

64 Anderson, *Daily Life*, 96.

65 Bainton, *Women of the Reformation in France and England*, 75–80.

66 Quoted in Bainton, *Women of the Reformation in France and England*, 81.

67 VanDoodewaard, *Reformation Women*, 92.

68 VanDoodewaard, *Reformation Women*, 94.

69 Bowles, *Olympia Morata*, 38.

70 Good, *Women of the Reformed Church*, 128.

71 Good, *Women of the Reformed Church*, 129–30.

72 VanDoodewaard, *Reformation Women*, 96.

73 Quoted in Good, *Women of the Reformed Church*, 131.

CHAPTER 17 | *How Modern Feminists View the Reformation*

1 Roper, quoted in Stjerna, *Women and the Reformation*, 215.

2 Stjerna, *Women and the Reformation*, 221.

3 Stjerna, *Women and the Reformation*, 221.

4 Stjerna, *Women and the Reformation*, 24.

5 Stjerna, *Women and the Reformation*, 31.

6 Ozment, *Ancestors*, 39.

7 Stjerna, *Women and the Reformation*, 30.

8 Stjerna, *Women and the Reformation*, 14.

9 Stjerna, *Women and the Reformation*, 33.

10 Stjerna, *Women and the Reformation*, 215.

11 Stjerna, *Women and the Reformation*, 39.

12 Ozment, *Ancestors*, 23.

13 Ozment, *Ancestors*, 31.

14 Markwald and Morris, *Katharina Von Bora*, 31–32.

15 Ozment, *Ancestors*, 39–40.

16 Ozment, *Ancestors*, 32.

CHAPTER 18 | *Societal Changes in the Siteenth Century: The Reformation Made a Lot of Things Better*

1 Schaff, *History of the Christian Church 8*, 11.

2 Schaff, *History of the Christian Church 7*, 481.

3 Charles Colson and Nancy Pearcey, *How Now Shall We Live?* (Carol Stream, IL: Tyndale House, 1999), 302.

4 Stjerna, *Women and the Reformation*, 117.

5 William Clarence Webster, *A General History of Commerce* (London: Ginn, 1903), 184.

6 Marin Luther, "A Sermon on Keeping Children in School," in *Luther's Works*, Vol. 46, ed. Jaroslav Pelican and Helmut T. Lehmann (Philadelphia: Fortress Press, 1967), 213–57.

7 Luther, "A Sermon."

8 Lowell Green, "The Education of Women in the Reformation," *History of Education Quarterly* 19, no. 1 (Spring 1979): 93–116. https://www.depts.ttu.edu/education/our-people/Faculty/additional_pages/duemer/epsy_5314_class_materials/Education-of-women-in-the-Reformation.pdf.108.

9 Stock, *Better Than Rubies*, 65–66.

10 Stock, *Better Than Rubies*, 82.

11 Stock, *Better Than Rubies*, 66, paraphrasing Johann Comenius, a German pedagogue of the early seventeenth century.

12 Selderhuis, *Marriage and Divorce*, 241.

13 Ambrosius Moibanus, quoted in Green, "The Education of Women," 98.

14 Green, "The Education of Women," 95.

15 Stock, *Better Than Rubies*, 63.

16 Green, "The Education of Women," 97.

17 Green, "The Education of Women," 97.

18 Stock, *Better Than Rubies*, 63, quoting Melanchthon from Eby.

19 Stock, *Better Than Rubies*, 62.

20 Ivan L. Zabilka, "Calvin's Contribution to Universal Education," *The Asbury Theological Journal* 44, no. 1 (1989): 79-96, http://place.asburyseminary.edu/cgi/viewcontent.cgi?article=1408&context=asburyjournal; Virtual Museum of Protestantism, "The Protestant education in the 16th century," under Homes, Themes, https://www.museeprotestant.org/en/notice/the-protestant-education-in-the-xvith-century/.

21 Green, "The Education of Women," 105.

22 Green, "The Education of Women," 106.

23 Stock, *Better Than Rubies*, 65.

24 Stock, *Better Than Rubies*, 64.

25 Stock, *Better Than Rubies*, 68.

26 Schaff, *History of the Christian Church* 7, 478.

27 D'Aubigne, *History of the Great Reformation* 3, 285.

28 Douglass, quoted in Stjerna, *Women and the Reformation*, 31.

29 Anderson, *Daily Life*, 122.

30 Ozment, *When Fathers Ruled*, 99.

31 Luther, *Lectures on Genesis*, 135–36.

32 F. Gerrit Immink, *The Touch of the Sacred: The Practice, Theology, and Tradition of Christian Worship* (Grand Rapids, MI: Eerdmans, 2014), 2.

33 Brienen, quoted in Immink, *The Touch of the Sacred*, 3.

34 Anderson, *Daily Life*, 66.

35 Anderson, *Daily Life*, 147.

36 Sarti, *Europe at Home*, 174.

37 Elaine Khosrova, *Butter: A Rich History* (Chapel Hill, NC: Algonquin Books of Chapel Hill, 2016), 54.

38 Khosrova, *Butter*, 187–88.

39 Khosrova, *Butter*, 55.

40 Sarti, *Europe at Home*, 173.

41 Webster, *General History*, 113–14.

CHAPTER 19 | *The Reformation and You*

1 Quoted in Markwald and Morris, *Katharina Von Bora*, 192.

2 Luther, quoted in Derusha, *Katharina and Martin Luther*, 151.

3 VanDoodewaard, "Reformation Church History—Women of the Reformation, pt 1."

4 Selderhuis, *Marriage and Divorce*, 123–24.

5 Rosaria Champagne Butterfield, *Openness Unhindered* (Pittsburgh: Crown and Covenant Publications, 2015), 189.

CHAPTER 20 | *What Does This Mean for Women's Vocations?*

1 P.J. O'Rourke, *All the Trouble in the World: The Lighter Side of Overpopulation, Famine, Ecological Disaster, Ethnic Hatred, Plague, and Poverty* (New York: The Atlantic Monthly Press, 1994), 9.

2 Morata, *The Complete Writings*, 102.

BIBLIOGRAPHY

Anderson, James M. *Daily Life During the Reformation*. Santa Barbara, CA: Greenwood, 2011.

Appel, Joshua. "A Theology of Regret: Augustine on the Good of Marriage." Paper, Reformed Theological Seminary.

Bainton, Roland H. *Women of the Reformation from Spain to Scandanavia*. Minneapolis: Fortress Press, 2007.

———. *Women of the Reformation in France and England*. Minneapolis: Fortress Press, 2007.

———. *Women of the Reformation in Germany and Italy*. Minneapolis: Fortress Press, 2007.

Beaty, Katelyn. *A Woman's Place: A Christian Vision for Your Calling in the Office, the Home, and the World*. New York: Howard Books, 2016.

Bloks, Moniek. "The Fifteen Princesses of Orange: Louise de Coligny." Royal Central. November 14, 2015. http://royalcentral.co.uk/blogs/the-fifteen-princesses-of-orange-louise-de-coligny-55996.

Brown, Raymond. "Medieval Spirituality." *The Baptist Quarterly* 27 (1978): 194–211. https://biblicalstudies.org.uk/pdf/bq/27-5_194.pdf.

Brundage, James A. *Law, Sex, and Christian Society in Medieval Europe*. Chicago: University of Chicago Press, 1987.

Calvin, John. *Calvin's Commentaries*. http://biblehub.com/commentaries /calvin/.

Calvin, John. *Institutes of the Christian Religion*. Philadelphia: Westminster Press, 1960.

Central Intelligence Agency (CIA). "Country Comparison: Total Fertility Rate." Accessed September 15, 2017. https://www.cia.gov /library/publications/the-world-factbook/rankorder/2127rank.html.

Chamberlain, Gary. "Protestant and Catholic Meanings of Vocation: Is Business a True Vocation?" University of St Thomas. Accessed September 15, 2017. https://www.stthomas.edu/media/catholicstudies /center/documents/businessasacallingpdf/06Chamberlain.pdf.

Cholakian, Rouben. *Marguerite de Navarre: A Literary Queen*. Bloomington: Xlibris, 2016.

Chrisman, Miriam U. "Women and the Reformation in Strasbourg 1490–1530." *Archive for Reformation History*, no. 63 (December 1, 1972): 143–168. https://doi.org/10.14315/arg-1972-jg09.

Coontz, Stephanie. "When We Hated Mom." *New York Times*, May 7, 2011. http://www.nytimes.com/2011/05/08/opinion/08coontz.html.

DeRusha, Michelle. *Katharina and Martin Luther: The Radical Marriage of a Runaway Nun and a Renegade Monk*. Grand Rapids, MI: Baker Books, 2017.

D'Aubigne, J.H. Merle. *History of the Great Reformation of the Sixteenth Century in Germany, Switzerland, &c Volume 1*, 3rd. ed. London: D. Walther, 1840.

———. *History of the Great Reformation of the Sixteenth Century in Germany, Switzerland, &c Volume 2*, 3rd. ed. London: D. Walther, 1840.

———. *History of the Great Reformation of the Sixteenth Century in Germany, Switzerland, &c Volume 3*, 3rd. ed. London: D. Walther, 1843.

———. *The Triumph of Truth: A Life of Martin Luther*. Translated by Henry White. Greenville, S.C: Bob Jones University Press, 1996.

Doll, Jen. "Dear Single Women of NYC: It's Not Them, It's You." *The Village Voice*. February 9, 2011. http://www.villagevoice.com/news /dear-single-women-of-nyc-its-not-them-its-you-6430067.

Evangelisti, Silvia. *Nuns: A History of Convent Life*. Oxford: Oxford University Press, 2007.

Filipovic, Jill. "The choice to be childfree is admirable, not selfish." *The Guardian*, August 16, 2013. https://www.theguardian.com /commentisfree/2013/aug/16/choice-child-free-admirable-not-selfish.

Foucachon, Valerie. *The Mirror of All Christian Queens: A Translation of Marguerite de Navarre's Correspondence*. Moscow, ID: Roman Roads Media, 2016.

Friedan, Betty. *The Feminine Mystique*. New York: W. W. Norton, 1997.

Good, James I. *Women of the Reformed Church*. San Bernadino, CA: Leopold Classic Library, 2016.

Green, Lowell. "The Education of Women in the Reformation." *History of Education Quarterly* 19, no 1 (Spring 1979): 93–116. https://www .depts.ttu.edu/education/our-people/Faculty/additional_pages /duemer/epsy_5314_class_materials/Education-of-women -in-the-Reformation.pdf.

Gregorovius, Ferdinand. *The History of the City of Rome in the Middle Ages, Vol. VIII, Part I.* Translated by Annie Hamilton London: George Bell and Sons, 1902. https://archive.org/details /historycityrome02hamigoog.

Hart, Ian. "The Teaching of Luther and Calvin About Ordinary Work: 2. John Calvin (1509–64)." *Evangelical Quarterly* 62, no. 2 (1995): 121–35. https://biblicalstudies.org.uk/pdf/eq/1995–2_121.pdf.

Hirshman, Linda R. *Get to Work:And Get a Life before It's Too Late*. New York: Penguin Books, 2006.

Immink, F. Gerrit. *The Touch of the Sacred: The Practice, Theology, and Tradition of Christian Worship*. Grand Rapids, MI: Eerdmans, 2014.

James, Carolyn Custis. "The Ezer Kenegdo: Ezer Unleashed." *Faith Gateway*. March 20, 2015. http://www.faithgateway.com/ezer-unleashed /#.WLB6CjvyvIU.

Khosrova, Elaine. *Butter: A Rich History*. Chapel Hill, NC: Algonquin Books of Chapel Hill, 2016.

Koenigsberger, H.G., George L. Mosse, and G. Q. Bowler, eds. *Europe in the Sixteenth Century Second Edition*. New York: Longman Scientific and Technical, 1989.

Luther, Martin. "The Estate of Marriage." Translated by Walter I. Brandt. 1215.org. Last modified October 31, 2010. https://www.1215.org /lawnotes/misc/marriage/martin-luther-estate-of-marriage.pdf.

————. *Luther's Works, Volume 1, Lectures on Genesis Chapters 1–5*. Edited by Jaroslav Pelikan. Saint Louis: Concordia, 1958.

————. 1530. "A Sermon on Keeping Children in School." In vol. 46 of *Luther's Works*, 213–57. Philadelphia: Fortress Press, 1967.

Markwald, Rudolf K. and Marilynn Morris. *Katharina Von Bora: A Reformation Life*. Saint Louis: Concordia, 2002.

McGrath, Alister. "Calvin and the Christian Calling." *First Things* 94 (June, 1999): 31–35. https://www.firstthings.com/article/1999/06/calvin-and-the-christian-calling.

McKee, Elsie, trans. and ed. *Katharina Schutz Zell: Church Mother, The Writings of a Protestant Reformer in Sixteenth-Century Germany*. Chicago: University of Chicago Press, 2006.

Merkle, Rebekah. *Eve in Exile and the Restoration of Femininity*. Moscow, ID: Canon Press, 2016.

Morata, Olympia. *The Complete Writings of an Italian Heretic*. Edited and translated by Holt N. Parker. Chicago: University of Chicago Press, 2003.

Ozment, Steven. *When Fathers Ruled: Family Life in Reformation Europe*. Cambridge, MA: Harvard University Press, 1983.

————. *Ancestors: The Loving Family in Old Europe*. Cambridge, MA: Harvard University Press, 2001.

Park, Madison. "US Fertility Rate Falls to Lowest on Record." *CNN*. August 11, 2016. http://www.cnn.com/2016/08/11/health/us-lowest-fertility-rate/.

Pearcey, Nancy. *Total Truth: Liberating Christianity from Its Cultural Captivity*. Wheaton, IL: Crossway, 2005.

Philipp Melanchthon 500th Anniversary Exhibit. Lutheran History, accessed September 15, 2017. http://www.lutheranhistory.org/melanchthon/.

Piper, John. "Martin Luther: Lessons From His Life and Labor." *Desiring God*, January 30, 1996. http://www.desiringgod.org/messages/martin-luther-lessons-from-his-life-and-labor.

Reston, James. *Luther's Fortress: Martin Luther and His Reformation Under Siege*. New York: Hachette Book Group, 2015. https://books.google.com/books/about/Luther_s_Fortress.html?id=tAGCBgAAQBAJ&printsec=frontcover

Robin, Diana Maury, Anne R. Larsen, Carole Levin, eds. *Encyclopedia of Women in the Renaissance: Italy, France, and England*. Santa Barbara, CA: ABC-CLIO, 2007.

Roos, Dave. "How Butter Fueled the Protestant Reformation." *How Stuff Works*, August 28, 2017. http://history.howstuffworks.com/historical -events/butter-fueled-protestant-reformation.htm.

Sandberg, Sheryl and Nell Scovell. *Lean In: Women, Work, and the Will to Lead*. New York: Alfred A. Knopf, 2014.

Sanger, Margaret. *The Pivot of Civilization (Classic Reprint)*. Forgotten Books: San Bernadino, CA, 2016.

Sarti, Raffaella. *Europe at Home: Family and Material Culture 1500–1800*. Translated by Allan Cameron. New Haven, CT: Yale University Press, 2002.

Schaff, Philip. *History of the Christian Church Volume 8: The Swiss Reformation*, 3rd ed. Peabody: Hendrickson Publishers, 1996.

———. *History of the Christian Church Volume 7: The German Reformation*, 2nd. ed. Peabody: Hendrickson Publishers, 1996.

———. *History of the Christian Church Volume 6: The Middle Ages*, 1st. ed. Peabody: Hendrickson Publishers, 1996.

Selderhuis, H. J. *Marriage and Divorce in the Thought of Martin Bucer*. Translated by John Vriend and Lyle D. Bierma. Kirksville, MO: Truman State University Press, 1999.

Slee, Nicola. *Faith and Feminism: An Introduction to Christian Feminist Theology*. London: Dartmon, Longman, and Todd, 2003.

Stjerna, Kirsi. *Women and the Reformation*. Malden, MA: Blackwell Publishing, 2009.

Stock, Phyllis. *Better Than Rubies: A History of Women's Education*. New York: Capricorn Books, 1978.

Terpstra, Charles. "The Reformation: A Return to the Primacy of Preaching." *Protestant Reformed Churches in America*, November 13, 2001. http://www.prca.org/current/Articles/reformat.htm.

Thompson, John Lee. *John Calvin and the Daughters of Sarah: Women in Regular and Exceptional Roles in the Exegesis of Calvin, His Predecessors, and His Contemporaries*. Geneva: Librarie Droz, 1992.

Traister, Rebecca. *All the Single Ladies: Unmarried Women and the Rise of an Independent Nation*. New York: Simon and Schuster, 2016.

Ulrich Zwingli: Militant Swiss Reformer. *Christianity Today*, accessed September 15, 2017. http://www.christianitytoday.com/history/people /moversandshakers/ulrich-zwingli.html.

Valenti, Jessica. "Not Wanting Kids is Entirely Normal." *The Atlantic*, September 19, 2012. http://www.theatlantic.com/health/archive /2012/09/not-wanting-kids-is-entirely-normal/262367/.

VanDoodewaard, Rebecca. *Reformation Women: Sixteenth-Century Figures Who Shaped Christianity's Rebirth*. Grand Rapids, MI: Reformation Heritage Books, 2017.

VanDoodewaard, William. "Reformation Church History—Women of the Reformation, pt 1." Lecture at Puritan Theological Seminary, November 13, 2015. https://www.youtube.com/watch?v=mwQpQyG4VNQ.

———. "Reformation Church History—Women of the Reformation, pt 2." Lecture at Puritan Theological Seminary, November 18, 2015. https://www.youtube.com/watch?v=l7e59ZYd71o.

Webster, William. "The Roman Catholic Teaching on Salvation and Justification." *Christian Truth*. Accessed September 15, 2017. http://www.christiantruth.com/articles/RCJustification.html.

Wiesner-Hanks, Merry. *Women and Gender in Early Modern Europe*. Cambridge: Cambridge University Press, 2008.

Wingren, Gustaf. *Luther on Vocation*. Translated by Carl C. Rasmussen. Eugene, OR: Wipf and Stock, 2004.

Zell, Katharina Schutz. "Defending Clerical Marriage." In *German History in Documents and Images: Vol. 1 From the Reformation to the Thirty Years War 1500–1648*. Translated by Thomas A. Brady Jr. http://germanhistorydocs .ghi-dc.org/pdf/eng/Doc.60–ENG-ZellMarriage_eng.pdf.